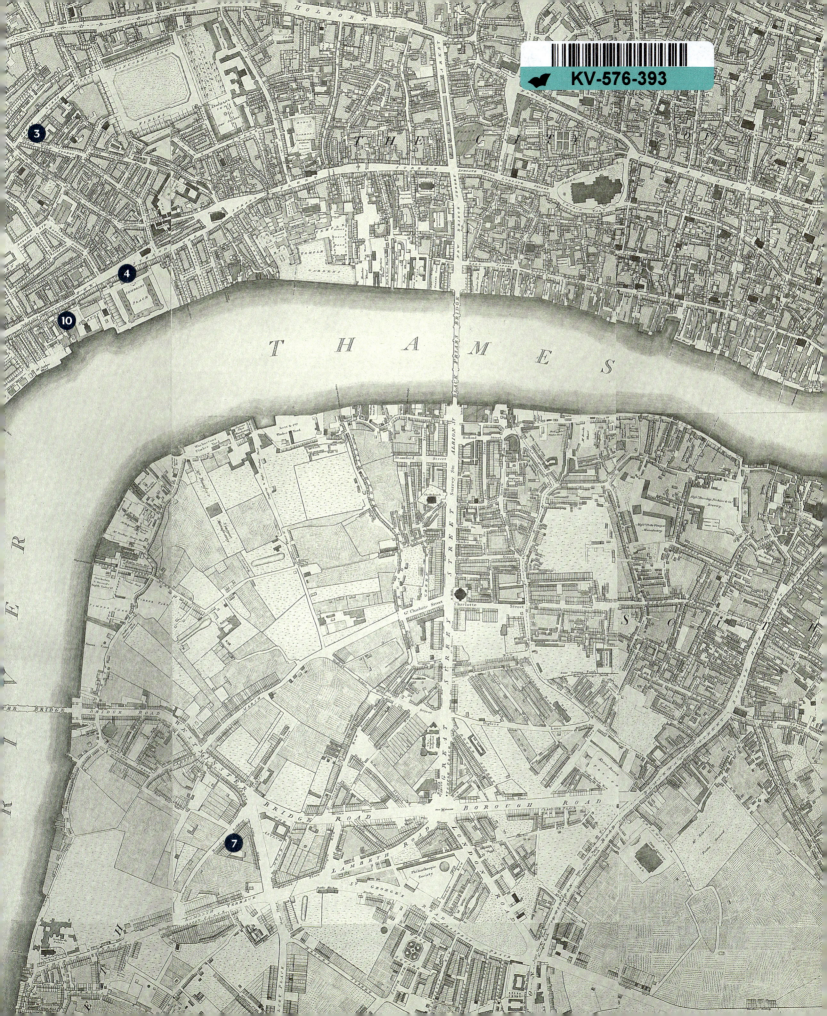

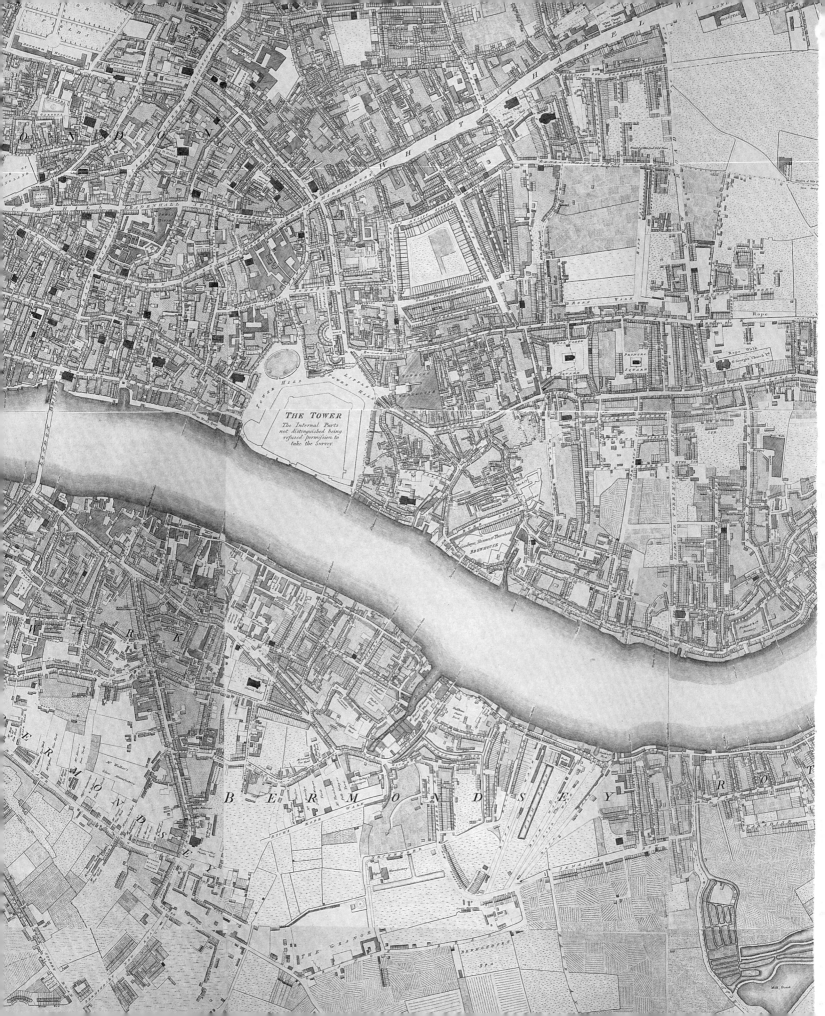

THE TOWER

The Internal Parts
not distinguished being
refused permission to
take the Survey.

William Blake

William Blake

Martin Myrone and Amy Concannon

with an afterword by Alan Moore

First published 2019 by
order of the Tate Trustees
by Tate Publishing, a division
of Tate Enterprises Ltd,
Millbank, London SW1P 4RG
www.tate.org.uk/publishing

on the occasion of the exhibition
William Blake

Tate Britain, London
11 September 2019 – 2 February 2020

Supported by Tate Patrons and Tate Members

Martin Myrone is Senior Curator,
Pre-1800 British Art at Tate

Amy Concannon is Curator,
1790–1850, British Art at Tate

Alan Moore, is a writer, performer, recording
artist, activist and magician, best-known for
his comic-book work including the acclaimed
graphic novel *From Hell* (1991).

A catalogue record for this book
is available from the British Library

ISBN
978 1 84976 644 9 (hardback)
978 1 84976 633 3 (paperback)

Library of Congress Control Number
applied for

Project Editor: Alice Chasey
Production: Juliette Dupire / Roanne Marner
Picture Researcher: Sarah Tucker
Designed by Fraser Muggeridge studio
Colour reproduction by DL Imaging,
London
Printed in Italy by Conti Tipocolor,
Florence

Front cover: William Blake,
The Ancient of Days, c.1827 (no.166)

Back cover: William Blake,
Christian in the Arbour, 1824–7 (no.162)

Inside cover / Endpapers: Richard Horwood,
*Plan of the Cities of London and Westminster,
the Borough of Southwark, and parts adjoining
Shewing every house*, 1792–9

Frontispiece: William Blake, *Visions of
the Daughters of Albion*, c.1795 (no.49)

All artworks by William Blake
unless otherwise specified.

Measurements of artworks are given
in centimetres, height before width,
before depth.

Curators' Acknowledgements

We are conscious that granting works as
vulnerable and as in demand as Blake's books,
prints and paintings is a challenge and are
therefore extremely grateful to all the lenders
of works to the exhibition. For their assistance
in researching and preparing works for
loan, we would like to thank all the registrars,
conservators, curators, collections managers
and librarians involved at various stages
of this project. Particular thanks to Robert
Essick, Shelley Langdale, Peter Bell, Carola
Bell, Annette Wickham, Mark Pomeroy, Jane
Munro, Kim Sloan, Julius Bryant, Matthew
Hargraves, Ted Gott, Cathy Leahy, Colin
Harrison, Jenny Gaschke, Melinda McCurdy,
Hannah Williamson, and Stephen Hebron.

The Paul Mellon Centre for Studies in British
Art supported a workshop at Tate Britain in
January 2018, which proved to be formative.
We would like to thank Mark Hallett, Sarah
Turner and their colleagues at the Centre for
their support then and on other occasions.
To the participants of this workshop, and
many others in the field of Blake studies
and British Romantic art we owe thanks for
conversations and input that has benefited
the development of this exhibition, including
David Worrall, Susan Matthews, Colin Trodd,
Michael Philips, David Bindman, Martin Butlin,
Jon Mee, Andrew Loukes, Sibylle Erle, Bethan
Stevens, Luisa Calè, Jason Whittaker, Naomi
Billingsley, Esther Chadwick and Hayley Flynn.
The exhibition has benefited materially from
the expertise and knowledge of numerous
colleagues from around Tate, including
Joyce Townsend and Bronwyn Ormsby,
Sam McGuire, Minnie Scott, Richard Martin,
Christopher Griffin, Emily Pringle, Ricky
Bowtell, Juleigh Gordon-Orr, Andy Shiel,
Paul Neicho, as well as Alice Insley, James
Finch, and our former colleagues Greg
Sullivan, Jean Baptiste Delorme, and
Emma Harpur.

At Tate Publishing we would like to thank
Alice Chasey, Juliette Dupire and Roanne
Marner, as well as the designers of the
catalogue, Aldo Caprini and Fraser
Muggeridge.

Martin Myrone and Amy Concannon

Director's Foreword

This is the fourth major exhibition of William Blake's work held at Tate at Millbank. Remarkably, he was the subject of the very first loan exhibition ever to be held at what was then the National Gallery of British Art, in 1913. It was remarkable because these were still relatively early days in the reassessment of Blake as a figure in cultural history, and remarkable, too, because the National Gallery of British Art had been established to showcase work by more modern British artists, and then primarily those working in the medium of oil painting rather than the watercolour and print media that Blake specialised in. A further show in 1947, organised by the British Council and touring to Paris, Antwerp and Zurich, served the purpose of post-war cultural diplomacy, and gave Blake a new currency among generations informed not only by the trauma of war but the imaginative freedoms associated with Surrealism and Neo-Romanticism. The major show in 1978, curated by Martin Butlin, was a landmark, taking account of the more rigorous scholarly work on Blake as a poet and visual artist undertaken in the previous three decades to set out a lucidly narrated overview of his work. The last major exhibition at Tate, in 2000 and one of the very first exhibitions at the gallery now reinvented as Tate Britain, offered a multi-faceted Blake: an artisan dedicated to his craft, a politicised artist deeply informed by his revolutionary sentiments and his experience of contemporary Britain, and a wildly imaginative interpreter of the Gothic.

There have been important exhibitions elsewhere in recent decades. Tate's collection was shown in Moscow in 2011–12; there have been further retrospectives in Paris and at the Ashmolean, Oxford in 2009 and 2014, respectively. But in the period of more than a century that has passed since that exhibition of 1913, Tate has established a very special relationship with this most idiosyncratic and distinctive of artists. The few works by Blake which had found their way into the National Gallery collection in the late nineteenth century were transferred to Tate at the beginning of the twentieth century, forming the kernel of what has become one of the outstanding collections of Blake in the world. Since the 1920s Blake has been on almost constant display at Millbank, accorded a separate gallery at various points including one with a specially designed mosaic floor by Boris Anrep which remains in place. There have been myriad different contexts in which Blake's work has been shown at Tate Britain, in temporary displays and exhibitions reflecting and adding to shifting perceptions of this most fascinating of British artists. At Tate Britain, the home of British art, we position Blake alongside Turner and Constable as the three great exponents of Romanticism in the visual arts in Britain. This exhibition builds on this century and more of scholarship, display, interpretation and re-imagining. Blake's work as a maker of visual images, as well as a poet, has come increasingly into focus among scholars, and the exhibition reflects this shift. It also presents Blake as profoundly rooted in the experience of his time, not only the politics, religious beliefs and historical events which we now understand shaped even his most visionary and outlandish productions, but his domestic experiences, as a boy growing up in Soho in a supportive family context, as the husband of Catherine, whose creative and practical influence over his work is only beginning to be fully appreciated, and as a sometimes difficult and contrary friend of fellow-artists, collectors and patrons.

The Blake we see here is as singular a figure as ever, fiercely independent and uniquely imaginative. The visionary who has inspired successive generations of artists, poets, musicians and performers, radicals and independently-minded people of all sorts, is shown in force here. But we are also invited to see Blake as a flesh-and-blood individual, full of contradictions and failings, dependent to a degree

upon friends and family, and whose hopes and ambitions were shaped by his times, as much as they escaped and went beyond those historical circumstances. The exhibition puts a particular emphasis on the way that Blake's art was encountered by his contemporaries, showing many of his extraordinary prophetic books as books, rather than as disbound series of sheets fixed to the wall as museum-pieces, and focusing on the traumatic failure of his one-man show of 1809 and the ambitions he harboured to see his works executed on a massive scale as public frescos. We hope that the strength of his individual vision and personality might be appreciated even more deeply in these contexts, and the present-day relevance of his commitments and beliefs felt all the more warmly.

Showing Blake in all his diversity as a maker of images and books has required going far beyond Tate's collection, as deep and rich as it is. All of Blake's works, whether executed in watercolour, print or in tempera, are vulnerable to light exposure and can be shown only for limited periods under special lighting conditions, and we are enormously grateful to the many collections which have been able to agree such precious works for inclusion in this show. There are especially large groups of works from the Yale Center for British Art, New Haven, the Huntington Art Collection, California, from the Fitzwilliam Museum, Cambridge and from the National Gallery of Victoria, Melbourne. We include a remarkable range of Blake's illuminated books, each copy an extraordinary rarity and unique in its arrangement and colouring, lent by the Bodleian Library, Oxford, Cincinnati Art Museum, and the Library of Congress. We are grateful to all the institutional lenders to the exhibition, and to the private individuals who have been kind enough to share their works with us, including Robert Essick and David Bindman who, along with a range of other individuals noted by the curators in their acknowledgements, have provided vital assistance in shaping this project.

The exhibition has been curated by Martin Myrone, Senior Curator, British Art to 1800, and Amy Concannon, Curator, British Art 1790–1850, who have also authored this catalogue. I wish to thank them for the commitment and fresh insight they have brought to each aspect of this project. Each of us is grateful to Alan Moore, the trailblazing graphic novelist, for contributing an afterword for this publication that is testimony, once again, to Blake's ongoing influence on modern and contemporary art and culture. Thank you also to Alice Chasey for her editorial management of this publication.

We would like to thank Tate Patrons and Tate Members for generously supporting the exhibition, for which we are very grateful.

This exhibition has also been made possible by the provision of insurance through the Government Indemnity Scheme. Tate Britain would like to thank HM Government for providing Government Indemnity and the Department for Digital, Culture, Media and Sport and Arts Council England for arranging the indemnity.

Alex Farquharson
Director, Tate Britain

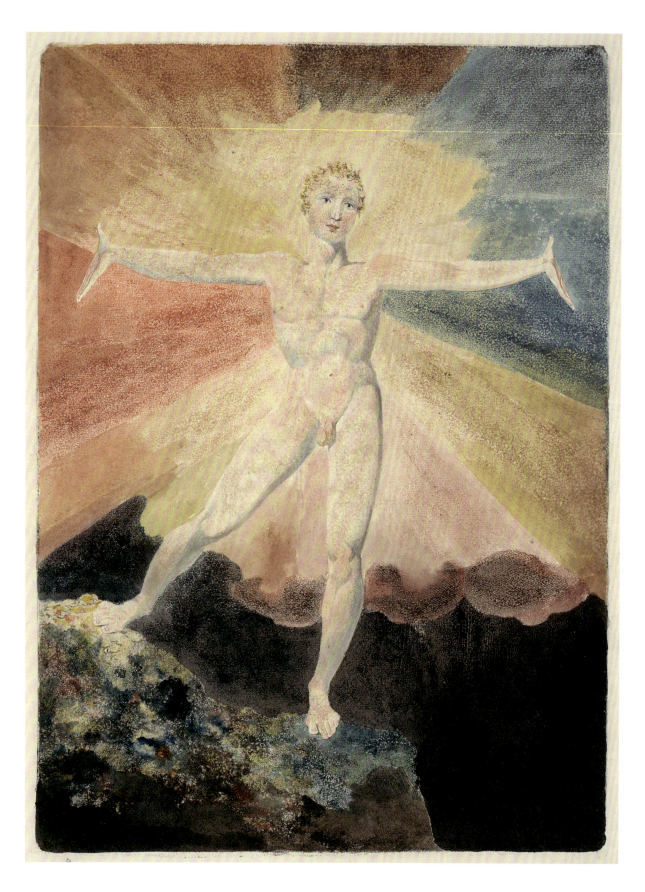

1. *Albion Rose*, c.1793
Colour engraving and etching with hand-colouring on paper, 36.8 × 26.3

THE MAKING OF A MODERN ARTIST

The figure of a young man, resplendent in his nakedness, arms outstretched and seeming to leap up from a craggy rock, a dazzlingly prismatic burst of colour behind him, has become an emblem of freedom of all sorts. It has served as a clarion call for revolutionary action, whether in relation to politics and social justice, the poetics of the counter-culture, or ideas of imaginative freedom, psychic well-being and body confidence. It has done so in books and on book covers, on album sleeves and posters, alongside essays and polemics, on tote bags and in museum exhibitions and gallery displays, in libraries and school-rooms, and at home or in the street, on Twitter and YouTube, in blog postings and websites. It has served to represent an idea of 'British values', of universal human values, of the value of resistance, of creativity, of freedom. Together with several other of the same artist's images, most obviously *Newton*, *The Ghost of a Flea* and *The Ancient of Days*, the image has been exhibited and discussed, published, recycled and repurposed, innumerable times and in a dazzling array of different – sometimes radically contrasting – contexts. The story of the man who made those images, William Blake, has been told repeatedly, and not only as a way of explicating his poetry and art for those of us most interested in such things, but also as a fable of inspiring self-transformation with much wider application. Blake, the son of a London hosier and haberdasher who was apprenticed to an engraver and destined to dedicate himself to that laborious trade, sought instead to create art and poetry of wild ambition and originality, scarcely understood or appreciated by his contemporaries. His famed self-sacrifice, imaginative independence and creative ambition have come to symbolise the very idea of authenticity, in art, life and politics.

This print, usually known as *Albion Rose* or *Glad Day*, has – along with the hundreds of other prints, paintings and drawings that Blake produced – also been subject to a century and a half of dedicated scholarship. Sometimes speculative, often highly technical, occasionally inscrutable, each word of his writings, each printed sheet, each drawing and painting, has been catalogued and described, analysed, interpreted and argued over. The print shown here is from the collection of The

Huntington in California, originally amassed by the American railroad magnate, Henry E. Huntington. It is a second impression of the colour-printed design, the first being in the British Museum in London.[1] It was preceded by a linear version of the same design dated as early as 1780 although probably engraved around 1793, and a pencil drawing of a figure with similarly outstretched arms which was probably an imaginative rendering but can be related in its technique and presentation to the studies Blake must have undertaken at the Royal Academy as a student there in c.1779–80.[2] On alternate sides of the same sheet, there the figure is shown from the front and from behind, his left foot and hand touching what we can read as the opening of a cave, the figure therefore arising, stretching out, on meeting the light outside.

These are all now single, seemingly independent sheets, held in pristine mounts in the rarefied conditions of the modern prints and drawings room or museum storage. But the impression of the print shown here was bound in at the end of Blake's prophetic book *The Song of Los*, when that volume was acquired by Huntington in 1915. *The Song of Los* is a poetic text printed by Blake himself in 1795, one of a succession of 'prophetic books' that he produced in the 1790s and that have become the foundation of his posthumous literary and artistic reputation. Featuring Blake's invented characters in an epic text organised under the headings of 'Africa' and 'Asia', it concerned the decline of morality in public life, the venality of the European slave trade, and the promise of global revolution as this had been awakened by the first, generally optimistic phase of the French Revolution (1789–93). Its themes can be related to historical events and values from Blake's time, but this was a visionary work rather than descriptive or literal. It included characters from the Bible and history (Adam, Noah, Socrates) and Blake's own invented figures with names that are made up but also resonate somehow with names that we already know (Brama, Los, Urizen).

In their material form and modes of distribution, Blake's books were not like the industrially produced books we are used to. Composed of plates executed in his unique colour-printing technique, combining the text and images in a single design, each sheet in each copy might be printed differently, coloured differently, and the books themselves have existed in multiple arrangements which have fascinated (and frustrated) scholars and collectors. This impression of *Albion Rose* is on different paper from *The Song of Los*, but the most eminent Blake scholars have come to different views as to whether this was intentionally included by the artist as a final plate of that book, as it came to Henry Huntington, or if this was something contrived by a later owner of the sheets. Their opinions derive from a lifetime of looking at Blake, at the different

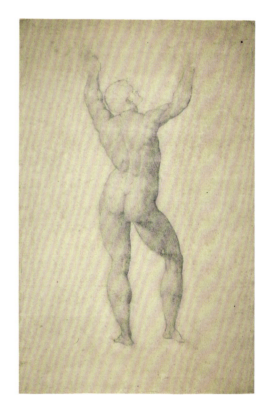

2. *Academy Study (figure seen from behind)*, c.1779–80, Graphite on paper, 34.9 × 22.5

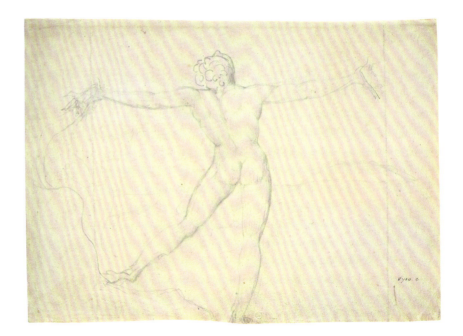

3. *Study for 'Glad Day', 'Albion Rose' or 'The Dance'*,
c.1780, Graphite on paper, 20.6 × 28.8

versions of the books, at the individual plates and the separate
drawings and paintings, years of thinking about and discussing Blake's
poetry, attending to the kind of paper he used, its weight and colour
and texture, the techniques of his printmaking and printing, the smears
and accidental marks he made in the process, as well as the tiniest
details of the intended design.

If this impression of the print was deliberately included by Blake at the
end of *The Song of Los*, it there served as a bright emblem of political
rebellion, rather more optimistic in its outlook than the apocalypse
that concludes the text and the rather reflective image of a giant Los
with his hammer looking down on what appears to be a bloody globe
of his creation:

> Orc raging in European darkness
> Arose like a pillar of fire above the Alps
> Like a serpent of fiery flame!
> The sullen Earth
> Shrunk!
>
> Forth from the dead dust rattling bones to bones
> Join: shaking convuls'd the shivring clay breathes
> And all flesh naked stands: Fathers and Friends;
> Mothers & Infants; Kings & Warriors:
>
> The Grave shrieks with delight, & shakes
> Her hollow womb, & clasps the solid stem:
> Her bosom swells with wild desire:
> And milk & blood & glandous wine.[3]

11

So is Blake's figure now his invented character of Orc raging, 'like a pillar of fire above the Alps'? A symbol of vaulting liberation contrasting with the weightiness of Los? Blake had opposed these figures, in words and pictures, before and would do so again. Maybe, but if this is the case, the figure has other roles to play in other contexts.

The conventional title for this composition is derived from the engraving which is dated '1780' but probably from at least a decade later, captioned 'Albion rose from where he laboured at the Mill with Slaves Giving himself For the Nations he danc'd the dance of Eternal Death'.[4] Albion is the traditional, mythical name for Britain, and a central character in Blake's later poetry, where he is conceived as a giant personification of the nation as well as a geographical entity. The figure has also been associated with an image of physical heroism evoked in Blake's early prose work 'King Edward the Third', printed in his *Poetical Sketches*, a slim volume of his youthful writings published in 1783 with the financial support of some friends:

> ... the bright morn
> Smiles on our army, and the gallant sun
> Springs from the hills like a young hero
> Into the battle, shaking his golden locks
> Exultingly; this is a promising day.[5]

But if we don't have that knowledge of Blake's earlier poetic writings and his mature symbolism, the technical information about the relationship of the plate with the *Song of Los*, the history of the print as an object, we are free to decide quite otherwise – as the makers of tote bags and the designers of libertarian websites have discovered.

At one pole are the specialised Blake scholars, full-time academics given over to research and teaching, pondering each plate and ruminating over each word. The concern might be with Blake's symbolism, his language and thought, or with the materiality of his art and the social circumstances of its production. In its most positive light, this is the realm of what the contemporary sociologist Richard Sennett would identify as 'the craftsman', where opinion and thought are rooted in deep practical experience, probably extended over many years.[6] More negatively, this might be viewed as elitist, recondite, and therefore properly to be damned, in a way which has become more possible in recent times, when such criticism can be bolstered by populist ire against undemocratic 'expertise' and readily brushed aside with reference to the apparently irresistible exigencies of economic austerity. At the other pole there is the spontaneous and apparently egalitarian engagement with Blake as a figure of all-encompassing

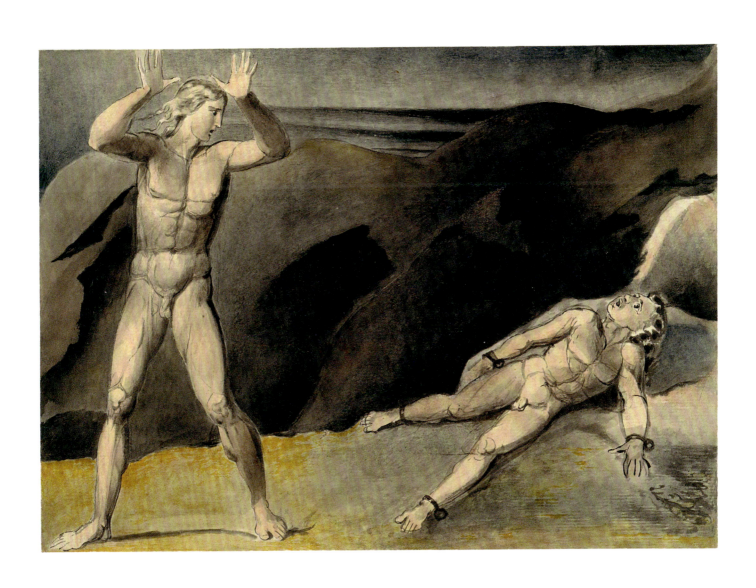

4. *Los and Orc*, c.1792–3
Ink and watercolour on paper, 21.7 × 29.5

freedom, a spiritual, intuitive interpretation of his images and words. There may be guides in such interpretation – Carl Jung or Karl Marx, Buddhism or the Bible, Jack Kerouac, Jah Wobble or Philip Pullman, a principled adherence to pacifism or sexual equality or queer protest or anarchism – but it is a deeply personal matter. In a positive light, this is 'Blake for all', everyone's opinions can matter, everyone can have a say, express a viewpoint and understand in their own way. In a negative light, this is the realm of 'emotivism', where the wholly individualised pursuit of pleasure is a mask for more deeply manipulative forces, an illusion of self-fulfillment fostered by and complicit with global consumer culture and big business.[7]

We can all place ourselves on a spectrum of interpretation, although we would all surely resist the negative characterisation of the extreme positions sketched out here. We will probably all occupy several, perhaps many different positions on the spectrum, at different times and in different settings. As the curators of the exhibition, and as the authors of this book, we need also to position ourselves. Our own views differ from one another's, and certainly from the views of some of our colleagues. As exhibition makers we must acknowledge and work with the full spectrum of experiences Blake's works might be expected to elicit. The exhibition aims to present a 'Blake for all'. It is precisely Blake's association with creative freedom, his perceived resonance with the array of socio-economic types identified by media teams and marketeers, that has had to be embraced to justify the time, money and energy expended on putting together a show of an eighteenth-century British artist when such historical figures risk being disregarded in the context of 'the current head-long rush towards the contemporary and the concomitant celebration of the products of a now fully globalized art market'.[8]

What we want to do is to introduce a note of reflection. The approach taken here is determinedly historicist and materialist. This means, simply, that we think that it really matters where and when these artworks were created, who got to see them and what they seem to have thought, who collected them. This means, among other things, shifting attention from the epic and dense poetry to the watercolours and paintings, the book illustrations and the more prosaic-looking of the relevant literary documents, such as the *Descriptive Catalogue* that accompanied Blake's disastrous one-man show in 1809, the magazine notice puffing the appearance of his epic illuminated book *Jerusalem: The Emanation of the Giant Albion* issued by Thomas Griffiths Wainewright without, it seems certain, great effect in actually securing sales for the artist. We are not seeking to expose Blake's patrons as simplistically self-interested or misled, or to say that his critics

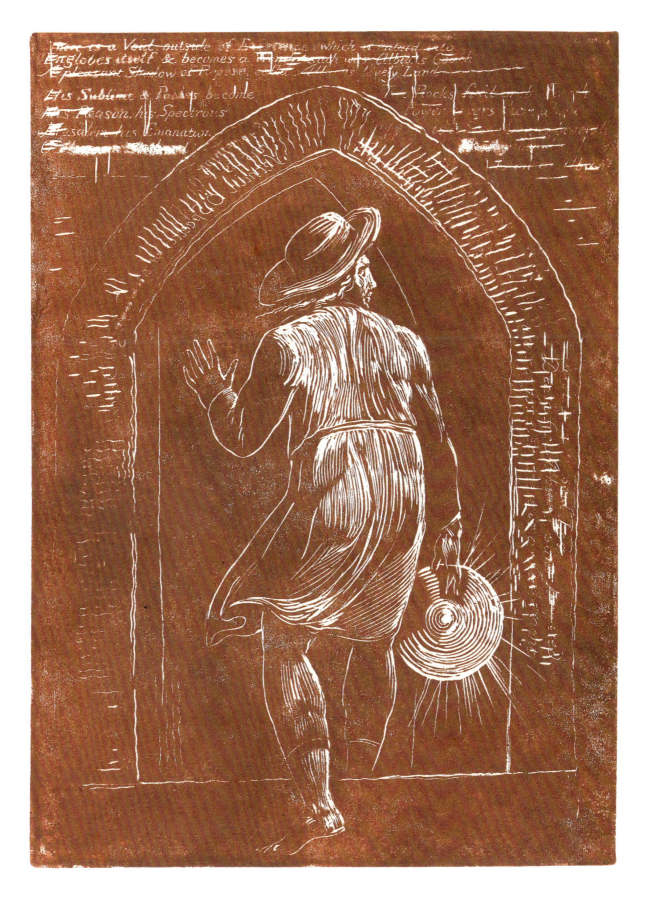

5. *Frontispiece to Jerusalem: The Emanation of the Giant Albion*, c.1804–18, printed c.1832
Relief etching using black carbon ink on paper, 22.2 × 16.5

misunderstood him, or that the failure of the public to recognise his stature as an artist was the result of some sort of collective moral failure. We do not want, either, to presume that those patrons who did admire him were endowed with some kind of heroic profundity or depth of aesthetic understanding. Blake's failures, and his successes, are equally social facts. When his friend and supporter William Hayley noted of him, that he 'is very apt to fail in his art: – a species of failing peculiarly entitled to pity in Him, since it arises from nervous Irritation, & a too vehement desire to excell',[9] he is registering not (or not only) some outstanding challenge to the logic of cultural production as observed within post-structuralist literary theorising, but a perception of a practical position arising from and contributing to an individual experience of the world, expressed even in posture, poise, a way of speaking and acting. But it is not, either, that there is a simple unity between biography and art: there are contraries and inconsistencies as well, and such 'nervous Irritation' as Hayley detected might be taken as a sign of struggle and self-division.

The exhibition and this book join that long effort at de-mythologising Blake, established at the dawn of modern Blake studies in the late 1940s, and affirmed from different perspectives in major studies by David V. Erdman in 1954 and E.P. Thompson in 1963.[10] The latter's assertion that Blake can be aligned with a tradition of working-class protest and the emergence of class consciousness has been enormously influential. Erdman's exposure of the specificities of time and place which are threaded through Blake's visionary poetic work re-orientated Blake studies. These are approaches resumed with such penetrating detail (much assisted by the new digitalisation of historical records) by recent scholars including Michael Phillips, Angus Whitehead, Keri Davies and Mark Crosby among others. These writers have provided an unprecedented depth of detail about the physical arrangements of the spaces that Blake worked within, his immediate family and social and professional contacts, and the intellectual and spiritual traditions which formed his inheritance. There has also been important technical work, throwing new light on his materials and processes, by Joyce H. Townsend, Bronwyn Ormsby and Mei-Ying Sung. Other writers, Jon Mee, Susan Matthews and Sarah Haggarty included, have thought deeply about the social networks that Blake operated within and the social values that circulated through his work. These various historicist interpretations of Blake are now dominant, matched only by the interest shown in Blake's reception history in Britain, Europe and the wider world, with important work done by Colin Trodd and Jason Whittaker, and many others in the fields of literature, art, intellectual history and contemporary cultural studies. Eminent elder scholars, including David Bindman, Robert N. Essick,

Morton D. Paley and our distinguished forerunner at Tate, Martin Butlin, have also continued to contribute their experience and wise judgement to the field. Meanwhile, Blake's works and words have become instantly accessible in digital form, thanks to the extraordinary online presence of The William Blake Archive, including a growing corpus of digital versions of his works, Erdman's standard edition of his writings, essays and commentary, and archived copies of the specialist journal *Blake/ An Illustrated Quarterly*. The Archive, edited by Morris Eaves, Robert N. Essick and Joseph Viscomi, really has made a Blake 'for all'.

We owe great debts to this collective body of scholarship. Our task has been to translate some of the lessons of this vast, sophisticated, and not necessarily simply complementary, body of work into forms that can stimulate, provoke and perhaps unsettle in the context of an art exhibition. The exhibition is a space of encounter, and of negotiation, as we look, as we read and try to interpret and perhaps disagree with the captions and wall texts we read, the visual pairings and patterns we are presented with on the wall. The question of what friends Blake had, who his neighbours were, what he wore and how he looked, might seem distant from that encounter, even a distraction. But we recommend the historicist interpretation as a means of deepening and complicating our appreciation of Blake, and understanding the enduring relevance of the lessons provided by his life and experience. He was a man of his time, even in those aspects of his imaginative life and creative practice that seem most wholly out of his time. History is mobilised here to trouble what may seem like the most straightforward encounter with Blake's works as supposedly autonomous aesthetic objects. Blake's fate neatly exposed the dissonance between industrial enterprise and the 'love of the arts', as this was taking shape as a cultural theme in the 1830s. The perverse logic of modern art dictated, as was said of Blake, that 'Persons ... living in a garret and in an abject poverty, enjoyed the brightest visions, the brightest pleasures, the most pure and exalted piety'.[11]

Blake is a modern artist, and that modernity consists importantly not, or not only, in the formal 'modern-ness' of his art (the distorted bodies and startling juxtapositions that seem to anticipate Surrealism and Expressionism, or the elements of visionary self-exposure that seem to be replayed in some video and installation art), but in his departures from the dominant values of his own time. His opposition to emerging modern values, in politics, art and morals, has its own modern-ness, exemplifying how 'the Romantic view constitutes modernity's self-criticism'.[12] Key to this understanding is the bald statement that Blake *was an artist*. By this we mean to emphasise his visual output. In recent years, several scholars primarily interested in Blake as a writer have felt

able to admit that it was the visual arts that occupied him most greatly. Introducing the most recent edition of his poems, Nicholas Shrimpton notes that Blake's 'involvement in literature was, by comparison, occasional and, in his own view, probably of secondary importance'.[13] This is by no means to underplay his towering contributions to English literature, or the deep and profound impact his words have had on culture more widely. But it is the case that it was as a visual artist that Blake dreamed himself as a boy, that his education at Henry Pars' drawing school, at James Basire's workshop and at the Royal Academy, was as a draughtsman and engraver, and that it was engraving work that filled his days, and painting that filled his evenings. But we also want to emphasise that he was an artist in the sense of the new idea of the inspired, autonomous creator. He was an artist in the sense that this involved a new way of being in the world, of living in society, or even just of living with other people – partners, family members, friends.

Blake moved between social worlds, occupying different identities in different settings at different times. Rather than being placed at a distinct distance from the emerging liberal, literary culture of the metropolis, he was clearly deeply embroiled with it, albeit with a particular relationship which was not one of straightforward identification.[14] The romantic-socialist fantasy of Blake as oppressed worker giving visionary voice to popular political sentiments has given way to a more nuanced sense of his networks, connections and beliefs, and of the complex and compromised nature of class relations in the era. We take much here from Jon Mee on Blake's radical connections and Sarah Haggarty's finely detailed book on Blake's relationships with his patrons and friends, but we want to test out the implications of these arguments, to see how they are part of the genetic mix that defined the modern idea of 'the artist'.

For the literary historian Saree Makdisi, Blake was able to negotiate an oppositional stance towards empire – however futile and compromised – because he 'was making art for an audience that literally did not exist, that no longer existed – or that does not yet exist'.[15] We can run Makdisi's point alongside the sociologist Pierre Bourdieu's assertion that 'although this is something that is generally forgotten, those who must produce their market (i.e. create a market that does not exist as yet) must be able to carry on being productive for a certain period of time in the absence of a market'.[16] The market never arrived for Blake, at least not sufficiently. But the support was there. In the commentary that follows there is a particular attention given to the contexts in which he was working. We care about how Blake made a living, who was paying him and for what, the kinds of resources he was able to muster. We give special attention to the question of his personal origins.

There has been a lot of insightful historical work done on the places that Blake lived in during his working life: Hercules Buildings in Lambeth (1791–1800); a cottage in Felpham in Sussex (1800–3); South Molton Street, off Oxford Street, for a long period later in life (1803–21); and in more confined, though still comfortable circumstances in Fountain Court, off the Strand, in his last years (1821–7). There has been some attention given to the homes of his youth, the family home in Broad Street, Soho, and his lodgings in Poland Street (1785–91), and the experience of London's social life – and especially its scenes of social suffering and injustice – as these infiltrated and were worked through his poetry and art. The very fabric of the house in Broad Street has been given concerted attention, as the site of his disastrous one-man exhibition in 1809 which provides a key turning point in his life. Of these various locations, it is the Broad Street address that we will return to most often, as Blake himself did in his life, for it remained with the family until 1812. That date, also the last occasion that Blake exhibited in public, represents another key turning point in his life, for he afterwards retreated from the world. As we interpret it here, that turning away from the world involved a final detachment from his original family. For we subscribe to an idea of social identity as peculiarly 'sticky', that the place and circumstances of one's origins set a trajectory – not absolutely, but with probabilistic force.[17] Moreover, we would emphasise that Blake enjoyed certain privileges because of that trajectory – a certain access to material and social resources, a degree of indulgence, encouragement and formal support from his family background that made his extreme individualism and commitment to liberty more possible than they might otherwise have been. This is something that only becomes clear when we think about Blake in a communal context, as part of various populations (people living in Broad Street, Soho; students of the Royal Academy; printmakers working in London at the end of the eighteenth century; artists trying to make their way in the harsh years after the Battle of Waterloo).

While the allure of the idea of Blake as working-class hero, Cockney visionary or rebel with a cause is doubtless strong, it is also the case that his work has proved unusually well adapted to a particular kind of 'middle-class radicalism'.[18] The degree to which we might admit that Blake's economic and social relations were adapted to a bourgeois and capitalist conception of art, unwittingly and despite appearances, depends upon our position on whether art's critical capacities are genuinely resistant to dominant economic forces, or whether 'artistic critique' itself has already been absorbed within it.[19] Given the way in which the values of art, creativity and imagination have been so thoroughly absorbed by global enterprise, managerial cultures and education over the last decades, we are perhaps in a position to give

greater credence to the latter possibility. As we review the literature on Blake, it is striking that it was J.C. Strange, a corn chandler (merchant) who was in the early 1850s amassing a Blake collection and thinking about writing the artist's life, who considered 'the transference of the patronage of the Arts to the mercantile & manufacturing men' as an 'injury to the Arts', while Dante Gabriel Rossetti, a bohemian artist and Pre-Raphaelite painter and a key figure in the reappraisal of Blake, defended the art collections of the businessmen and bankers who were the new patrons of art as 'disinterestedly made'. Strange noted that Rossetti's conversation '& ready manner reminded me more of the Exchange than of the studio'.[20] Given the degree to which the Pre-Raphaelites have been re-positioned as pioneer avant-gardists and democratically inclined radicals by popular publications and exhibitions of recent years, Rossetti's perceived complicity with ascendant bourgeois capitalism – manifested informally even in his language and self-presentation – is at the very least thought-provoking, considered in the context of his active role in re-evaluating Blake.[21]

This present commentary on Blake is also instinctively art-historical in its focus. This may again seem an obvious point, for surely if Blake is an artist, he has necessarily to be treated art-historically? But art historians have generally not been greatly occupied with Blake, at least compared to their colleagues in the field of literature. While Blake's works have been laboured over by literary historians and theorists through generations, and while his printmaking techniques have been scrutinised intensively over the last decades, it remains the case that there is still a lot to be done in the way of understanding Blake's work as visual art. Ellis K. Waterhouse rather famously declined to engage with the artist in his influential synoptic study, *Painting in Britain, 1530–1790*.[22] His heir in the same task, David H. Solkin, has shown little more enthusiasm but rather greater art-historical insight in his *Art in Britain 1660–1815*, where Blake is introduced into the story of British painting at two points to demonstrate the doomed fate of grand narrative art. In Solkin's account, the diminutive and cryptic nature of Blake's art exemplified the ultimate failure of artists to address a contemporary public with high-minded history painting. But such an interpretation may not sufficiently account for the material and thematic singularities of Blake's art – not least, in being a poet as well as a visual artist – and it may rest on too absolute a sense of his privations, failure and retreat into a private realm of imagination.[23]

Blake has proved to be a problem figure for such surveys of British art history – and in other more general accounts of the history of art. The monographic focus of this book and the accompanying exhibition risks re-asserting Blake's isolated position, presenting him as so singular he

sits outside the mainstream story of art altogether. While Blake's art has been an enduring inspiration, and artists across the generations have emulated certain aspects of his art, the technical idiosyncrasies of Blake's art and nature of his vision meant that there could not ever really be a 'school of Blake'. Blake was though a seminal figure in being poised so precariously and obstinately between obscurity and publicness, success and failure, legibility and absolute obscurity. Plenty of artists tried and failed to be history painters, but not many were able, like Blake, 'to carry on being productive for a certain period of time in the absence of a market', and none came to have such standing as a model for the creative type for his combination of literary and visual art. If his dedication to imaginative writing and art meant that Blake without doubt suffered materially and socially, especially after 1812 and before salvation in the form of support from the younger artists John Linnell and Samuel Palmer at the end of his life, neither did he disappear altogether.

He survived, paid the rent, only once fell back on institutional charity, while others disintegrated mentally, took their own lives, disappeared, or simply turned to another trade. And even at his lowest ebb, Blake was earning more than the many thousands of servants who occupied garrets and basements across London (including Blake's family home and his own home in Hercules Buildings for a while), the hundreds of thousands of labouring men and women across the country. Meanwhile, we would venture that Blake's reputation as the model of the self-sacrificing and authentic artist is not a mere historical fiction, conjured out of thin air by later commentators, but was a fact of his experience, emerging in the words of his supporters within his lifetime. What this exhibition sets out to suggest is that it is not an accident that Blake has become for so many people an exemplar of the creative type, the ideal artist in his authenticity, his struggles and suffering. It is not by chance that his art and words have connected so powerfully the political right, the political left, the establishment and the opposition, the marginalised and the mainstream, libertarians of all extreme forms, as well as the moderate and middle-class. Because the kind of freedom that Blake espoused, the kind of freedom that he experienced as a distinct kind of precarious and passionate worker, belongs distinctively to the modern Western world, providing ideals which are subscribed to across much of the political spectrum, and embodying wider values that we are all expected to cherish and defend. MM

William Blake is the exemplary 'inspired artist', an idea crystallised in this image of him. Although the attribution is disputed, this appears to be a self-portrait done in the very first years of the nineteenth century. The format and size suggest that it might have been prepared for engraving. Blake stares out at us with hypnotic intensity, his features and body organised with strict symmetry. There are no conventional signs that this *was* a self-portrait – no brush or pencil, no half-painted canvas or artist's model – but nor would Blake wish himself to be seen as a conventional artist. The artist is instead an isolated, heroic figure. Rather than being defined by what he does or how he acts, he invites us to search out the signs of creative intensity in his direct gaze. Such images had appeared in the history of art before, famously with Albrecht Dürer's Christ-like self-portrait (Alte Pinakothek, Munich). But Blake's image was one of several from around this date which signalled a seminal shift in the way artists imagined themselves. His visionary intensity was, however, exceptionally strongly expressed and even notoriously so.

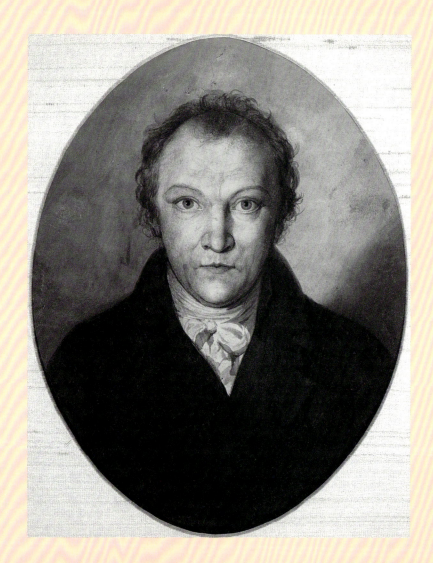

6. *Portrait of William Blake*, c.1802–3
Graphite and wash on paper, 24.3 × 20.1

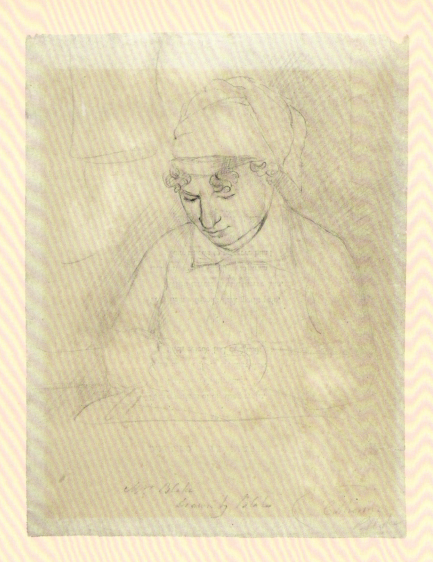

7. *Catherine Blake*, c.1805
Graphite on paper, 28.6 × 22.1

William Blake's casually conceived sketch of his wife Catherine
was drawn on the back of a spare sheet from the poet William Hayley's
Ballads (1802), which Blake had illustrated. The couple had married in
1782: although there were evidently periods of turmoil between them,
the relationship ended only with Blake's death in 1827. It is notable
that Blake's visual art and poetry only really started to develop in
original ways after their marriage. Early biographers acknowledged
that Catherine played a huge part in Blake's creative and commercial
work, helping him with printing his designs, colouring his prints, and
even finishing his drawings posthumously. She also looked after the
household and finances. Blake himself acknowledged his debts to her,
although it is her domestic labour which this drawing seems to suggest.
It was said that he would always get the stove going, before she got
up, a modicum of domestic service which hardly matches a lifetime
of practical and emotional support. Arguably, Blake's extraordinary
vision depended in some very real ways on the domestic stability of
his life with Catherine.

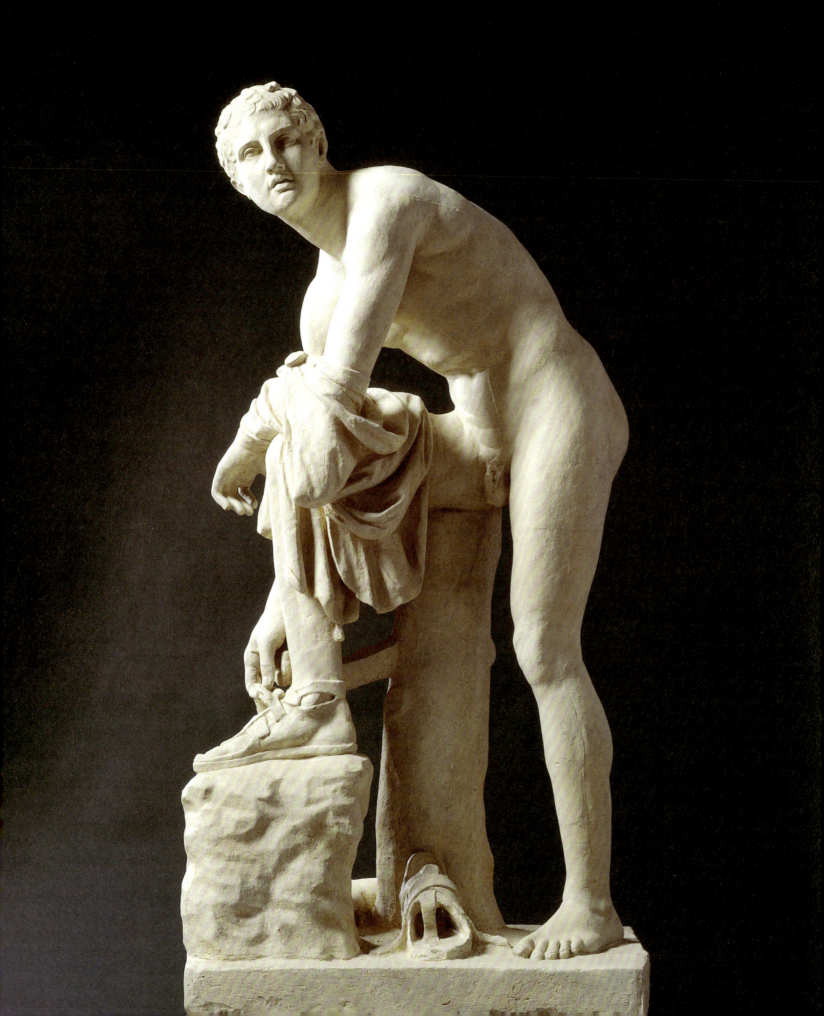

'BLAKE
BE AN ARTIST!'

From 8 October 1779 when, at the age of 21 his name was entered into the official Register of Students, William Blake enjoyed the privilege of attending the drawing schools at the Royal Academy.[1] He would already have spent a period in the Academy, preparing the drawing of a cast after a classical antique which provided the passport to registration. At that date the privilege was enjoyed for life (it was later limited to ten years, after reforms in 1800). Many students attended for many years, but what Blake did is very uncertain. There are no surviving daily registers of attendance from this time, and student drawings have not generally been preserved. In Blake's case, we have only a small handful of drawings attributed to him which might have been produced in the Academy schools. Based largely on his later, extremely hostile comments on the art and thought of the President of the Royal Academy, Sir Joshua Reynolds, commentators have taken Blake to be an enemy of the Academy and of formal education altogether. But Blake's earliest biographer, Benjamin Heath Malkin, asserted on the basis of conversations with the artist that 'here he drew with great care, perhaps all, or certainly nearly all the noble antique figures in various views' and that, notwithstanding 'his peculiar notions' that were taking shape at the time, 'he drew a great deal from life, both at the academy and at home'.[2] Blake made a note about arguing with the Keeper, George Michael Moser, when he was 'looking over the Prints from Rafael & Michael Angelo. [sic] in the Library of the Royal Academy'.[3] But whatever use he made practically of the facilities, there is no doubt that this was a turning point in his life and art. As David Bindman noted, after an obscure youth, 'he emerges

more clearly' for us as of this date.[4] It was, we would argue here, a pivotal moment, encapsulating at the level of individual experience the grand historical transformation of the makers of paintings and drawings from the status of being an 'artisan' into the status of being an 'artist' in a modern sense.[5]

9. *Study of the lower part of the cast of Cincinnatus*, c.1779–80? Pen, graphite, ink and wash, 24.2 × 33

This was a transformation which took shape in a specific time and place. Like many students in the schools, Blake had only a short walk across central London to get to class. He had been born on 28 November 1757 at 28 Broad Street, Carnaby Market,[6] where his family ran a hosiery shop and haberdashery under the sign of the Woolpack & Peacock, selling 'all kinds of Baizes, Flannels, etc etc'.[7] He grew up there, and if he probably moved in with the engraver James Basire when he was apprenticed to him for seven years in 1772, that was in Great Queen Street, Holborn, less than twenty minutes' walk away, and he would presumably have

Drawn by B Eakes
from the print from
Michael Angelo
Touched by Fredk. Tatham

10. After Michelangelo, *Matthan*, c.1785
Ink and watercolour on paper, 24.4 × 17.4

regularly gone home. He would have returned there on a full-time basis for a period after the apprenticeship ended in the summer of 1779. Broad Street played a continuing part in his life. In 1784–5, with a modest bequest from his father, he had set himself up as a print publisher with his fellow Royal Academy student James Parker at no. 27, next door. The family stayed on at no. 28, his brother James, who had started a business apprenticeship while Blake was having his drawing lessons at Pars' school, taking over the shop.[8] William and Catherine stayed there when they returned to London in 1803, after a period staying in Sussex where Blake worked for the poet William Hayley, and his one-man exhibition was held in the rooms above the family shop in 1809. He published his *Canterbury Pilgrims* from the address in 1810. His brother remained at no. 28 with his wife and unmarried sister until 1812, and it is only after that date that the connection with Broad Street, and with the immediate family, seems finally to have been broken.

What kind of street was Broad Street? Commentators on Blake have in the past drawn attention to the presence of artists and engravers, on Broad Street itself and in the immediate vicinity.[9] The leading engraver Francesco Bartolozzi had been down the street at no. 49 in around 1768–74, along with his young apprentice (and student at the Royal Academy) John Keyse Sherwin; the printmakers Francis Chesham and William Pether were there in 1778. Bartolozzi was one of a number of Italian artists and decorative painters in the area, including the decorative painter Michael Angelo Pergolosi on Broad Street itself for a time. There was James Wildsmith, a statuary (although probably retired), at no. 22 a few doors down from the Blakes, and further along again there was Henry Fremont, an embroiderer by trade but an auction of his property in 1783 showed also an assiduous academic draughtsman, and apparently a student at the Academy.[10] There was John Hakewill at no. 45, a trade painter but begetting a dynasty of architects and artists, and the Irish architect James Gandon (both sent sons to the Royal Academy); and in

1780–81 lodged for a time at no.1 Henry Fuseli, the Swiss-born translator and poet of considerable intellectual pretensions, newly returned from a period in Rome where he had decided for himself, and had persuaded a few others, too, that he was to become an artist of gigantic ambitions equalled only by Michelangelo – the archetype of wild genius.

More prevalent, however, were the producers of fashionable luxury goods, including cabinetmakers, upholsterers, furniture designers and suppliers. At Dufours Court, Broad Street, there was the fashionable cabinetmakers and designers Ince and Mayhew, and Sefferin Alken, a high-class carver and gilder (whose son attended the Royal Academy, and who became the founding figure in a dynasty of artists and printmakers); and in Broad Street, John Hartley, maker of looking glasses, and at no. 5 William Bainbridge, described with the deceptively unalluring term 'glass grinder' in insurance records, who maintained a stock of 'tasteful frames … brilliant mirrors' and 'some valuable prints, drawings, and paintings'.[11] There were, most notably, the makers of harpsichords and pianos, still a novelty and items of great expense. The trade had developed in London only in the 1760s, with the arrival of a number of German makers.[12] In Broad Street there were several, taking up multiple or extended properties: Frederick Beck at no. 4 and no. 10, Abraham Kirkman at nos. 18 and 19, Christopher Ganer at nos. 47 and 48, as well as Francis Werner, a fashionable musician and music publisher immediately across the road from the Blakes at no. 30 for a time.

There were, certainly, more mundane trades: several tailors, an ironmonger, a plumber, a carpenter, as well as, predictably, the bakers, hairdressers and public houses, all the shops and establishments that appeared on almost any substantial street in central London at the time. But there were also (although more towards the wider, eastern end of the street, and in declining numbers during the Blake family's time here), colonels, clergymen, and navy pursers, surgeons and physicians, well-off widows and retired gentlemen, representatives of the affluent middle class and gentry.[13]

The Blakes were at the cheaper end of the street, where households were more intensively involved in retail and production.[14] But there was no neat division, and the street as a whole was orientated towards the upper ends of the social world. James Blake would have dealt directly with elite clients in the grander streets and squares all around. It was, for instance, he who provided in 1772 a substantial lot of £8 of ribbons to 'Mr. Banks new Burlington Street' – the famous explorer and scientist Joseph Banks, preparing for another possible circumnavigation with Captain Cook.[15]

It is not that there aren't signs of financial failure, immorality and criminality. But there weren't many, at least before 1800. Henry Fremont, the embroiderer and draughtsman at no. 9, was bankrupted in 1782 – hence the sale of his stock and drawings.[16] Thomas English, a thirty-eight-year-old looking-glass manufacturer, was in 1801 declared 'a lunatic and doth not enjoy lucid intervals', so his property was seized.[17] The nineteen-year-old Elizabeth Bishop, who had been servant to Mrs Griffiths at no. 47 for £4 yearly and lodgings, was out of work and declared a pauper in 1776.[18] A house at the junction of Broad Street and Poland Street was openly announced as a brothel in 'Harris's List', the notorious guide to sex workers published through the late eighteenth century.[19] Mansur Hatton, a button-seller immediately over the road from the Blakes in Broad Street, was identified as the father of an illegitimate child born to a Bett Hall in 1776.[20] More dramatically, on 18 January 1778, a young hairdresser from nearby Panton Street, Peter Ceppi, known as Skipio, shot and injured his former lover Henrietta Knightly in a lodging house run at no. 41.[21] They had lived together in lodgings run by a Julia Cross, a German woman, but she was now living in Broad Street with a new partner, a Jewish man called Leverman who worked as an artificial flower maker. Having been put on trial and found guilty, on Friday 22 May 1778, he and six others were paraded along the traditional route from the prison at Newgate in the City of London to Tyburn, at the far western end of Oxford Street, and executed.

Whether Blake was with Basire in Great Queen Street, or was at home in Broad Street, the procession would have been only a couple of blocks away, and such was the noisome, high-profile character of these events that he could hardly have been unaware of them.

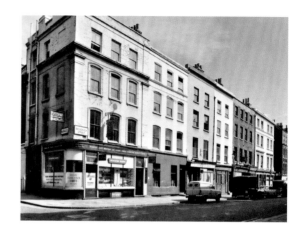

11. *62–74 Broadwick Street by Marshall Street, Westminster, London* 1962

The Ceppi case is worth pausing over briefly. It is a reminder that many Londoners – although not the Blake family – were living in short-term, subdivided accommodation, rooms above other people's shops, back-rooms, basements and attics, lacking job security and with uncertain long-term prospects.[22] They might change partners, routinely co-habit, and have entangled love lives. They were often scraping a living in workshops and marketplaces, labouring or cleaning. And there are reminders that London was, determinedly, a cosmopolitan city. When Ceppi had an earlier run-in with the law, he was bailed by Joseph Serafini of Great Suffolk Street, 'picture dealer', surely an Italian: 'being a foreigner', Ceppi himself needed an interpreter in court. The ferocity of the 'Gordon Riots', the sudden burst of anti-Catholic violence which broke out in London in the summer of 1780, was perhaps especially shocking given that French and Italians, Germans and Swiss, Jews, Catholics and French Protestants were so visible in daily life in the metropolis. London was already a multicultural society, in a way we would recognise. Among the lodgers who passed through

12. Robert Blake, *The Preaching of Warning*, c.1785
Graphite on paper, 34.3 × 46.7

was at one time at no. 22 'a Single Young Man of Colour, 28 years of age', looking for work 'as Servant, in a small Family, or with a Single Gentleman'.[23] The artist Agostino Brunias, who was at no. 20 in 1778, had been based in the Caribbean and may have raised a family with a woman of colour (although whether his family accompanied him back to London is uncertain).[24] More certainly, William Sancho, a Black Londoner and the son of the acclaimed musician and author Ignatius Sancho, was running the office of the Vaccination Pox charity at no. 44 from 1799.

Scholars have cast around for evidence of Blake's encounter with low life and social suffering, the brutality of the criminal justice system, Industrial Revolution or echoes of the French Revolution, his experience of cosmopolitanism, of Britain's wars and global empire. In truth, all these were in evidence on his doorstep, or the doorstep of the family home at any rate. It is clear that the street changed within Blake's lifetime, and even within the time that the Blake family were based there. There was industrialisation, with the brewer W.T. Stretton installing a 'sun and planet' steam engine at no. 49–50 in 1800 and in the next two decades taking over the entire block of houses, surely to the detriment of the street as a whole.[25] If we have learned that Blake's famous words about 'dark Satanic Mills' should not be taken too literally, it is also the case that mechanisation was appearing across the road from the family home, as well as on the banks of the Thames, where Blake certainly knew the famous Albion Mills. Meanwhile, in 1794, an anonymous informer reported that for 'above two months post papers from [the infamous radicals] Hardy and Thelwall have been deposited in the house of Mr Hartley a Grinder in Broad Street Carnaby Market', this being John Hartley, the manufacturer of looking glasses at no. 38 and a documented member of the London Corresponding Society, the most prominent of the radical reform groups fired up by the French Revolution.[26] But there is every sign that, until Waterloo at least, this was a very satisfactory place to live, certainly for a family like the Blakes.

Georgian London has been rather besmirched by the retrospective view taken of it by writers from the Victorian era onwards. Thus when the publisher Adam Black recalled visiting Thomas Sheraton, the cabinetmaker, designer and Methodist preacher who had retired to Broad Street in 1799, he evoked a scene of dreadful disintegration, dirt and poverty: 'He lived in an obscure street, his house half shop, half dwelling-house, and looked himself like a worn-out Methodist minister, with threadbare black coat.'[27] Sheraton was doubtless impoverished in later life, but Black's distaste for the mixture of working space and domestic life comes from a later, nineteenth-century perspective (the memoir was composed in the 1860s), when industrialisation, transportation and lifestyle changes meant that spaces for living and working were separated more sharply. The independent gentlemen and widows, attorneys and surgeons who might live in a central London street like Broad Street in the 1760s or 1770s alongside traders and makers of goods of many kinds, all inevitably within a few doors of a tavern which would also serve as a meeting place and coroner's office, were by the early nineteenth century more likely to have moved to new pastures. Meanwhile, Broad Street's name had been blackened by association with the terrible cholera outbreak in 1854, traced to the water fountain outside no. 40, beside the public house which now bears the name of the man who exposed the scandal, John Snow.

What is especially salutary to bear in mind is how, in Blake's time, the art world was not as 'distant' from the everyday life as it may now sometimes seem to be. Broad Street presents, in microcosm, something of the cultural energy of later Georgian London, the proximity and mixing of tradesmen and professionals, gentry and artists, all getting by or getting on in various ways, through making and selling, trading and investing, rents and speculations. The visual arts formed one, essentially normalised facet of this world. There were prints and pictures in the shops, the music publisher and the stationer over the road, and even the unfortunate Peter Ceppi had as a friend a West End picture dealer.

The cabinetmakers Ince and Mayhew, just round the corner from the Blakes, both had picture collections.[28] In this one street there were at least six households with members who went off to the Royal Academy schools in the late eighteenth century. These were not especially affluent households, and they included Frederick, the son of John Sebastien Meyer, a tailor at no. 49, who studied architecture at the Academy and with Sir John Soane.

So although Blake was born into a family occupied with commerce, the art world was not so distant, perhaps least of all physically. Blake's walk from the family home to the Academy (just over 1.1 miles, which might have taken some 25 minutes) would lead him past the entrance to Dufours Court, and over the road to the public house on the corner (now the John Snow), turning south down into Cambridge Street, and the longer, narrower route that ran all the way down to Piccadilly, crossing Brewer Street and continuing into Great Windmill Street. Here, all the way down, there were smaller houses than his own, the makers and doers of the textile trades with tailors and hosiers, staymakers and linen drapers, and the Public Office where official business was locally done, and the inevitable pubs and grocers. But to the left at the south end there was the grand, purpose-built house and 'museum' (only the haggard-looking façade remains) of the acclaimed surgeon William Hunter, Professor of Anatomy at the Royal Academy.[29] At Piccadilly Blake would turn left, down Coventry Street, and then down and across Whitcomb Street with its stables and builders' yards, into the open space of Leicester Square, where portrait painters had their painting rooms, and where most famously Sir Joshua Reynolds, first President of the Royal Academy, lived. From the south-east corner of Leicester Square, down the short line of shops and tradesmen's accommodations on Green Street (Blake was to lodge in a house at the west end of this street with his wife after their marriage in 1782), he would come, on the right, to the intimidating façade of St Martin's Workhouse (where Mansur Hatton's illegitimate son was born) – surely a more immediate point

of reference for Blake than the ostensibly more physically proximate St James's Hospital, whose largely hidden presence north of Broad Street has been identified as a source of inspiration for his poems on London poverty. Crossing St Martin's Lane, where the previous generation of artists and craftsmen had congregated around William Hogarth and Francis Hayman, he would head further east, towards Covent Garden, crossing Bedford Street into Maiden Lane, immediately to the left a barber's shop belonging to William Turner, serving the artists of the Academy, with a young son whose precocious drawings were posted up in the window. Blake could cut down into the Strand, following one of the several narrow alleys available to him on his route, or if he wanted to keep his shoes clean he would carry on down Maiden Lane, turning right on Southampton Row at the end, and, with the famous vegetable market in Covent Garden to his back, head down the slope past the gate that kept unwanted traffic out, and then onto the Strand, a grand but congested commercial thoroughfare that provided one of the major axes of the metropolis. There, beside the china shops and publishers, printshops and lacemen, and the multitude of drinking holes, looking east towards Sir Christopher Wren's St Clement Danes church, Blake would have had his first sighting of the Royal Academy, its palatial frontage surmounted by gleaming sculptures by John Bacon, RA, which would have risen above the road traffic and bustling pedestrian flow of the Strand itself.

When late in life Blake told the journalist Henry Crabb Robinson of his choice of the life of the artist, he represented it in visionary terms: 'The spirit said to him "Blake be an artist & nothing else."'[30] The line was taken up by the artist's biographers, with added emphasis: 'Blake Be an Artist!'[31] But we don't need recourse to the language of imagination to register that there was a kind of alchemy, a social magic, at work in the transformation he underwent on entering the Royal Academy and being able to claim the aspiration to be an artist, inspired to compete – as the lecturers of the Academy compelled their

students to do – with Raphael and Michelangelo. In certain respects, the transformation was not so magical as it was for Frederick Meyer, the tailor's son from Broad Street, or John Keyse Sherwin, the woodcutter's son from Sussex who ended up lodging with his master on the street, given where they were on the social scale.

Some of the elements of the social magic that could make Blake's exclusive vocational commitments seem at least initially viable are quite readily distinguished. Blake was born into an era of prodigious cultural change. The accession of George III and the victorious end of the Seven Years' War (1756–63) established Britain as a major world power with burgeoning imperial ambitions. This was an era of national reform, aimed at making Britain's arts and sciences match its military and colonial enterprise. Hunter's museum originated in proposals for a national academy of anatomy mooted by him in the 1760s; the Royal Academy was founded in the winter of 1768 after years of agitation from artists. The move to purpose-built rooms in Somerset House, a new urban palace for government offices, seemed for many a triumphant proclamation in stone of the promise of state patronage. The arts, it seemed, were flourishing, and artists were proliferating, many raised in the hot-house of the Academy schools.

At the same time, art seemed newly endowed with oppositional powers. In the 1760s several artists had taken up history painting – in conventional art theory the highest genre of art, dedicated to representing high-minded themes through complex multi-figure compositions – to comment on the national past in terms that were barely disguised as critiques of monarchy and the establishment. The genre had been famously neglected in Britain, where the state or church patronage which had traditionally fostered it in France and Italy was lacking. James Barry, John Hamilton Mortimer and Henry Fuseli emerged in the late 1770s as the leading proponents of a new, imaginative form of narrative painting, often tackling supernatural, fantastic or shocking themes (what

was captured in contemporary criticism and theory as the 'Sublime' or 'Gothic'). Their work caused a sensation at the annual art shows, and responded to the changing audiences for art, and new opportunities for exhibition and publication: such might be interpreted as commercial self-interest, playing to the cheap seats, or motivated by profound engagement with the idea of creativity. It is certainly the case that the more adventurous varieties of history painting that proliferated in the exhibitions and printshops during Blake's formative years came to serve as the mainstay of the grandest commercial art enterprises of the age – the several influential galleries of literary painting formed in the late 1780s and 1790s. But even these projects, John Boydell's Shakespeare Gallery and Thomas Macklin's Poet's Gallery most notably, were able to reconcile their commercial motivations with strident claims to patriotic service *and* aesthetic ambition.[32]

However we interpret it, it is clear that for a period – Blake's formative years – there seemed the realistic promise that British art could be renewed, that it could be patriotic but not simply an instrument of the state, that artistic autonomy was to be enlarged but patronage and commercial success remained a real possibility. Blake's boyhood drawing classes at Henry Pars' school, on the Strand, and his apprenticeship to a well-established engraver, were not indulgences: they were setting Blake on course for a perfectly viable career, as we discuss in greater depth in the next chapter.

If there was a new world of opportunity opening up in Blake's youth, it was not really open to all. He was fortunate in having a master who seems to have fostered the creative interests of his apprentices, many of whom went on to study at the Royal Academy.[33] If Blake could live at home and walk to the Academy during his studies, or visit the annual exhibition at Somerset House for free which was his privilege as a registered student, he still needed paper and chalks, casts and prints to draw from.[34] In fact, James Blake seems not only to have tolerated but actively indulged his son's

interest, buying casts for him to draw from, which would likely have cost several pounds, and paying for drawing lessons at Pars' drawing school.[35]

What did Blake actually learn at the Academy? We know what was expected of students: to draw carefully after plaster casts of antique figures, study prints by Old Masters in the library, and once sufficiently advanced in skill move on to the Life Academy and to draw after the living model. It is certainly the case that the clean lines and expressive clarity of the bodies conceived by the ancient sculptors were foundational to Blake's own art: a figure like the Cincinnatus, a favourite among students at the Academy schools, including Blake, provides a template for his expressive forms. His studies of the living body may have been a springboard for his imaginative manipulation of the human form, as we have seen with *Albion Rose*. But in some important regards there were greater things still at stake than the imbibing of certain aesthetic values and the cultivation of manual skills. The schools at the Royal Academy were notoriously lax and badly equipped. That students continued to attend in numbers is a sign more of its efficacy as a site of socialisation, not only between fellow apprentices or pupils in a master's workshop, but also with the more diverse – although also, increasingly, more genteel and more middle-class – population of the Academy's schools.

Blake clearly did socialise with fellow students, and these connections proved important to him commercially, artistically and emotionally. Although the documentary evidence doesn't quite add up, it does seem likely that the Robert Blake at the schools at the same time was his younger brother, whose early death in 1787 was to have a great impact on the artist. It was also at the schools that Blake met Thomas Stothard, John Flaxman and George Cumberland, who were all to play important roles in his life. A fellow apprentice at Basire's, James Parker, who went on to become Blake's business partner, was also a contemporary at the schools, and was in 1780/81 a member of a sketching party on the Medway with Blake and Stothard, leading them to be briefly arrested on suspicion of being spies (this was in the midst of war with America and its European allies).[36]

Blake would not have been paid for the work he undertook as part of his apprenticeship to Basire; any fees would have gone to his master. He certainly found some engraving work in his own right soon after his apprenticeship ended. He may have received £16 for engraving a plate in 1779, and his income from engraving in 1780 (£68) would have put him in a position to start living, modestly, independent of the family. In 1781–2 he became more established as an engraver, probably drawing in something like £210 and £389 in those two years, respectively (remember that Elizabeth Bishop had been earning £4 a year as a servant).[37] These figures are derived from a body of modern scholarship which has examined the documentary record closely and made some speculations about the authorship of individual published plates.[38] There may have been more. Reproductive engravers often complained that their own work was published under the names of others: Blake's precise contemporary at the Royal Academy schools, the engraver Thomas Gosse, certainly complained that he suffered in this way.[39] Blake may have sold a few drawings for small sums over these years, but the point we should take is that by the time he started to make a proper living for himself, sufficient for him to be able to get married in 1782, he had spent fifteen years learning the arts of engraving and drawing at the expense of his parents. And what put him in the position to move out and set up on his own was not being an 'artist' selling his work or enjoying patronage, but being a reproductive engraver working for other people.

Blake, living at home and an art student, first ventured into the public eye with a coloured drawing exhibited in 1780, 'The Death of Earl Godwin' (British Museum, London). Watercolours and drawings from these years show immediate debts to examples of Barry, Fuseli and Mortimer, and in their themes pick

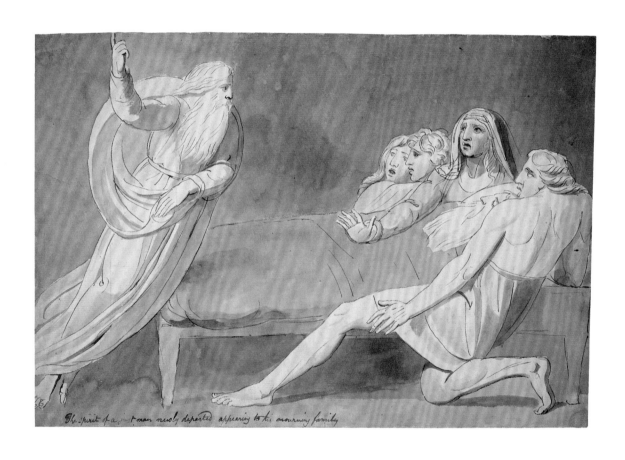

13. *The Spirit of a Just Man newly Departed Appearing to his Mourning Family*, c.1780–5
Ink and wash on paper, 33 × 48.3

up on the radical history painting of the 1760s (several examples of which had been engraved). Blake's style achieved a pitch of refinement and ambition with the three large watercolours of the biblical story of Joseph that he showed at the Academy in 1785. By that date the optimism for high art had started to evaporate. The war with revolutionary America and its allies (1775–83) had ended badly; London was overrun with demobbed military men. Unemployment and urban discontent were on the rise.

With a modest inheritance from his father Blake had ventured to become an independent publisher with James Parker, based at 27 Broad Street. Meanwhile, Flaxman had introduced him to the Reverend Anthony Stephen Mathew and his wife Harriet, and together they had financed the publication of a slim volume of Blake's writings, the *Poetical Sketches*. But if these reflected the political and cultural themes of the preceding decade, Blake was moving in new directions as well. Among his watercolours there are subjects which are less obviously related to historical or literary themes, and which defy ready interpretation. And it was at social gatherings organised by the Mathews that Blake reputedly would sing his poetry, assuming an inspired, bardic identity which was an important element in a developing ideal of the creative poet. Though the *Poetical Sketches* achieved no great celebrity, they did serve as a kind of calling card. Flaxman sent a copy to the poet William Hayley in 1784, noting of their author that their mutual friend, the successful painter George Romney, 'thinks his historical drawings rank with those of M[ichel] Angelo'.[40] There was even talk of putting together the funds to send Blake to Italy, where he could be expected to transform himself into an artist of grand ambition ready to compete with that fierce Renaissance master (as had happened with Fuseli and several others over the last decade). That Blake was emerging simultaneously as original visual artist and writer is significant in itself, pointing to a newly amorphous sense of 'the artist' as it was emerging in some cultured metropolitan circles, not as involving the technical mastery of specific skills within specific media but, rather, a generally creative spirit.[41]

Blake's partnership with Parker did not last beyond 1785, even after it had been sustained artificially with financial input from the Mathews. It seems likely that Blake himself was venturing to produce some kind of original, illustrated poem only shortly afterwards. For from this date we have a manuscript poem, *Tiriel*, and a record of a set of twelve wash drawings to accompany it, nine of which are known to survive. Blake's poem involves a blind king, Tiriel, his queen, Myratana, their children, and the ancient figures of his parents, Har and Heva. In a bleak and blasted fantasy landscape, Tiriel undergoes a series of travails and confusing encounters, family curses, estrangement and rebellions evocative of Greek tragedy, Shakespeare's *King Lear*, and the fabulised Gaelic epics of 'Ossian' published sensationally by James Macpherson in the 1760s. The uniform technique and format of Blake's designs, and the fact that the poem exists separately in manuscript, suggests that he planned to have the poem set in conventional type, and to print the illustrations separately; the designs would have fitted into a landscape-format folio page quite neatly, although generally also at a 90 degree angle to the text. Like the prints issued from Boydell's Shakespeare Gallery, we might assume that they might have been issued as single plates. Although we know that Blake had his own printing press – he held onto this after the Parker-Blake partnership was dissolved – and so would have been able to print the plates separately, he did not have the facilities to print the text of the poem in the conventional manner. Even if the artists and tradesmen variously involved in the printing of texts and of images tended to be located in the same London districts, the skills, equipment and techniques involved were completely separate, and incorporating engraved images in a printed book was a costly and difficult business.[42] Blake's *Tiriel* might be a testament to his growing dual ambitions as an artist and a poet, but what remains in the form of unpublished text and un-engraved drawings shows that he had not yet the means to realise those ambitions. MM

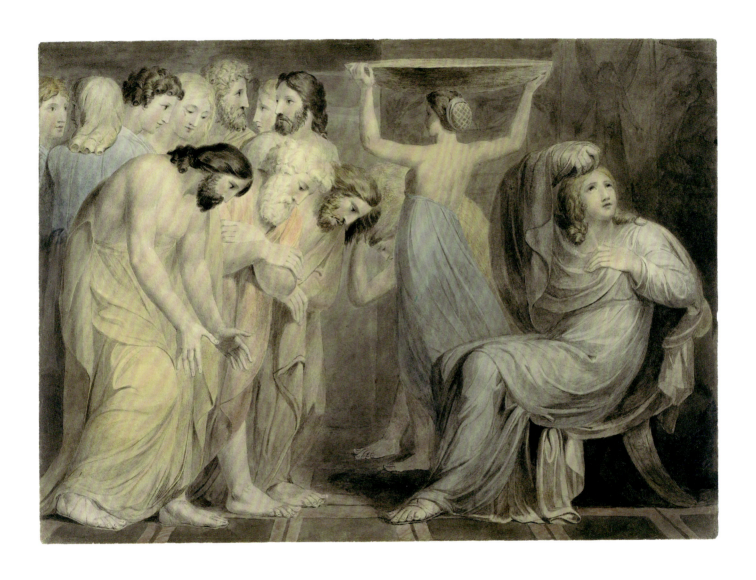

14. *Joseph's Brethren Bowing Down before him. The Story of Joseph*, c.1784–5
Ink, watercolour and graphite on paper, 40.3 × 56.2

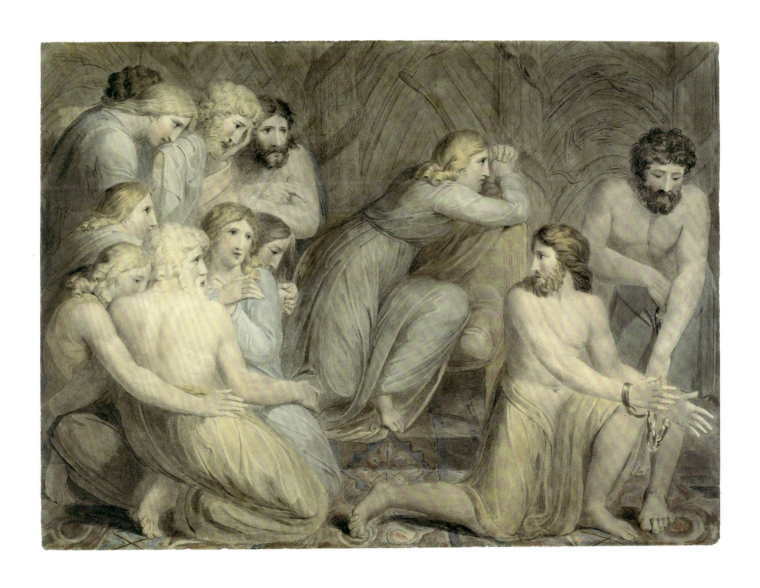

15. *Joseph Ordering Simeon to be Bound*, c.1784–5
Ink, watercolour and graphite on paper, 40.5 × 56

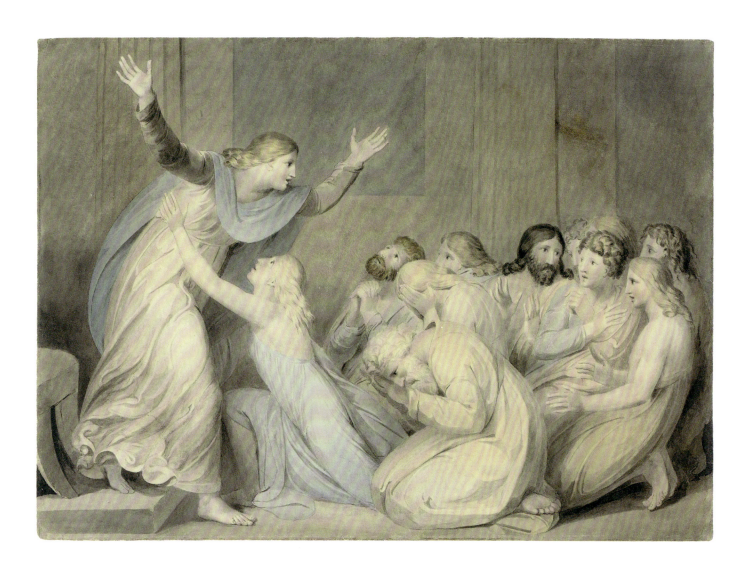

16. *Joseph Making himself Known to his Brethren. The Story of Joseph*, c.1784–5
Ink, watercolour and graphite on paper, 40.5 × 56.1

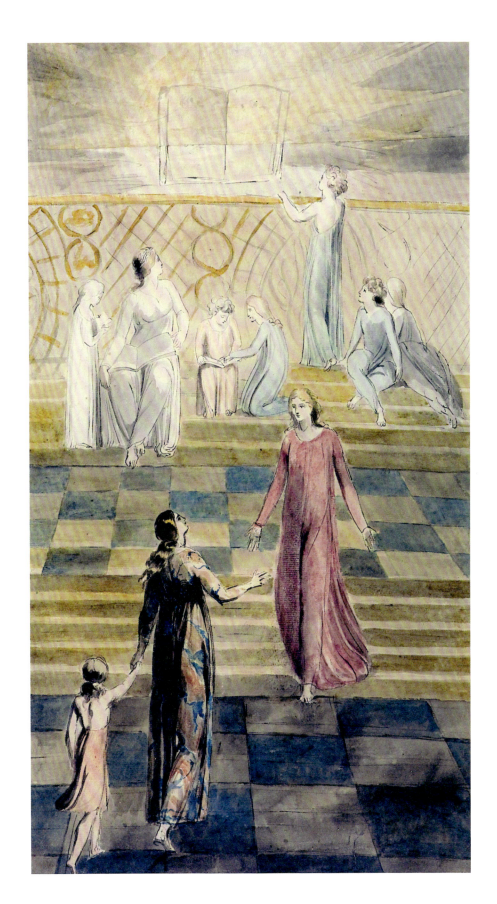

17. *An Allegory of the Bible*, c.1780–5
Ink, watercolour and graphite on paper, 61.5 × 34.9

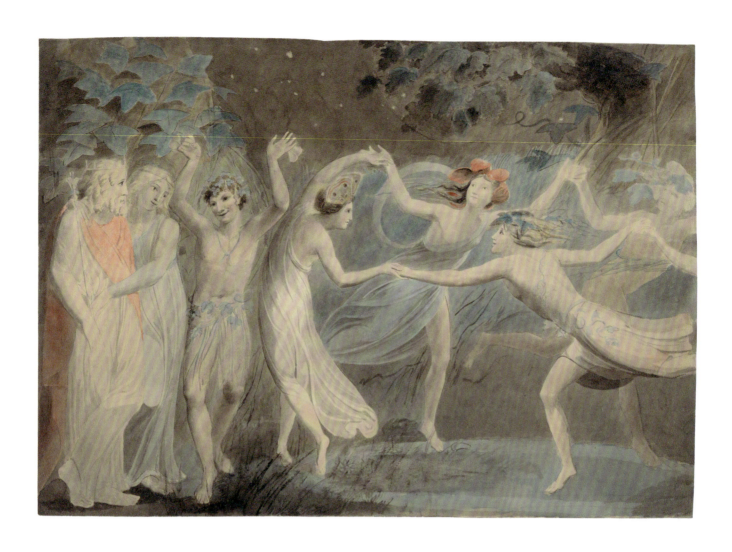

18. *Oberon, Titania and Puck with Fairies Dancing*, c.1786
Watercolour and graphite on paper, 47.5 × 62.5

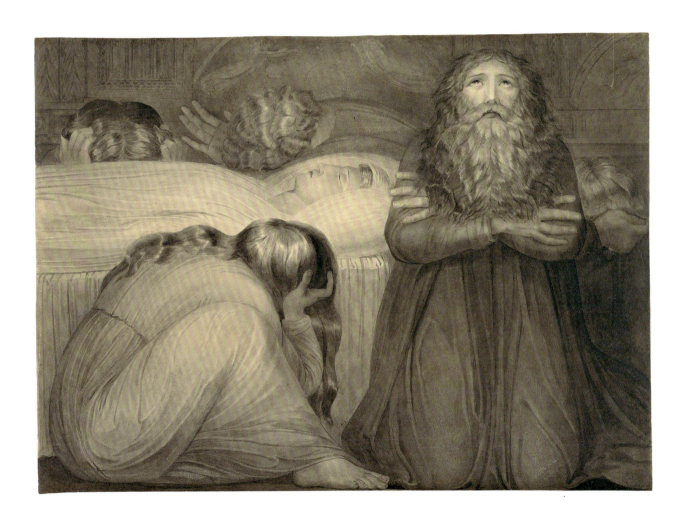

19. *The Death of the Wife of the Biblical Prophet Ezekiel*, c.1785
Pen and ink and wash over graphite on paper, 34.6 × 47.9

And aged Tiriel stood & said where does the thunder sleep
Where doth he hide his terrible head & his swift & fiery daughters
Where do they shroud their fiery wings & the terrors of their hair
Earth thus I stamp thy bosom rouse the earthquake from his den
To raise his dark & burning visage thro the cleaving ground
To thrust these towers with his shoulders. let his fiery dogs
Rise from the center belching flames & roarings, dark smoke
Where art thou Pestilence that bathest in fogs & standing lakes
Rise up thy sluggish limbs, & let the loathsomest of poisons
Drop from thy garments as thou walkest wrapt in yellow clouds
Here take thy seat in this wide court let it be strewn with dead
And sit & smile upon these cursed sons of Tiriel
Thunder & fire & pestilence. hear you not Tiriels curse

He ceast the heavy clouds confusd rolld round the lofty towers
Discharging their enormous voices, at the fathers curse
The earth trembled fires belched from the yawning clefts
And when the shaking ceast a fog possest the accursed clime

The cry was great in Tiriels palace his five daughters ran
And caught him by the garments weeping with cries of bitter woe

Aye now you feel the curse you cry. but may all ears be deaf
As Tiriels & all eyes as blind as Tiriels to your woes
May never stars shine on your roofs may never sun nor moon
Visit you but eternal fogs hover around your walls
Hela my youngest daughter you shall lead me from this place
And let the curse fall on the rest & wrap them up together

He ceast & Hela led her father from the noisome place
In haste they fled while all the sons & daughters of Tiriel
Chaind in thick darkness uttered cries of mourning all the night
And in the morning lo an hundred men in ghastly death
The four daughters stretchd on the marble pavement silent all
falln by the pestilence the rest moped round in guilty fears
And all the children in their beds were cut off in one night
Thirty of Tiriels sons remaind. to wither in the palace
Desolate. Loathed. Dumb Astonishd waiting for black death

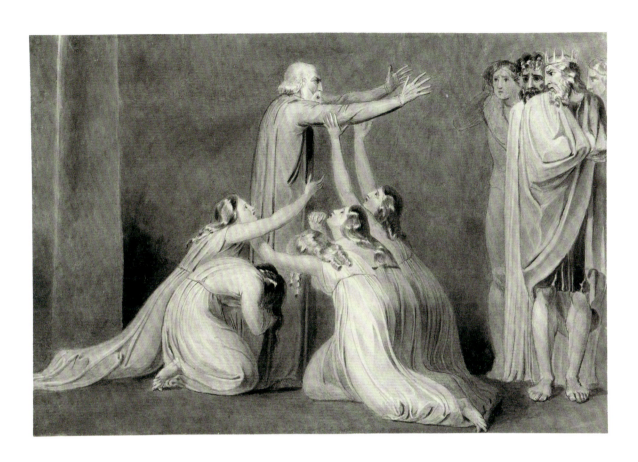

21. *Tiriel Cursing his Sons and Daughters*, c.1789
Ink and wash on paper, 18.2 × 27

20. *Tiriel MS*, c.1788–9, Open at p.10 'And aged Tiriel
stood & said where does thunder sleep...', 15.7 × 42

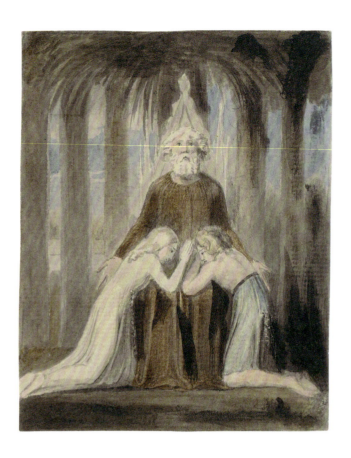

22. *Tiriel and his Children*, c.1785–1790
Watercolour, ink and graphite on paper, 12.2 × 9.8

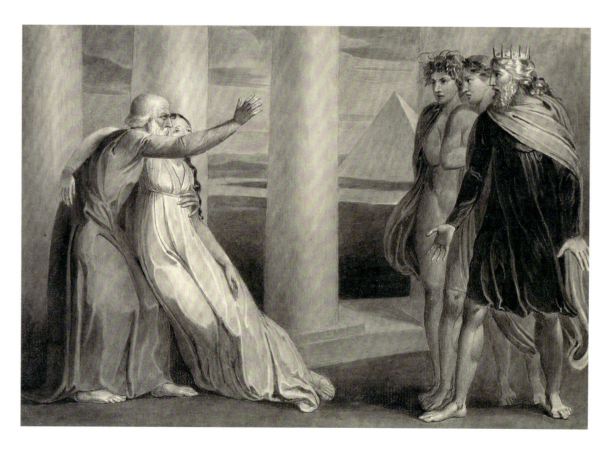

23. *Tiriel Supporting the Dying Myrantana*, 1789
Ink, wash and watercolour on paper, 18.6 × 27.2

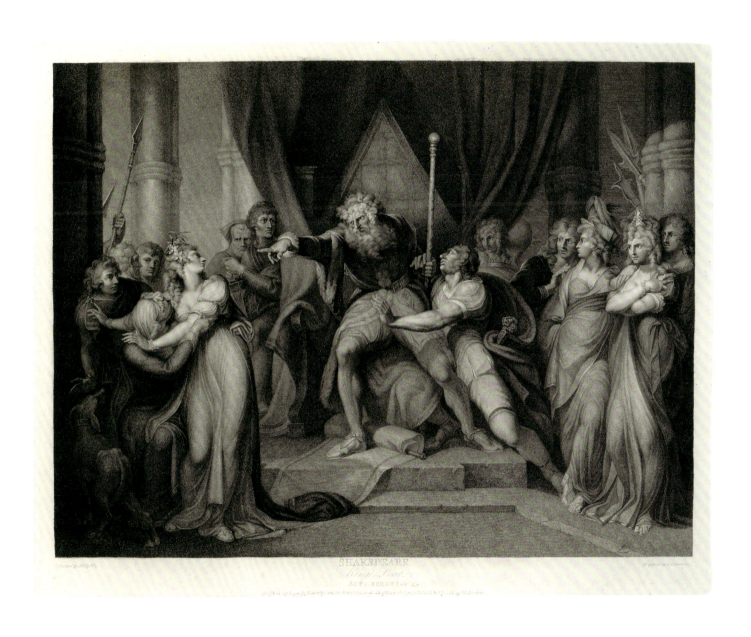

24. Richard Earlom after Henry Fuseli, *King Lear: Act 1, Scene 1 (King Lear Casting Out his Daughter Cordelia)*, 1792
Stipple engraving, 44.8 × 59.8

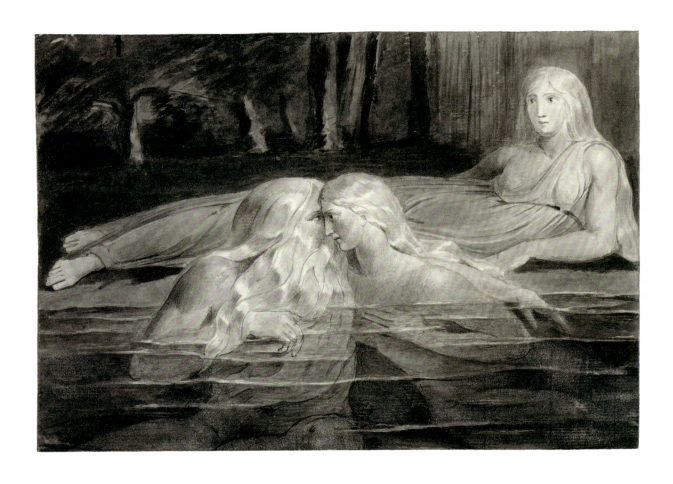

25. *Har and Heva Bathing, Mnetha Looking On*, c.1785–9
Ink and wash on paper, 18.1 × 27.3

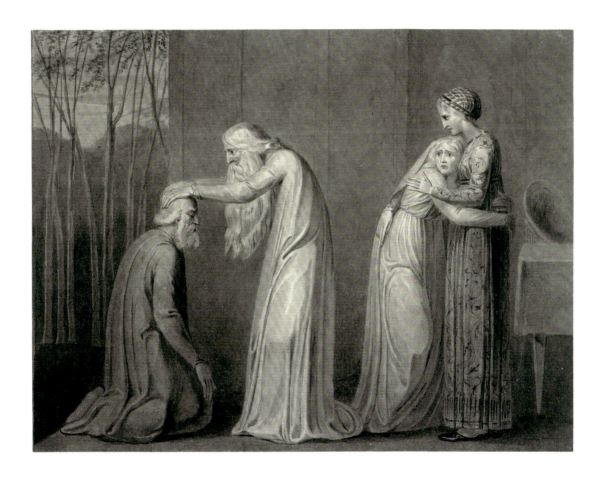

26. *Har Blessing Tiriel while Mnetha Comforts Heva*, 1789
Ink on paper, 18.3 × 24.3

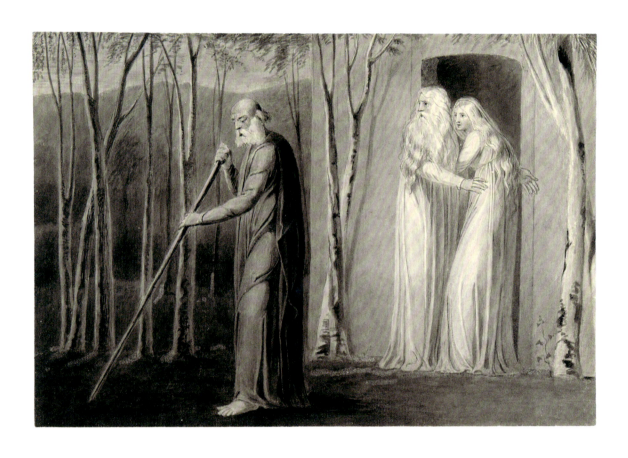

27. *The Blind Tiriel Departing from Har and Heva*, 1789
Ink and wash on paper, 18.2 × 27

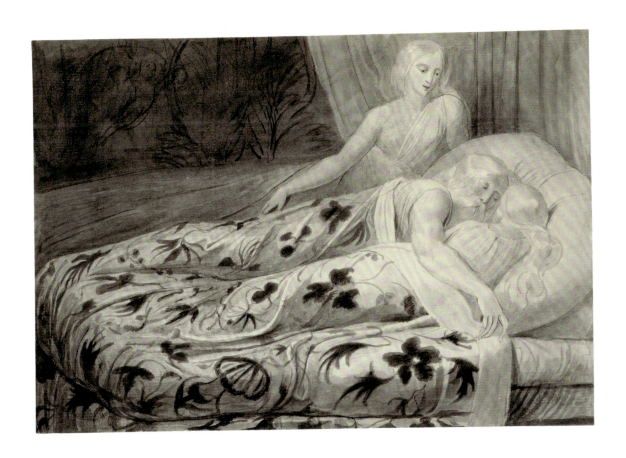

28. *Har and Heva Asleep with Mnetha Guarding them*, c.1789
Ink, wash and chalk paper, 19.2 × 28

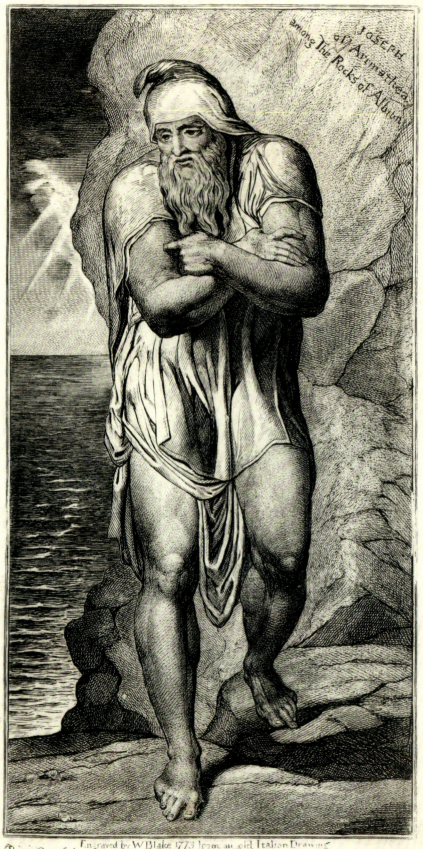

Joseph of Arimathea among The Rocks of Albion

Engraved by W Blake 1773 from an old Italian Drawing
This is One of the Gothic Artists who Built the Cathedrals in what we call the Dark Ages
Wandering about in sheep skins & goat skins of whom the World was not worthy
such were the Christians
in all Ages

Michael Angelo Pinxit

MAKING PRINTS,
MAKING A LIVING

The morning of 28 November 2018. The producers of the BBC Radio 4 news programme, *Today*, have themed their daily maths puzzle to help mark an anniversary:

It's eleven minutes to seven.

Today's 'Puzzle for Today' has been set by Bobby Seagull, a school maths teacher and Cambridge University doctorate student. Today would have been the birthday of William Blake, the poet, printmaker and painter. Tyger, Tyger, burning bright, can you get this puzzle right? On a particular working day, Blake spent 40% of the working day writing poetry, a quarter of his working day printmaking, and the remaining $3\frac{1}{2}$ hours on painting. How long was his working day?

The answer, to save you the headache, was that Blake's working day was ten hours long, with four hours spent writing poetry and two and a half printmaking. If Blake had, miraculously, access to a time machine, or if he, hardly less remarkably, had lived to be 261 years old and so been in a position to hear this broadcast, his response might well have been to snort: 'As if...!'. While he may have been heartened to have his life commemorated in this way, he would, we suspect, have been bemused at the suggestion that he might ever get to sit around for four hours a day writing, and spend only two and a half hours printmaking, and his average working day could be expected to be limited to ten hours overall.

We don't, of course, know for sure what Blake's typical day would have looked like, although we can reasonably surmise how it would have panned out at the different stages of his life. Apprentices basically worked all day for their masters, and only had limited time to themselves first thing and last thing, and on Sundays; Benjamin Heath Malkin relates that '[Blake] began to engrave two designs from the History of England, after drawings which he had made in the holiday hours of his apprenticeship'.[1] One late eighteenth-century apprentice in the art of engraving recalled drawing 'chiefly of the hours before eight o'clock in the morning and after 6 o'clock in the evening, at my father's residence' (his father being a cook).[2] Students at the Royal Academy had life classes in the evening. Depending on their circumstances they might be at liberty to draw in the plaster schools, or visit the library in the day. They might be studying with a master, or more likely studying at home; some may have been serving their apprenticeship and some, certainly, were working in offices or in some other occupation to make ends meet. Labourers typically worked a ten- or eleven-hour day; shops also kept long hours, from early morning to evening. Office workers were in a better position, and several Royal Academy students held down day jobs of this sort, putting them at liberty to study in the evening. Malkin again relates of Blake that during his student days, 'he continued making designs for his own amusement, whenever he could steal a moment from the routine of business'.[3] 'It was', wrote another early biographer, J.T. Smith, referring to the same years, 'his chief

29. *Joseph of Arimathea among the Rocks of Albion*, c.1810
Engraving, ink on paper, 25.6 × 16 (sheet)

delight to retire to the solitude of his room, and there to make drawings, and illustrate these with verses, to be hung up together in his mother's chamber.'[4]

But this organisation of Blake's productive life was not limited to his time as an apprentice and student. It continued into adulthood and as he established himself as an independent engraver. It was reproductive printmaking which was the backbone of his working life, and this served as, quite literally, his day job, while his creative work as a poet and painter was largely undertaken at other times. As Smith noted, 'The day was given to the graver, by which he earned enough to maintain himself respectably; and he bestowed his evenings upon painting and poetry, and intertwined these so closely in his compositions, that they cannot well be separated.'[5] Blake himself wrote imaginatively of his poetic labour taking up no time at all, undertaken as it was in the spirit of inspiration: 'twelve or sometimes twenty or thirty lines at a time without Premeditation & even against my Will'.[6] A number of those who knew him late in life related that he would work at odd hours and in odd patterns: 'his application was often so incessant that, in the middle of the night, he would, after thinking deeply about a particular subject, leap from his bed and write for two hours or more; and for many years, he made a constant practice of lighting a fire, and putting on the kettle for breakfast before his Kate awoke'.[7] His friend, the artist Frederick Tatham, related, too, that Blake 'was very much accustomed to get out of his bed in the night to write for hours'.[8] His visionary drawings, undertaken at the behest of the astrologer and painter John Varley, were done 'from ten at night till three in the morning'.[9]

The material evidence is that Blake would draft and redraft his poetry, and the question of how spontaneous he could be in utilising the distinctive process of relief printing, which became the main vehicle of his poetic output, has been a controversy in itself. In accounts of his visual art he emphasised the labour involved in printmaking, labour whose precise technical demands had its own poetic value, and he lamented his struggle to make paint as decisive in its effects. However we look at it, writing and making art took time, and this was time that was not available to him without doing other work (the subject of this chapter) or without the support of others (the topic considered in the next chapter). What Blake imagined as a way of working which rendered time 'Non Existent', and his working in the night hours in a fever of inspiration, were responses to a situation where he did not often have four hours a day to work on his poetry, and spent only a couple on the paying work of engraving.[10]

The practice of working hurriedly, passionately, in private spaces and at odd hours, might be accorded a kind of special value in itself. Blake's early patron, the Rev. Mathew, wrote in his 'advertisement' for the *Poetical Sketches*, that they were 'the production of an untutored youth … he has been deprived of the leisure requisite to such a revisal of these sheets, as might have rendered them less unfit to meet the public eye', but Mathew also valued them for their primal energy.[11] Creative art was thus being located as something other than work, on the one hand, or simple leisure, on the other. Blake himself tried to recuperate some sense from the situation, casting his paid work and creative labour as being locked into a painful but mutually productive arrangement, claiming that he 'sometimes thought that if he wrote less, he must necessarily do more graving & painting', but that he discovered having 'debarred himself of his pen for a month or more' he actually did less, '& the little that was done by no means so vigorous'.[12] He became, at that point, the kind of 'passionate worker' that is promoted within the present-day labour environment, sacrificially taking on the burden of too much work to get something, anything, more satisfying done along the way. He might even be taken as a pioneer of what's known today as 'slasher culture', in his multiple roles as 'artist/engraver/poet/visionary'.

Thus is already set in motion principles that are exposed more explicitly in the emergence of the

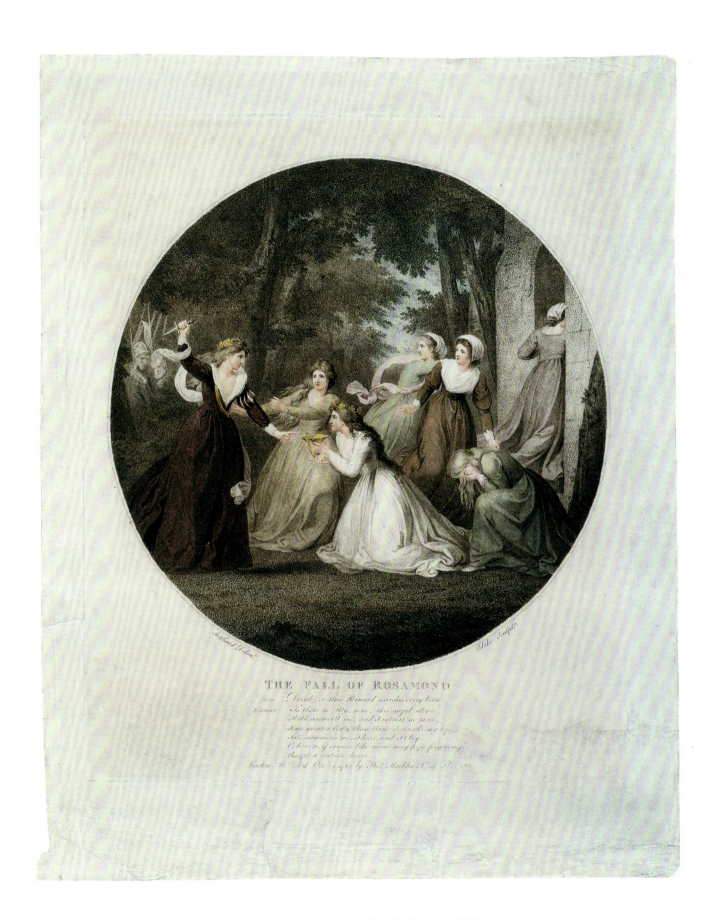

30. After Thomas Stothard, *The Fall of Rosamund*, 1785
Etching, engraving and watercolour on paper, 30.6 diameter

'bohemian' artist of the nineteenth century, who aspired characteristically to an experience of 'time used freely for freely chosen, gratuitous ends which ... may be those of work, but work which is freed, in its rhythm, moment and duration, from every external constraint and especially from the constraint imposed through direct monetary sanction'.[13] It is in his organisation of his day, in the pace of his working life and in his complex relationships with patrons that Blake sets a model for the modern artist, a model that was developing rapidly when the story of his life was being written in the 1820s and 1830s, and from the 1860s when it was crystallised. The influential sociologist Pierre Bourdieu, quoted here, presents this as an illusion, for in an unequal world the possibility of achieving such an experience of time, as artist or as student or intellectual, is delimited as the individual encounters 'a signposted universe, full of injunctions and prohibitions, signs of approbation and exclusion, obligatory routes or impassable barriers, and, in a word, profoundly differentiated, especially according to the degree to which it offers stable chances, capable of favouring and fulfilling stable expectations'.[14] These observations are important, for they challenge us to confront the 'universalistic illusion' that time is experienced in a socially undifferentiated way. They are important for us as art historians, for they provide a model for thinking about how the socially determined temporalities experienced by different artists might direct those choices that might otherwise appear to be freely made: genre, scale, manner, even technique (what paints to use, how to deploy materials, impetuously and with immediate effect or in glazes over already dried surfaces, using solvents to artificially accelerate drying times or novel media in search of unexpected effects, and so on – matters that surely involve 'possession of the necessary minimum of assurances concerning the present and the future').[15] Blake lived a long life, by the standards of his day, dying three months before his seventieth birthday. If the story that once circulated about him making an engraving of Milton at the age of three is spurious, he was certainly drawing as a boy and studying with

an art teacher when he was ten, started his apprenticeship as an engraver when he was fifteen, became a student at the Royal Academy (really, a sort of post-graduate level of study) when he was twenty-one, sold his first drawings that year, and exhibited for the first time at the Academy, the premier exhibiting body in London, the next. He produced something like 2,000 drawings, watercolours and single coloured prints, printed off over 160 copies of his illuminated books, and engraved and sometimes designed hundreds of commercial designs for publishers. 'I have written', he told the journalist Henry Crabb Robinson in 1826, 'more than Rousseau or Voltaire – Six or Seven Epic Poems as long as Homer And 20 Tragedies as long as Macbeth.'[16] Then there were annotations, notes, correspondence. He must have kept accounts after a fashion (not, perhaps, his forte), undertaken all the business of daily life, and all this with the active support, partnership and involvement of his wife Catherine.

In material terms, it was Blake's day job as a reproductive engraver that made this prolific output of poetry and painting more possible. A single large print, like the *Fall of Rosamond* done for Thomas Macklin, earned Blake £80. But engraving was a time-consuming job, beset with difficulties both technical and commercial in nature. Engravers were regularly underpaid and exploited by publishers, and by other engravers, who might not credit them properly. Just the time taken to produce a plate, which might extend to many months, created risks as the marketplace changed and as employers went out of business or changed their plans. But however taxing and laborious the work, Blake was fortunate in first entering the trade when it was flourishing to an unusual degree. The engraver Ann Taylor – who, with her sisters, was raised to the trade by her father, the printmaker Isaac Taylor – recalled that at least until the French Wars (1793–1815) there were lots of opportunities. Training as an engraver did not inevitably mean a trajectory into drudgery; rather, it was potentially a lucrative career:

At this time a change was passing over the country – over Europe, I should say – which blighted the prospects of almost all the artists, young and old. Engraving had offered so fair an opening just previous to the French war, that almost every family having a son who could draw, hastened to place him with an engraver, as in later times, every likely lad has been for trying his skill as an engineer.[17]

British printmakers and publishers won an international reputation in Blake's time for quality and innovation. It was also the case that paper prices plummeted in the 1780s, so the scope for making profit increased that much further.[18] The closure of the European market and the general tightening of belts with the French Wars were disastrous for the print trade, but no one could have known that when they sent their sons off to an apprenticeship as an engraver in the 1760s and 1770s.

This was a practical business, and working engravers were involved in preparing inks and copperplates, dampening paper ready for printing, and operating the rolling press – a multitude of demanding specialist tasks. But rather than being a straightforwardly radical, artisanal sub-culture, the world of the art engraver was in this period home to distinctly middle-class and even genteel youths looking to make a decent living in business. Among Blake's contemporaries at the Royal Academy who professed engraving were, besides James Parker, the son of a corn chandler, Joseph Strutt, whose father had been a miller in Essex, and Thomas Gosse, whose family had done well in the wool trade in the West Country.[19] Mansur Hatton, the button-seller who had fathered an illegitimate child in 1776, took up trade as a printseller in Pall Mall when he later married and settled down, presumably with monies that came from his new wife's family as part of the marriage settlement.[20] The world of engraving that Blake knew best was made up of independently-minded artists and businessmen, often with strong affiliations with the cultural and social establishment.

It was not a world of oppressed artisans waiting to be radicalised by the French Revolution, as is sometimes imagined. It was not, after all, engravers and artists who populated the radical London Corresponding Society in the greatest numbers, but the really oppressed workers – the shoemakers and tailors – instead.[21]

During the 1780s and 1790s Blake was able to draw a decent living from his work as an engraver. His move to Poland Street in 1785 put him in the company of tailors and tradesmen of various kinds, but also surgeons and clergymen, and artists including the caricaturist Thomas Rowlandson, the modeller John Charles Lochée and the antiquarian draughtsman Jacob Schnebbelie, all of whom had been at the Royal Academy schools. The house there was divided, but incorporated something that resembles what we would consider to be a perfectly reasonable self-contained apartment, for it seems that the Blakes would have had two rooms, a 'closet' and their own kitchen.[22] The further move to Hercules Buildings, Lambeth, in 1791, took them to the new pastures south of the river. This was an 'emerging and bizarre no-man's-land of suburban amenity, ready-made slums and institutional decant', spreading only since the recent opening of new bridges over the Thames that made for a more regular connection with the centre of London.[23] The Blakes' house was more certainly 'suburban amenity' than slum, a larger house to themselves, with eight or ten rooms, and their own garden and a servant for a while, in a row populated mainly by people identifying themselves as gentlemen or widows rather than active tradesmen. There was not here the bustle of commercial activity of the Broad Street of Blake's youth, or of Green Street or Poland Street, but a view over fields towards the river and a quiet back garden. Such a move, for an engraver of sufficiently established reputation, was not unreasonable, however: Isaac Taylor, whose daughter Ann was quoted above, had taken his family and workshop out to Suffolk in the late 1780s and was able to continue to work regularly for the London publishers even from that greater distance.

Blake's venture into print publishing with his fellow Academy student James Parker did not end well, but he had work from other publishers to keep him going. Prominent among these was Joseph Johnson, who was Blake's most extensive and regular employer through the 1780s and 1790s. While there was certainly a commercial arrangement with Johnson, it is also the case that the connection gave Blake access to a sociable circle of radical thinkers who congregated at upstairs at his bookshop, including the pioneering feminist Mary Wollstonecraft. For Johnson, Blake, amongst much else, illustrated and engraved for Wollstonecraft's work, and produced reproductive engravings of designs to accompany an account by a mercenary, John Stedman, of the brutality of slave labour, not in the British colonies but in Dutch Surinam, though with obvious relevance given Britain's extensive involvement with slavery.

31. *The Wit's Magazine*, vol.1, 1784
showing William Blake after Samuel Collings,
May-Day in London, etching, 18.9 × 22.6

The degree to which Blake's shocking and disturbing designs simply illustrate the relevant writer's thoughts – and indeed the actual drawings that Stedman had produced – or interpret and elaborate these materials in line with his own thinking has been much debated. It is certainly the case that, as much as we have wished Blake to be a feminist and a fierce opponent of slavery and its brute foundations in prevailing European racial prejudice, it is not clear that either can absolutely be said to be the case.[24] Meanwhile, quite how easily Blake fitted in with this circle is in question, although it is the case that Johnson believed in Blake enough to risk printing (although not publishing) his explicitly political poem *The French Revolution* in 1790, at a date when the British government's response to the threat of radical unrest was becoming increasingly violent and oppressive.

32. Mary Wollstonecraft, *Original Stories from Real Life*, 1791
open to the frontispiece, designed and engraved by William Blake,
Look What a fine Morning it is, etching and engraving, 16.8 × 9.5

33. John Gabriel Stedman, *Narrative of a five years expedition against the revolted Negroes of Surinam*, 1796, vol.1, p.116: 'A Negro hung alive by the ribs to a gallows', etching and engraving, 19.1 × 14.1

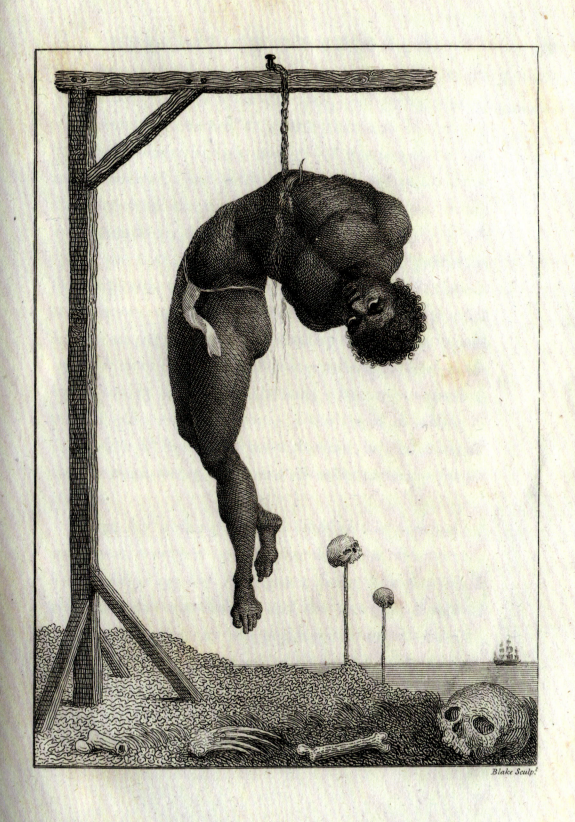

A Negro hung alive by the Ribs to a Gallows.

Blake Sculp!

It is a sign of Blake's professionally established status that in 1788 he took on his only apprentice, Thomas Owen.[25] Blake's relationship with Owen has only recently come to light, but it affords us an insight into the life of a more routine printmaker of the age. The normal terms of apprenticeship would be that the master provided board, although this could simply comprise a temporary bed in one of the living spaces. Owen may have assisted Blake with some plates around 1790, although this is only speculation, as much as the claim that the apprenticeship only lasted a few weeks.[26] It seems likely that his apprenticeship ended somewhat early, for he married in 1794 and would have lived independently with his new wife.[27] Together they raised an extended family over the next two decades. At first the couple lived in Holborn, in the heart of the printing trades. By the time of the 1841 national census they were living out in Stepney, and in 1851 Owen was widowed, in Shoreditch and living with a daughter and her husband, she a box maker and he a wood cutter. He died the following year. In these various legal and parochial records, Owen is recorded as an engraver, but his career is almost wholly obscure. His geographical and social descent, however, and that of his family, seems to be clear: from an apprenticeship in Poland Street to a working life in Holborn to the new slums of the East End.[28] What has been designated as the 'Engels Slump' – the stultification of working people's wages in the first half of the nineteenth century, with the resulting urban decay and social strife that was famously described by the socialist philosopher Friedrich Engels in the 1840s – may be in evidence.[29]

Thomas Owen's story gives us a glimpse of the life and legacy of many working engravers in the tougher economic climate of the early nineteenth century. Blake, by that measure, was never so anonymous, and can even be reckoned a success for much of his working life. The commercial struggles he faced in the 1810s may be more a reflection on the general economic slump rather than an indictment of the trade in particular or his personal shortcomings. But Blake was not, of course, only a working engraver.

He had already surfaced in the 1780s as a maker of ambitious historical watercolours, and had gained some reputation as an imaginative artist and poet within London's more liberal cultural circles, and especially among fellow artists. He still harboured hopes of becoming established as a designer and engraver of historical subjects when in 1793 he published a prospectus of works for sale in Hercules Buildings, optimistically addressed 'To the Public', and including a mysterious book of engravings of 'The history of England', and the plate of *Edward and Elinor* which in its style and subject directly echoes the radical history painting of painters like Robert Edge Pine and John Hamilton Mortimer in the 1760s and 1770s.[30] But that list also included 'Illuminated Books' said to be 'Printed in Colours, and on the most beautiful wove paper that could be procured'. These were said to be produced in a 'method of Printing both Letter-press and Engraving in a style more ornamental, uniform, and grand, than any before discovered' and were of quite another character. They were the visionary works printed in Blake's unique form of 'relief etching' which have been seen as the works central to his creative achievement in modern times.

The techniques of the 'relief etching' method that Blake announced in 1793 had been developed around 1788. Quite what was involved has long perplexed scholars and collectors, and Blake himself left no clear statement of his methods. There are, instead, the anecdotes of visionary visitations, and obscurely allegorical comments. In *The Marriage of Heaven and Hell* (1790), he imagined the acids and corrosive effects of relief printing in daemonic terms: 'But first the notion that man has a body distinct from his soul, is to be expunged; this I shall do, by printing in the infernal method, by corrosives, which in Hell are salutary and medicinal, melting apparent surfaces away, and displaying the infinite which was hid'.[31] The very act of creating a design on the copperplate is cast here as a form of revelation, provocatively aligning the act of making a print with the apocalyptic drama which seemed to be unfolding in the world at large in the wake of the French Revolution.

34. *Edward and Eleanor*, c.1780–93
Engraving and etching on paper, 37.3 × 48.8

35. *'Hell beneath is moved for thee, to meet thee at thy coming' – Isaiah, XIV, 9*, c.1780–5
Ink and wash on paper, 36 × 43.2

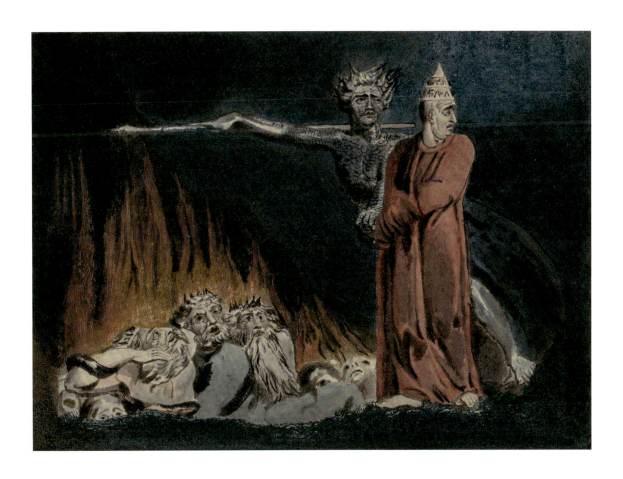

36. *Lucifer and the Pope in Hell*, c.1794–6
Etching, engraving, watercolour and ink on paper, 19.9 × 27.4

Although the details of Blake's process are still controversial and debated, it appears to have involved printing from copper plates, as with conventional engraving or etching. But while these intaglio techniques rely on cutting into the copper and forcing ink into those cut lines, with relief printing it is the raised surfaces which are coated with ink and printed. Instead of cutting into the copper, Blake drew or painted a specially resistant liquid onto the plate, so that when acid was applied to this surface these areas remained raised and could be printed. Blake used different coloured inks, printing any given book in several contrasting colours, or giving different colour effects on a single plate. With the addition of watercolour and drawn ink lines, or even gilding, the pictorial qualities of the different versions of a given book could vary a great deal. Any single plate might be printed in one single colour, several colours, or in several colours with additional watercolour.

Because Blake etched his texts and images together, and made these plates into little books, they are both like and unlike conventionally printed books. We are meant to pick them up and 'read' them, but they also need to be looked at. While conventional printing techniques for illustrated books meant that different people would engrave and print the images, and set the individual letters ('type') in blocks from which the text would be mechanically printed, Blake appears to have conceived, executed and printed the whole independently, aided by his wife, Catherine. As 'a method of Printing which combines the Painter and the Poet',[32] it overcame the practical challenges which had frustrated the production of *Tiriel*, and fused the dual creative identities as poet and painter assumed by Blake in the mid-1780s. Each book could be quite different each time it was made, with the plates in a different order, and individual sheets or whole sections removed or added in. Conventional printing techniques were valued because they created a uniform product: a single image, a single text, could be multiplied hundreds, and thousands, of times. The initial investment put into creating the plates and setting the type could

potentially be repaid over and over again – for the publishers and booksellers, at least, if not for the original artist and engraver, who would most likely have been paid a set fee. Blake's illuminated books, however, spoil this logic: they are at once multiple, and unique. Which version of a given book is the primary one? Does each book, instead, have its own unique validity? And if some of the illuminated books circulated through the booksellers, they were primarily on offer from the artist himself, at his home.

37. *There is no Natural religion*, c.1788, printed c.1794
Colour relief etching, 13.4 × 10.5 (leaf size)

Blake's first attempts to integrate texts and images appear to be the miscellaneous series of little emblems and aphorisms collected as *All Religions are One* and *There is No Natural Religion*. The first successful and complete printing of an illuminated book of poetry came with the first copies of *Songs of Innocence* (1789), subsequently joined by *Songs of Experience* (1793), and printed together as a single *Songs of Innocence and of Experience* (from 1794). These were, by Blake's standards, best-sellers, and most of his main patrons acquired copies in his lifetime. Meanwhile, several of the poems were printed in conventional form in other contexts at an early date and became comparatively well known. *The Book of Thel* (c.1789) was the first illuminated book to feature Blake's invented characters, followed by *The Marriage of Heaven and Hell, Visions*

of the Daughters of Albion and the books known as the 'Continental Prophecies': *America: A Prophecy*, *Europe: A Prophecy* and *The Song of Los*. These trace the theme of revolution in global terms and through increasingly obscure allegory. In *America* it is still possible to relate these in a fairly direct way to historical events. Urizen, the bearded patriarch who appears in Blake's prophetic works as the embodiment of reaction and oppressive law, can be interpreted as a version of George III, overwhelmed by the loss of the American colonies. The poem thus extends the themes of madness and tyranny which had already emerged in *Tiriel* and, indeed, in British art more generally in the 1760s and 1770s. Orc, the athletic youth surrounded by flames, is here the emblematic embodiment of the rebellious Americans.

These 'Continental Prophecies' were followed by the 'Urizen books' focusing on Blake's invented mythic character of that name, and consisting of *The First Book of Urizen*, which incorporates a much more dominant visual element than previously, *The Book of Los* and *The Book of Ahania* both of which consist of colour-printed designs but with the text engraved. Blake appears to have concluded around this time that colour printing was best used for images; hence the creation of the large colour prints in around 1795, prints that were, as Blake later put it, 'unaccompanied by any writing',[33] although produced using a form of monotype combined with significant enhancement with paint and drawn ink rather than relief etching. In 1794–6 he also produced at least three separate volumes of images reprinted, without texts, from the existing illuminated books. There were two volumes called the 'Small Book of Designs', and one surviving copy designated as 'Large Book of Designs'. Other, surviving loose plates suggest that there may have been a further copy of the 'Large' book. Whatever the precise bibliographical history, these were not 'books' in the sense even that the illuminated books were, but rather visual compendiums of plates detached from literary contexts, open to interpretation with the guidance only of our fore-knowledge of Blake's invented universe (something modern viewers, rather than his contemporaries, are more likely to bring, given the ready access to the published reference works and The William Blake Archive) or, in some cases, suggestive new poetic inscriptions by the artist.

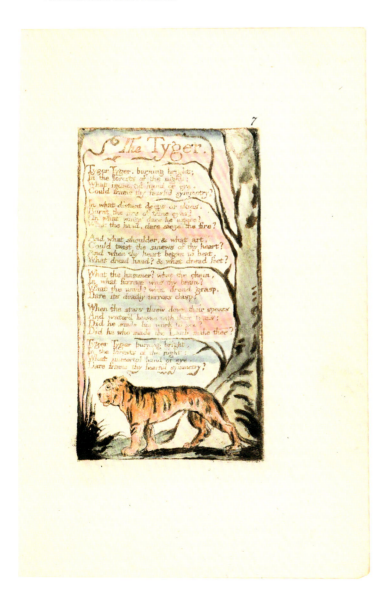

38. *Songs of Innocence and of Experience*, 1794
54 relief-etchings, hand-coloured with watercolour, with some gold, bound in calfskin. Open at '*The Tyger*', 11 × 7 (page size)

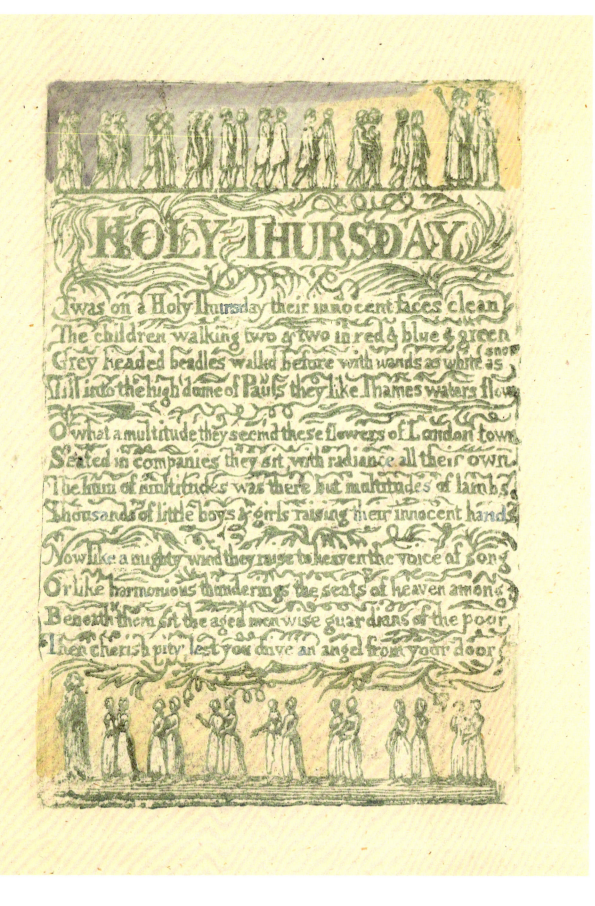

HOLY THURSDAY

Twas on a Holy Thursday their innocent faces clean
The children walking two & two in red & blue & green
Grey headed beadles walked before with wands as white as snow
Till into the high dome of Pauls they like Thames waters flow

O what a multitude they seemd these flowers of London town
Seated in companies they sit with radiance all their own
The hum of multitudes was there but multitudes of lambs
Thousands of little boys & girls raising their innocent hands

Now like a mighty wind they raise to heaven the voice of song
Or like harmonious thunderings the seats of heaven among
Beneath them sit the aged men wise guardians of the poor
Then cherish pity, lest you drive an angel from your door

39. Holy Thursday, 1789, Relief etching printed in green ink,
text strengthened with blue wash, and finished with watercolour on paper, 18.8 × 13.7

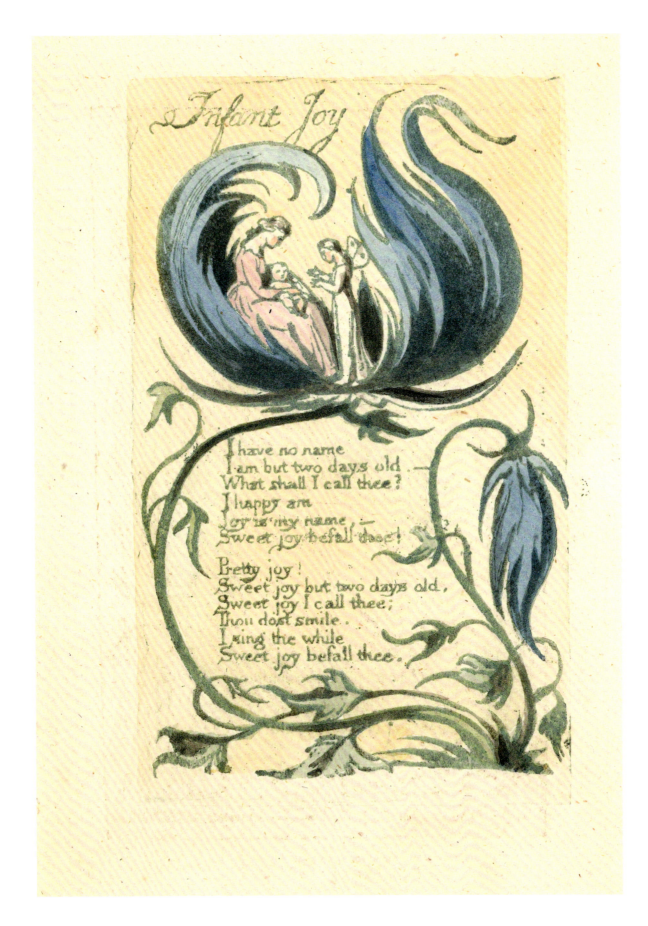

40. *Infant Joy*, 1789, Relief etching printed in green ink,
text strengthened with blue wash, and finished with watercolour on paper, 18.8 × 13.7

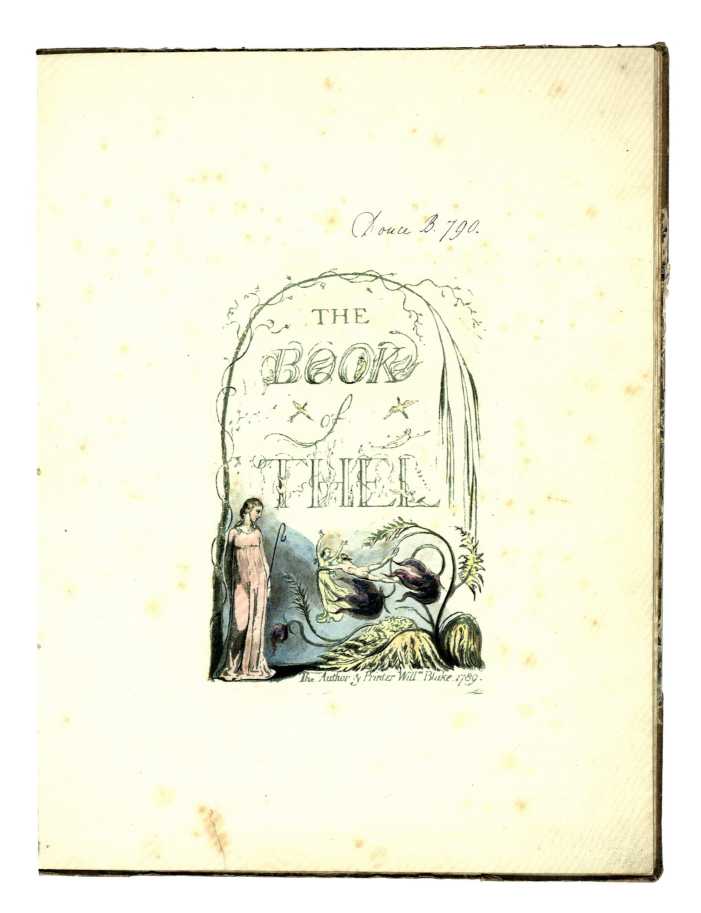

Douce B. 790.

41. *Book of Thel*, c.1789, bound c.1834
8 relief etched plates in green ink with hand-colouring on 8 leaves. Open to title page, 15.5 × 10.7 (image size)

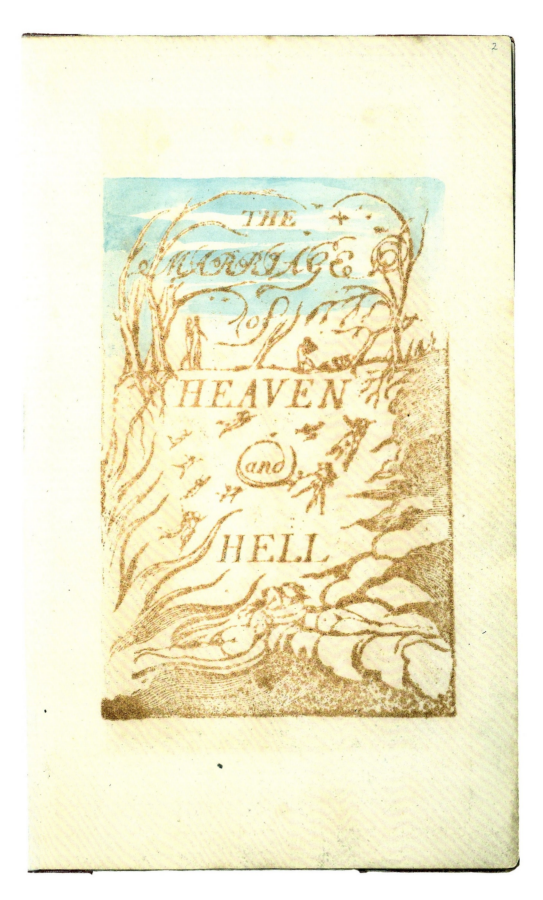

42. *The Marriage of Heaven and Hell*, c.1790–3, Bound c.1834
28 relief etched plates in coloured inks with glue-based pigments and hand-colouring on 15 leaves. Open to title page, 15.2 × 10.3 (image size)

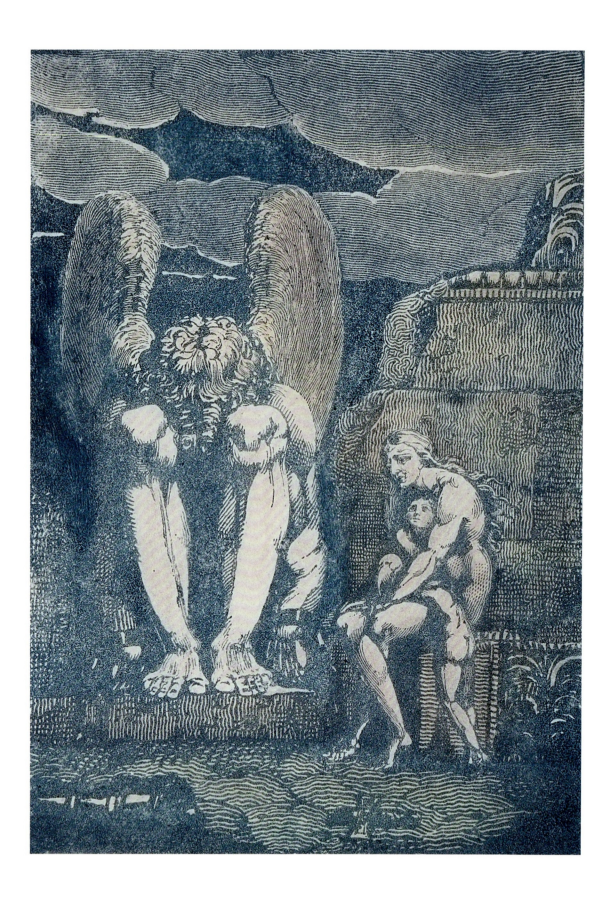

43. *Frontispiece for 'America a Prophecy'*, 1793
Etching on paper, 23.3 × 16.8

The text within the illustration reads:

ELEGY

WRITTEN IN A

COUNTRY CHURCH-YARD.

THE Curfew tolls the knell of parting day,
 The lowing herd wind flowly o'er the lea,
The plowman homeward plods his weary way,
 And leaves the world to darkneſs, and to me.
Now fades the glimmering landſcape on the ſight,
 And all the air a folemn ſtillneſs holds,
Save where the beetle wheels his droning flight,
 And drowſy tinklings lull the diſtant folds;
 Save

84. The Poems of Thomas Gray, Design 108, *Elegy Written in a Country Church-Yard*, Between 1797–8
Watercolour, ink and graphite on paper, 41.9 × 32.4

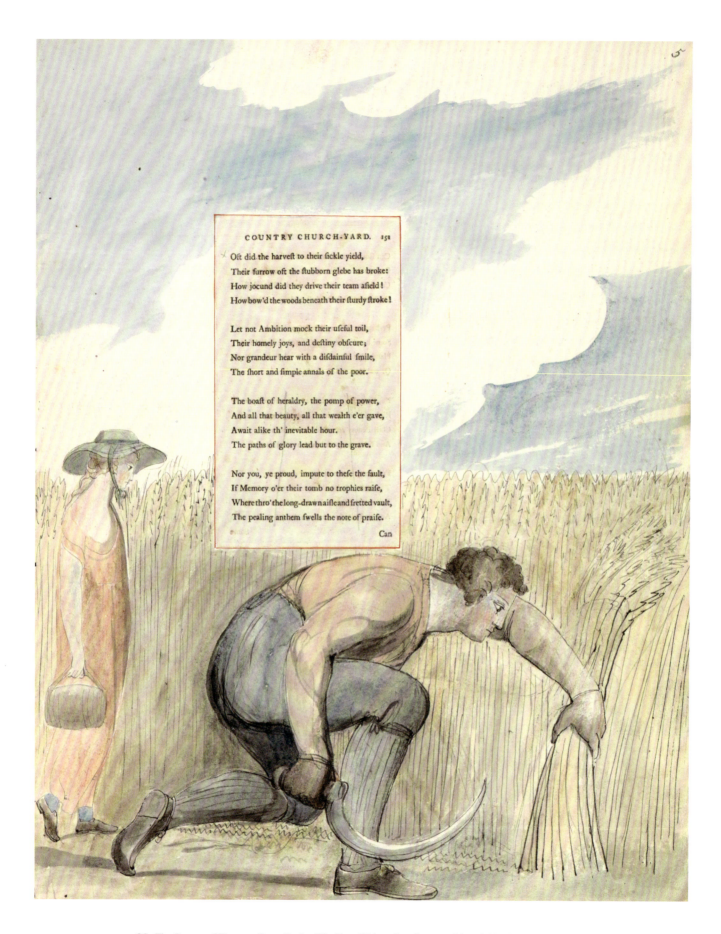

COUNTRY CHURCH-YARD. 151

Oft did the harvest to their sickle yield,
 Their furrow oft the stubborn glebe has broke:
How jocund did they drive their team afield!
 How bow'd the woods beneath their sturdy stroke!

Let not Ambition mock their useful toil,
 Their homely joys, and destiny obscure;
Nor grandeur hear with a disdainful smile,
 The short and simple annals of the poor.

The boast of heraldry, the pomp of power,
 And all that beauty, all that wealth e'er gave,
Await alike th' inevitable hour.
 The paths of glory lead but to the grave.

Nor you, ye proud, impute to these the fault,
 If Memory o'er their tomb no trophies raise,
Where thro' the long-drawn aisle and fretted vault,
 The pealing anthem swells the note of praise.

 Can

85. The Poems of Thomas Gray, Design 110, *Elegy Written in a Country Church-Yard*, Between 1797–8
Watercolour, ink and graphite on paper, 41.9 × 32.4

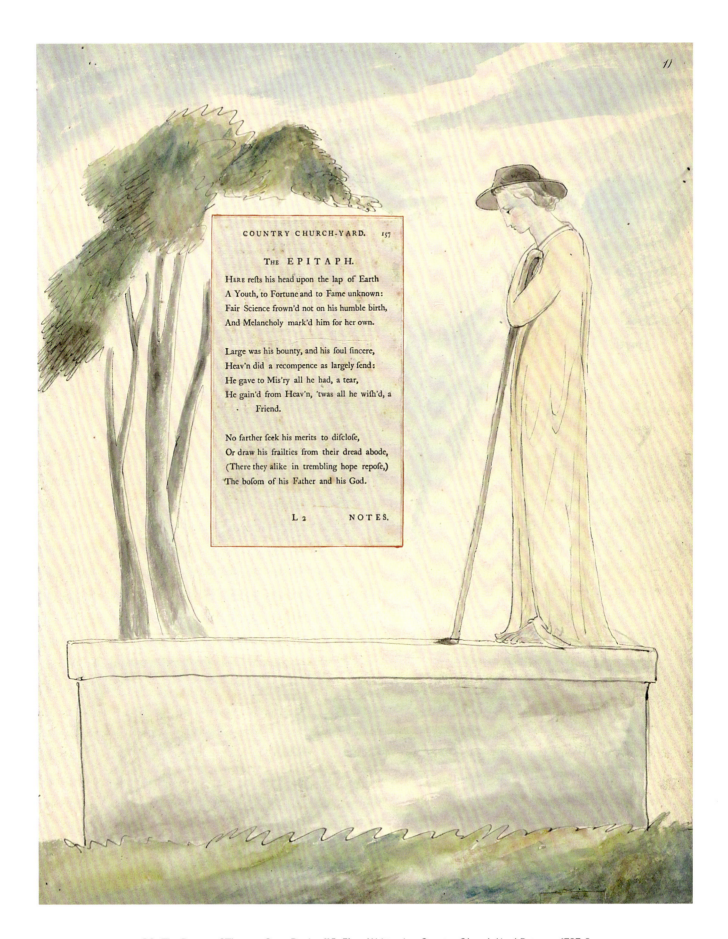

86. The Poems of Thomas Gray, Design 115, *Elegy Written in a Country Church-Yard*, Between 1797–8
Watercolour, ink and graphite on paper, 41.9 × 32.4

87. The Poems of Thomas Gray, Design 116, *To Mrs Ann Flaxman*, Between 1797–8
Watercolour, ink and graphite on paper, 41.9 × 32.4

88. *The Entrance Front of Hayley's House at Eartham*, 1801
Watercolour, ink and graphite on paper, 14 × 22.9 (sheet)

The artist's identity depends upon an act of self-identification, rather than an external affirmation; this latter, in the form of patronage, may be illusory. This independence-of-sorts may resemble, unexpectedly, the amateur, and this may suggest to us that Blake's self-identification as 'Honorary' in 1800 was not accidental or arbitrary. Freedom from patronage, or from state support, has liberated the artist, provided him with that special freedom accorded to the individual in liberal modernity: the freedom to be poor, lonely, misunderstood; the freedom to live without expectation of reward; freedom without the certainty of long-term employment, of external support if you are to fall ill or grow old. It was a bitter irony that an ideal of aristocratic freedom lived on in the figure of the artist, who so often lacked the resources (material or symbolic) of the aristocrat, or even the well-off members of the bourgeoisie or gentry. When George Cumberland withdrew from the world of work to indulge his love of art and knowledge, he could do so on the basis of an inheritance. In one of his darker moments, Blake wrote of his artistic hero, the history painter James Barry: 'Barry was Poor & Unemploy'd ... except by his own Energy', while 'only Portrait Painting [was] applauded &

rewarded by the Rich & Great'.[17] But while Barry was a controversial figure and lived in degradation, he was not in reality poor. His contemporaries suspected him of being miserly, instead, and he left a substantial amount of money on his death in 1806, which allowed a niece to set herself up (in masculine guise) as a successful army surgeon.[18]

Blake's optimistic declaration of newly independent status heralded a new phase of patronage, emanating from William Hayley. Flaxman had written to the wealthy poet Hayley about Blake as early as 1784, when he was trying to drum up support to send Blake to Rome, where he might be expected to make a name for himself in the grand style.[19] The move to Sussex to live near Hayley, perhaps motivated in part by a bout of ill health for Catherine and a wish to escape the city, brought with it the promise of a new level of financial independence. What transpired turned out to be rather more disappointing, and Hayley's outlook towards Blake has not traditionally won him many friends in the world of Blake studies. Blake did portraits for Hayley, including one of the poet's much loved son, Thomas Alphonso Hayley. He was also engaged to produce engraved illustrations

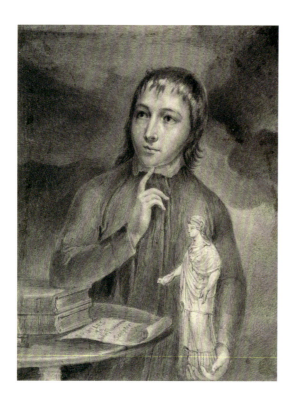

89. Attributed to William Blake, *Thomas Alphonso Hayley*, c.1800
Graphite and gouache on paper 17.1 × 13.3

for Hayley's literary output, including straightforward reproductions for his book on William Cowper, poet and hymnist. He was given decorative work for the library in the newly built tower at Hayley's house, producing a series of painted panels showing the heads of writers from the past and from recent ages. More promisingly he produced original designs for a series of ballads on animal themes that Hayley published. Although this did not sell well, Blake went on to lobby Hayley for the copyright, hoping that he could extend its commercial life,[20] but Blake ended up feeling the work for Hayley was trivial. He was also in trouble with the law after an ugly misunderstanding with a drunken soldier in the garden of the cottage he and Catherine were renting. The soldier claimed that Blake had 'damned the King of England – his Country and his Subjects', and Blake was called back from London to face a trial in Chichester in January 1804, where he was found to be innocent.[21] The incident reflected the general paranoia of the time, when the threat of invasion from the enemy France was deeply felt, and Blake seems to have been right

in relaying to Butts that the charges were cooked up. Hayley's readiness to defend Blake, even through this difficult time, reflects the basically genial intentions of his patronage.

Although Blake was traumatised by the overall experience and the brush with the law in particular, the Sussex period provided a nexus of contacts who turned into patrons, including Joseph Thomas, a clergyman who enjoyed financial independence thanks to his wife's inherited wealth, for whom Blake produced a series of literary designs; the Reverend John Johnson, for whom he painted panels for a fireplace; Elizabeth Ilive, by then Countess of Egremont at nearby Petworth, who commissioned and purchased paintings and prints; and John Chichester of Arlington Court (see p. 203), who commissioned a still-mysterious late watercolour.

The Blakes returned to London in 1803, disappointed by the whole venture. Staying first with his brother back in Broad Street, he and Catherine then settled in South Molton Street, off Oxford Street, living in an apartment, as they had done earlier in their married life in Poland Street, in the midst of tradesmen, makers and merchants. Blake resumed work on the biblical paintings, typically using more intense colour effects than he had previously. A series of receipts documents Butts's payments to Blake between

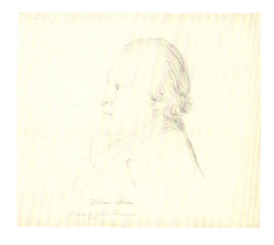

90. John Flaxman, *Portrait of William Blake*, c.1804
Graphite on paper, 42.2 × 32.7

91. *Landscape Near Felpham*, c.1800
Graphite and watercolour on paper, 23.7 × 34.3

1805 and 1810, usually five or ten guineas every couple of months over these years. This includes the purchase of twelve 'Large Colour Prints', the set of large-scale designs which mark a climactic development of the technical and iconographic possibilities inherent in Blake's experiments with colour printing.

What Blake alluded to as a set of 'Historical & Poetical' subjects[22] had been drawn from a range of sources, primarily from the Bible (with six subjects), from Shakespeare and Milton, and from his own imagination. If we view these prints as a sequence, we are obliged to shift our interpretative perspective: from viewing a visual presentation of scenes of the action of scripture or Milton, involving human agents or gigantic spiritual forces; to engaging with the 'literalization of figuration' that sees Shakespeare's lines 'And pity like a newborn babe' given direct visual form;[23] to pondering images that seem to depend in some way on our knowledge of Blake's own poetry but only inexactly and dubiously; and of course the fantastical rendering of the historical figure, Isaac Newton. If these can in some sense be considered as a 'cycle', and as such an echo of the grand pictorial schemes of the Renaissance, which was mooted as the proper aim of the most ambitious artists of the day, it is striking that they are rendered at a size and in a medium which means they could be readily displayed or stored in a domestic setting. Raphael and Michelangelo demanded palaces and cathedrals for their gigantic schemes; Blake was given the decent-sized house of a senior civil servant. Moreover, while scholars have doggedly attempted to impose a thematic coherence and systematic organisation on these twelve plates, either as a series in its entirety, or in smaller groups or pairs, there is no settled and agreed sequence. The meaning of the works individually, and the series as a whole, remains subject to seemingly interminable debate. In form and content this was heroic art reduced to the private realm.

92. *Heads of Poets: Dante Alighieri*, c.1800, Tempera on canvas, 42.5 × 87.8

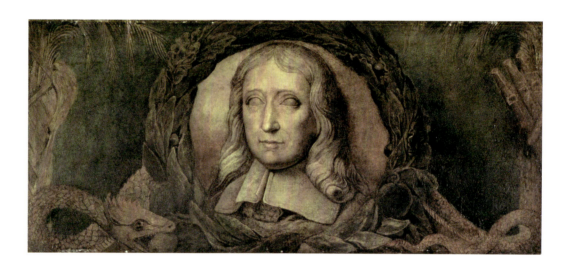

93. *Heads of Poets: Milton*, 1800–3, Ink and tempera on canvas, 40.1 × 90.9

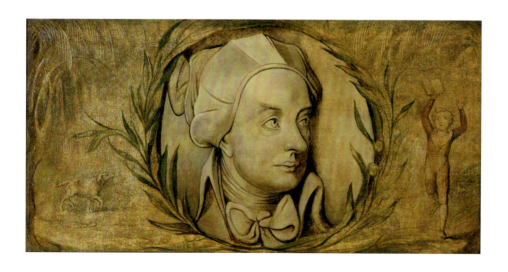

94. *Heads of Poets: Cowper*, 1790–1810, Ink and tempera on canvas, 41.9 × 83.6

95. *Evening*, c.1820–5
Watercolour and chalk on wood, 91.8 × 29.7

96. *Winter*, c.1820–5
Tempera on wood, 90.2 × 29.7

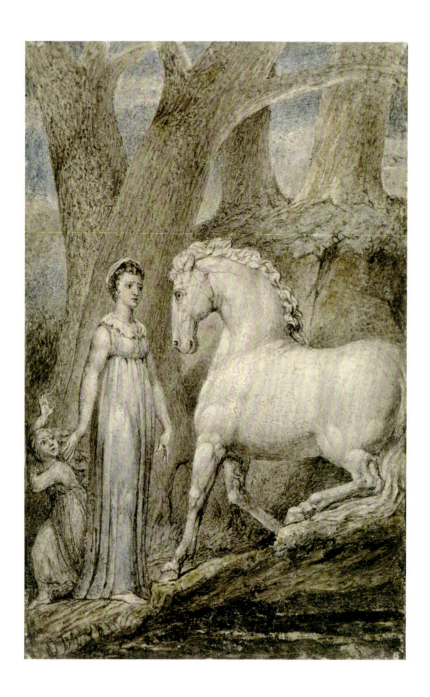

97. *The Horse*, c.1805
Tempera and ink on copper plate, 10.6 × 6.4

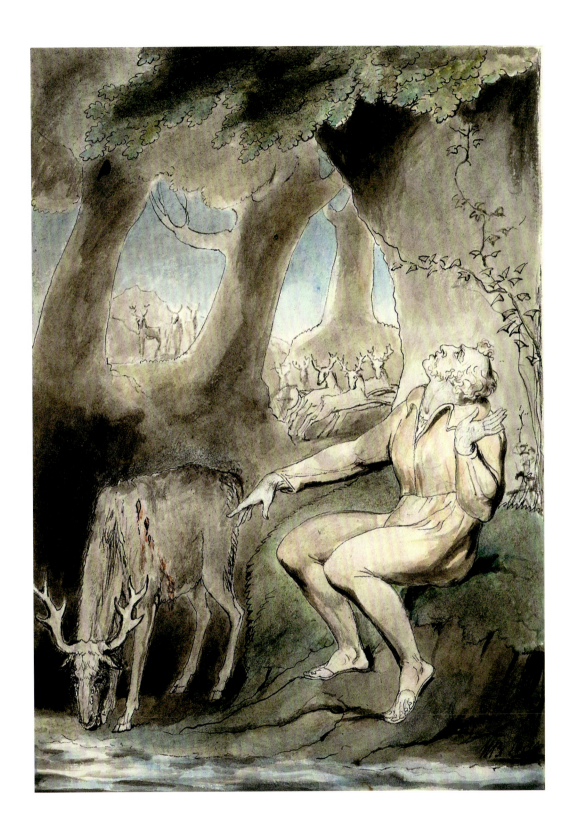

98. *Six illustrations to Shakespeare: Jacques and the Wounded Stag*, 1806
Ink, watercolour and graphite on paper, 30.6 × 19

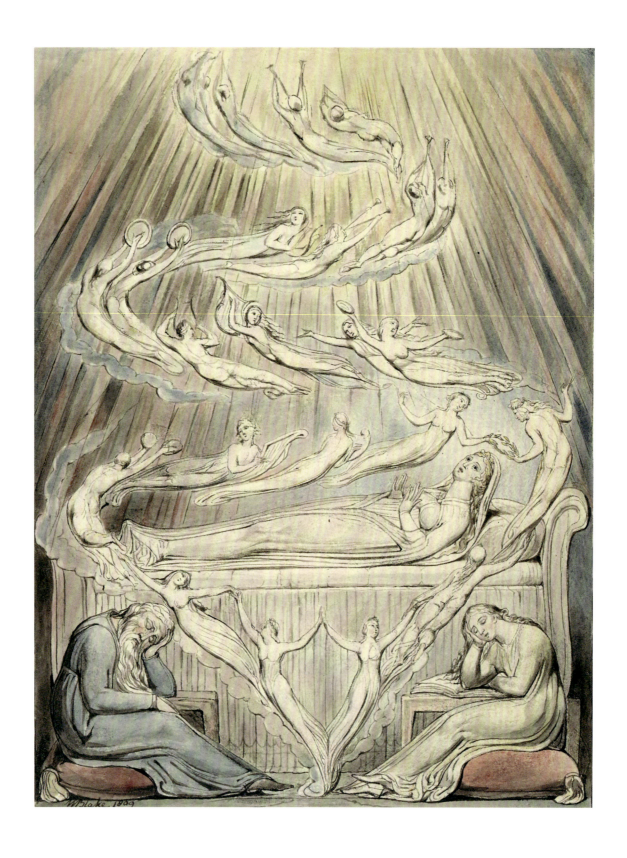

99. *Six illustrations to Shakespeare: Queen Katherine's Dream*, 1809
Ink and watercolour on paper, 30.7 × 19.4

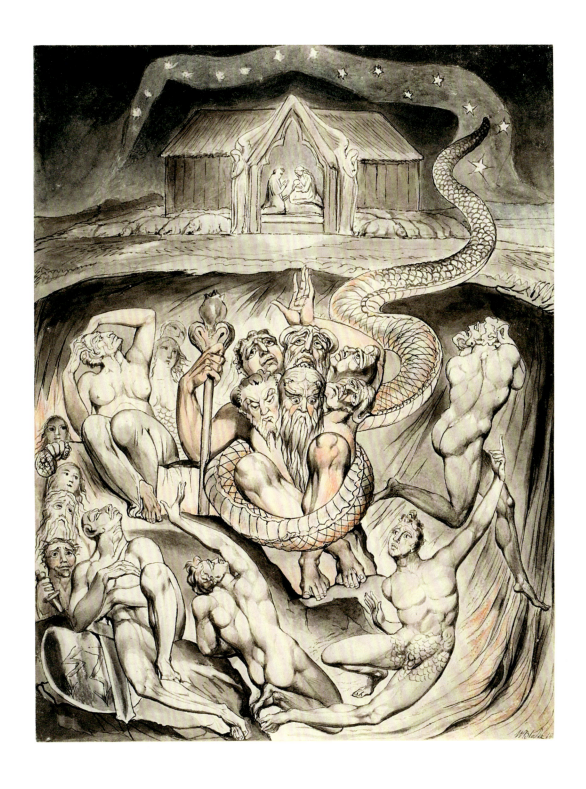

100. *Six illustrations to Milton's 'On the Morning of Christ's Nativity':*
The Old Dragon / The Descent of Typhon and the Gods into Hell: Milton's Hymn 'On the Morning of Christ's Nativity', 1809
Graphite, ink and watercolour on paper, 25.3 × 19.3

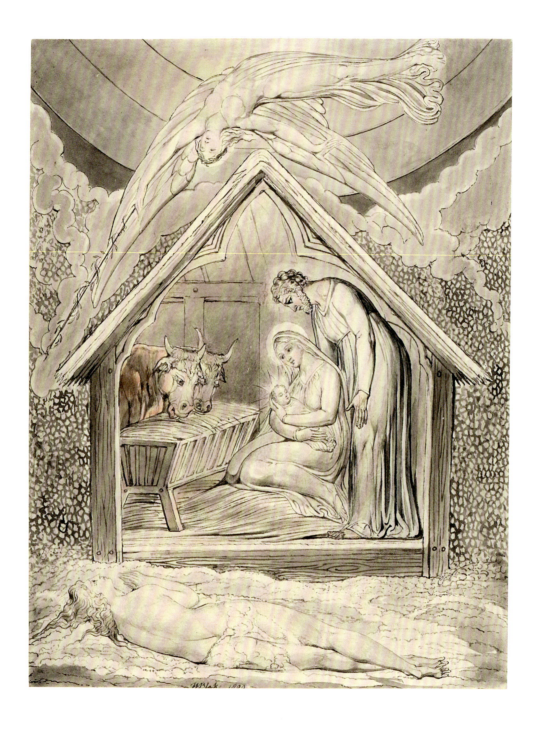

101. *Six illustrations to Milton's 'On the Morning of Christ's Nativity':*
The Descent of Peace / The Descent of Peace: Milton's Hymn 'On the Morning of Christ's Nativity', 1809
Graphite, ink and watercolour on paper, 25.5 × 19.5

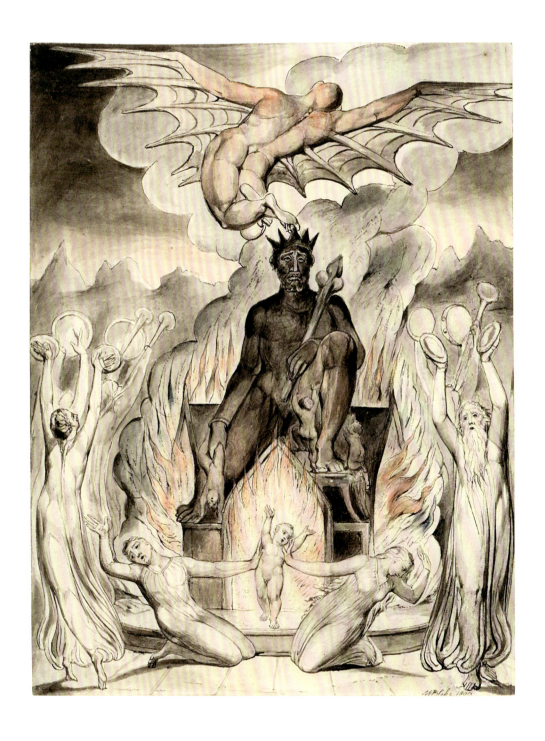

102. *Six illustrations to Milton's 'On the Morning of Christ's Nativity':*
The Flight of Molloch / Sullen Moloch: Milton's Hymn 'On the Morning of Christ's Nativity', 1809
Graphite, ink and watercolour on paper, 25.8 × 19.7

Hayley, Flaxman and Butts can be considered to share the title of being Blake's most consistent supporters, in the narrower sense of that term. But these relationships were not without complications. Blake evidently sought to put some distance between himself and Hayley. There were fallings-out with Flaxman, a sense of distance or disjunction between the sculptor's liberal cultural circles and Blake's more abrasive persona,[24] though Flaxman provided professional contacts and commercial introductions as well as direct patronage. But the same could be said even of Butts, for while Blake was in Sussex Butts tried to set up opportunities for him in London. In 1803, Blake had written to Butts thanking him for 'your kindness in offering to Exhibit my 2 last Pictures in the Gallery in Berners Street', which was undoubtedly the short-lived commercial gallery space The British School opened in Berners Street in October 1802.[25] On another occasion, Blake had written 'I am ... Grateful to you my Employer. & ... I look upon you as the Chief of my Friends'.[26]

The shift between friend and employer, patron and agent, was fluid and often couched in terms of sociable exchanges rather than explicit commercial arrangements. Butts, Flaxman and Hayley acted as patrons, but also commercial agents or promoters. On the other hand, patronage could be contested, rejected even, by the artist, hence the prickly tone of some of Blake's exchanges with even his kindest supporters. An early satirical play drafted in the mid-1780s, *An Island in the Moon*, had mocked the kind of sociable circle of intellectuals and artists that Blake had found at the Mathews, and offered barely disguised satires on his friends, including Flaxman. Meanwhile, a poetical dedication to Countess Egremont regarding her possible support declared, 'If she refuse I still go on' – a declaration of independence which flatters both patron and artist.[27] As Sarah Haggarty notes of Blake's patrons, this isn't simply a mask for base economic relations, but it does confuse and therefore disguise the mixture of financial and social stakes involved.[28] What was being formed between Blake

and his patrons – at least the patrons who supported him directly and bought his original works from him – was something more like the relationship between contemporary artists and 'gallerists' or curators, than the more straightforward kinds of commissioning or purchase found among other artists of his time. His relations with supporters anticipate what anyone with sight into the contemporary art world would observe about the close social, sometimes intimate, sometimes oppositional and abrasive relationships between artists, curators and commercial agents, at their parties and on shared holidays, effacing distinctions between the public and private, the commercial and the disinterested.

Blake himself had problems with private patronage, and appealed repeatedly to the promise held out by the market and the aesthetic wisdom of 'the public'. In 1803, he wrote to his brother, with what is surely knowing self-delusion, 'I know that the Public are my friends & love my works & will embrace them whenever they see them My only Difficulty is to produce fast enough.'[29] With the notable exception of *The Grave*, that public remained elusive, and the marketplace returned little on his original productions. With the work of commercial engraving providing a financial backbone, Blake repeatedly fell back on the personal support of private individuals. What was lacking throughout his career was the kind of state patronage for art (from government or monarchy) that was a particularly vain dream of the most uncompromising artists of the age, not unreasonably given the promise held out by the foundation of the Royal Academy. In its stead, it was left to private men and women to cultivate the arts. In the case of Blake, what appears to be the painful triumph for creative freedom, in a precariously unregulated open market for cultural goods, also involved the re-privatisation of artistic labour. MM

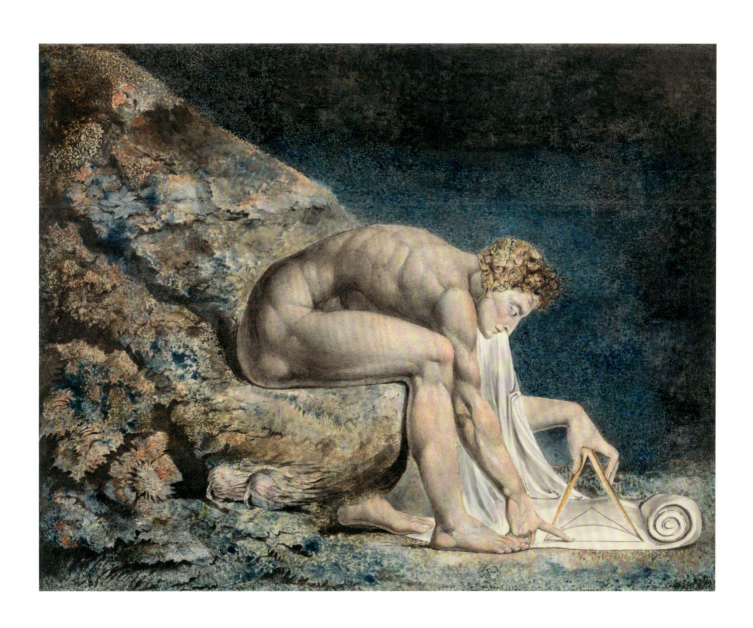

103. *Newton*, 1795 - c.1805
Ink and watercolour on paper, 46 × 60

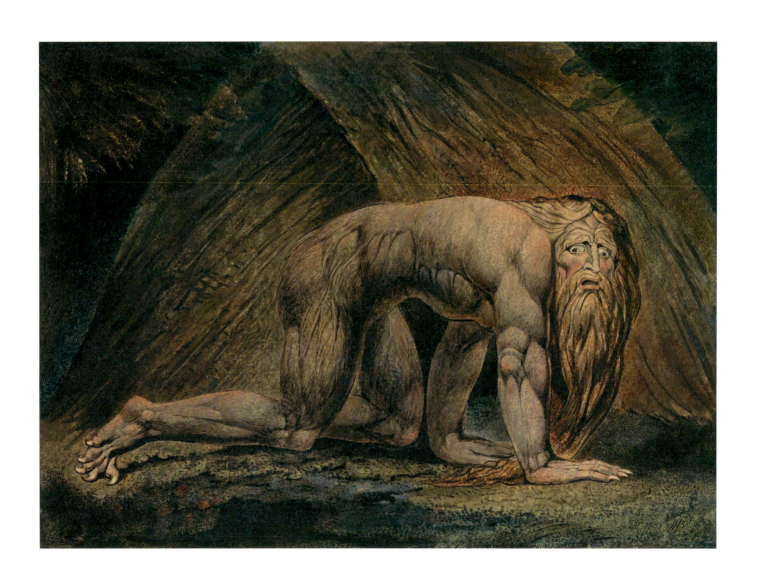

104. *Nebuchadnezzar*, 1795–c.1805
Ink and watercolour on paper, 54.5 × 72.5

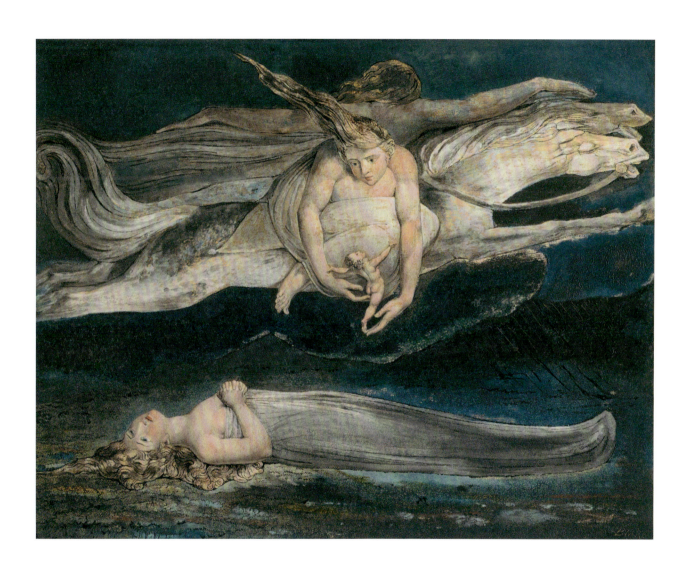

105. *Pity*, c.1795
Ink and watercolour on paper, 42.5 × 53.9

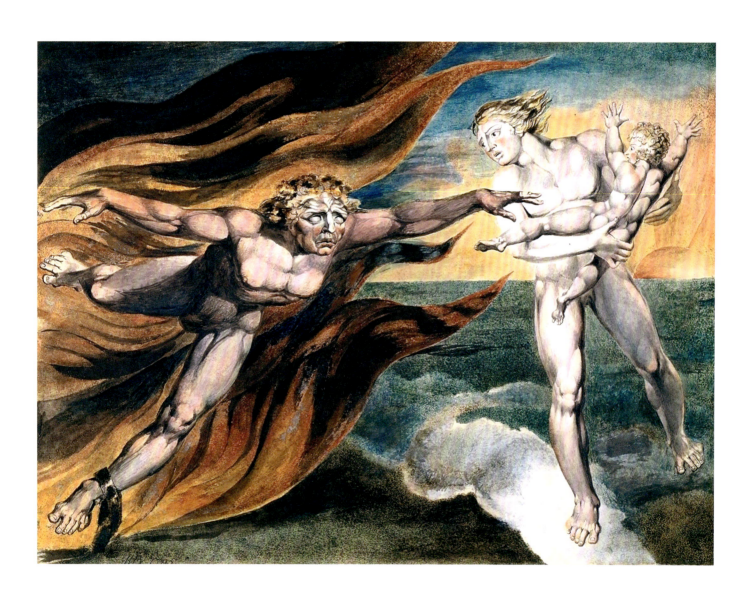

106. *The Good and Evil Angels*, 1795–c.1805
Ink and watercolour on paper, 44.5 × 59.4

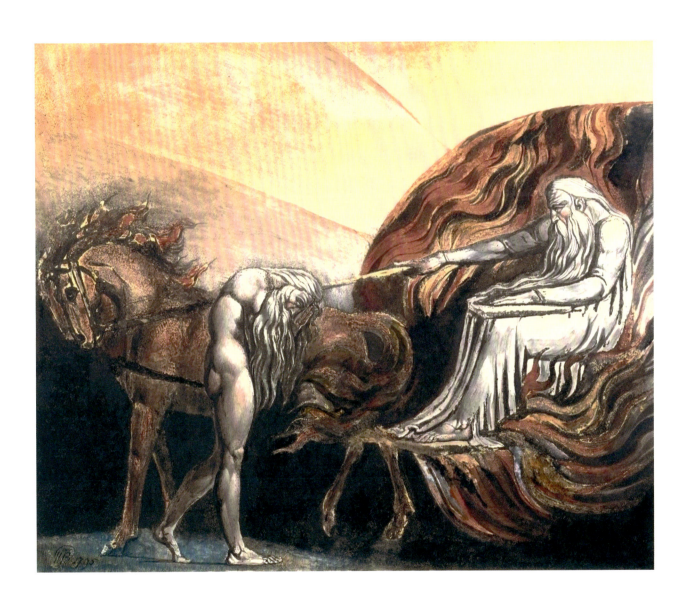

107. *God Judging Adam*, 1795
Etching, ink and watercolour on paper, 43.2 × 53.5

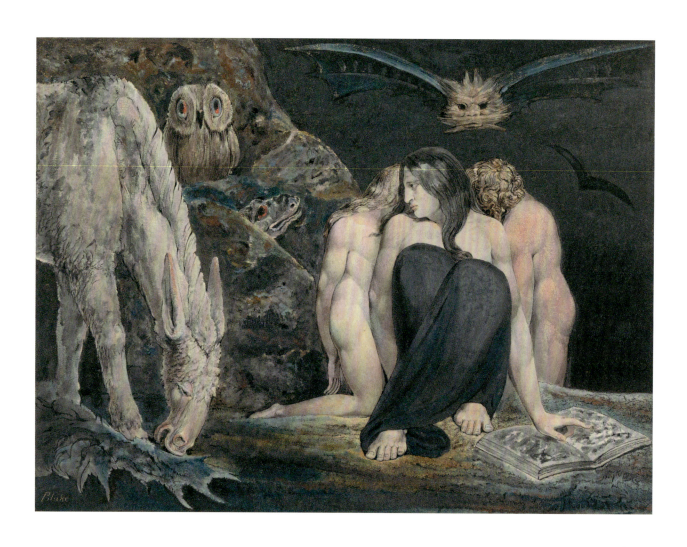

108. *The Night of Enitharmon's Joy (formerly called 'Hecate')*, c.1795
Ink, tempera and watercolour on paper, 43.9 × 58.1

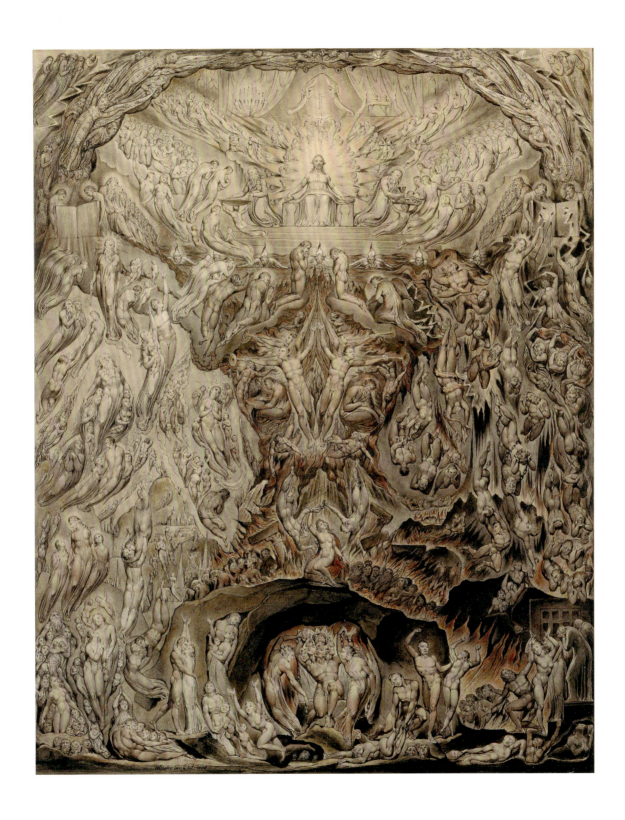

109. *The Vision of the Last Judgement*, 1808
Watercolour, ink and graphite on paper, 50.3 × 40

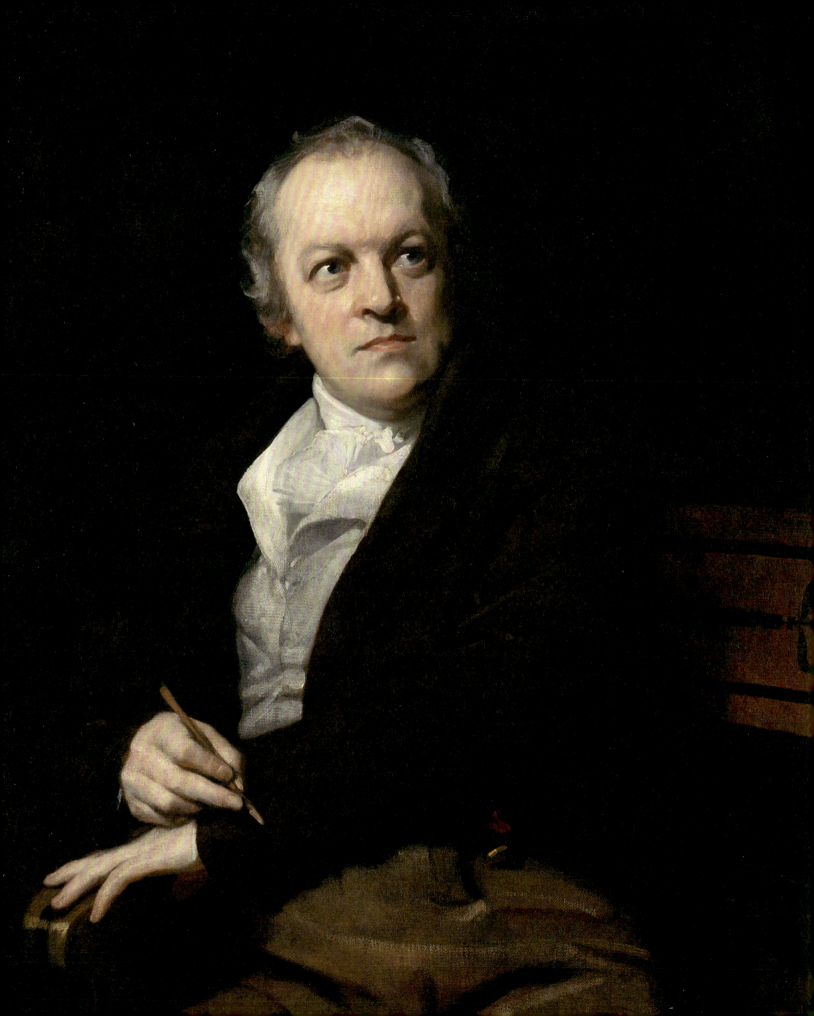

INDEPENDENCE
AND DESPAIR

In the portrait completed by Thomas Phillips in 1807 (no.110), we meet Blake the artist at the age of fifty. Eyes cast upwards and drawing tool poised, Blake seems relaxed yet alert, his lively expression containing perhaps just a hint of amusement. For Phillips, this was no ordinary sitting. He later relayed how he captured this inspired expression as Blake recalled a visit from the Archangel Gabriel, who, as 'a shining shape, with bright wings', opened the roof of Blake's studio, then 'stood in the sun, and beckoning to [him], moved the universe'.[1] Phillips's portrait marks the beginning of a period in which Blake, too, sought to stand in the sun: to actively seek a larger public for his work, to rejuvenate his professional profile and claim his place in the London art world.

Though Phillips was an up-and-coming society painter thirteen years Blake's junior, the two men shared some common ground. Having completed an apprenticeship with a glass engraver and japanner in Birmingham, Phillips started out in London with leading mezzotint engraver, Valentine Green. Sharing Blake's youthful aspiration to be a history painter, he assisted Benjamin West in the 1790s. Yet while Blake persisted with historical imagery in watercolour and print, sustained by an income from commercial book engravings, Phillips, unable to sell historical subjects, came to the realisation that 'I must attach myself to Portraiture if I hoped to live by my Profession'.[2] By the time he painted Blake he had been awarded Associateship of the Royal Academy, where he would eventually become Professor of Painting. By 1812, when Blake exhibited his work in public for the last time, it was

being said of Phillips that while he had started out 'without connections or patronage ... [h]e has now both to an extensive degree'.[3] The divergence in their trajectories highlights the degree to which Blake's own fortune – or lack thereof – was the result of his determination to preserve his integrity as a maker of historical images. He would go about making his work more visible to the public in a similarly uncompromising manner.

Phillips's portrait certainly heightened Blake's visibility. Its dramatic chiaroscuro, conjured by the brilliance of the white shirt against a dark background, would have helped the many thousands of visitors to the Royal Academy's 1807 summer exhibition spot 'Mr. Blake', even in its 'obscure' position in a secondary display space.[4] Included as an engraving within a book for which Blake provided illustrations, published the following year, this image of him entered hundreds of homes across the country. Upon its acquisition by the National Portrait Gallery in 1866, its fate as the enduring picture of Blake the artist was sealed. But who is Blake here? With his crisp white shirt, frilled collar, smart overcoat and gold fob watch, Blake is presented as a gentleman poised to embrace London society. The location of his lodgings, a modest two-roomed flat on the second floor of 17 South Molton Street (the only surviving Blake residence), befitted this profile. Blake referenced the darker side to this locale in his poetry – such as in his reference to Tyburn, the notorious criminal execution site, in *Jerusalem*, which he began work on here – but this refined part of London was a professionally advantageous place to be, and the

accommodation itself was not unfitting for a childless middle-aged couple. Here, he was in physical proximity to the network of artists, patrons and influencers whose friendship and backing he would require so as to thrive or, at the very least, survive.[5] Indeed, he lived but five minutes' walk from Phillips's house and studio.

As Bentley has suggested, however, the garb Blake wears in his portrait may have been a studio costume, borrowed from an array of props available to help sitters become what they, or the consumers of their likeness, wanted them to be.[6] Even the expression he wears here signifies a certain performativity – Blake as the visionary, 'eccentric' genius who communed with spirits. In his relationships with patrons Blake was certainly capable of modifying his language and artistic persona to facilitate connection.[7] Yet while there may be an element of dressing up to serve the conventions of formal portraiture, there are key signs of Blake's intent to project a particular image of himself. His porte-crayon, or pencil, signals that this is not Blake the engraver, but Blake the artist, whose identity as such stemmed from his impassioned belief in the centrality of draughtsmanship. Furthermore, the connection – by means of light and alignment – of eye, head (and therefore mind), and hand suggests Blake's unique selling point, as one whose work was driven by an exceptional imaginative ability and spiritualism. It was thus how Blake chose to assert his presence in the London art world, the most competitive and unforgiving stage.

Blake was likely sent to sit for his portrait by Robert Hartley Cromek. Hailing from Hull in Yorkshire, Cromek, too, had worked as an engraver before he approached Blake to provide the illustrations for his first venture as a publisher, a luxury edition of the popular melancholic poem, *The Grave*, written by Robert Blair in 1743. Having illustrated Edward Young's *Night Thoughts* (1797), Blake was a reasoned choice to illustrate a poem about death and the afterlife, and he had good reason to put his

faith in Cromek, connected as he was to members of his own trusted circle: John Flaxman, Thomas Stothard, George Cumberland, and the Hackney schoolmaster and antiquarian Benjamin Heath Malkin. There may be some felicitous parallel, too, between the theme of Blair's poem – progression through life and beyond – and the opportunity this presented to Blake to rejuvenate his profile and progress his own career after his sojourn in Felpham.

111. *Christ Descending into the Grave*, 1805
Ink, watercolour and graphite on paper, 23 × 12.4

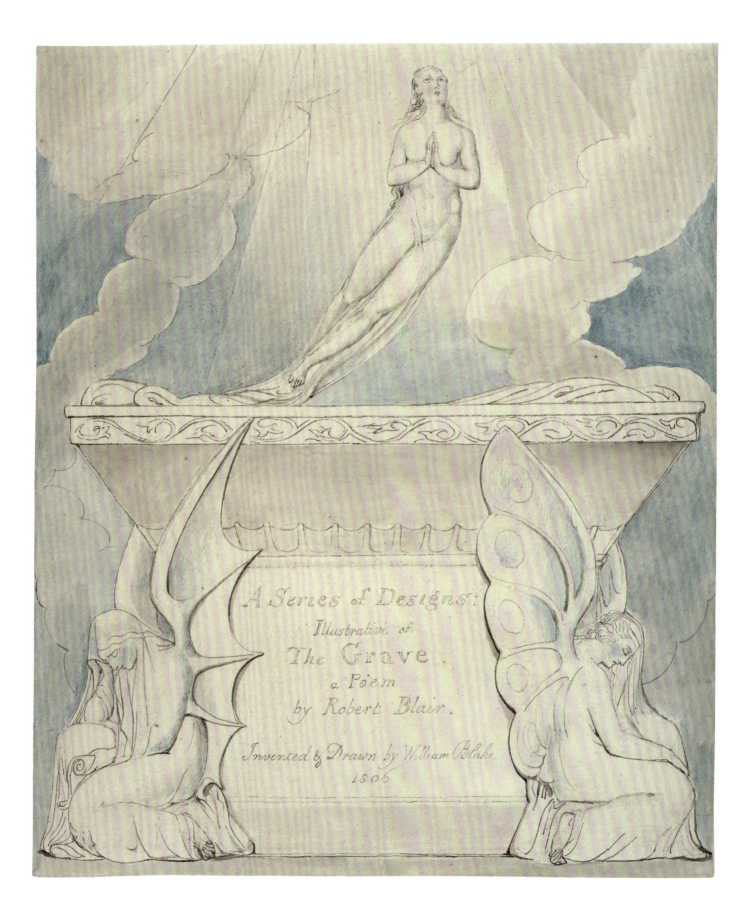

The text visible within the artwork reads:

A Series of Designs:
Illustrative of
The Grave.
a Poem
by Robert Blair.

Invented & Drawn by William Blake.
1806

112. *A title page for 'The Grave',* 1806
Ink and watercolour on paper, 23.8 × 20

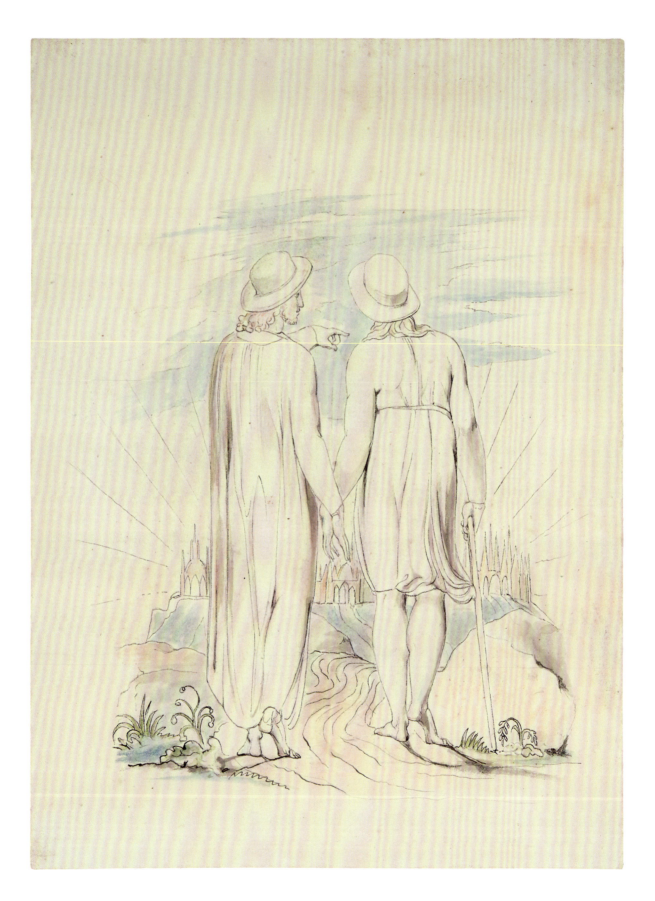

113. *Friendship*, 1805
Ink, watercolour and graphite on paper, 23.8 × 17.6

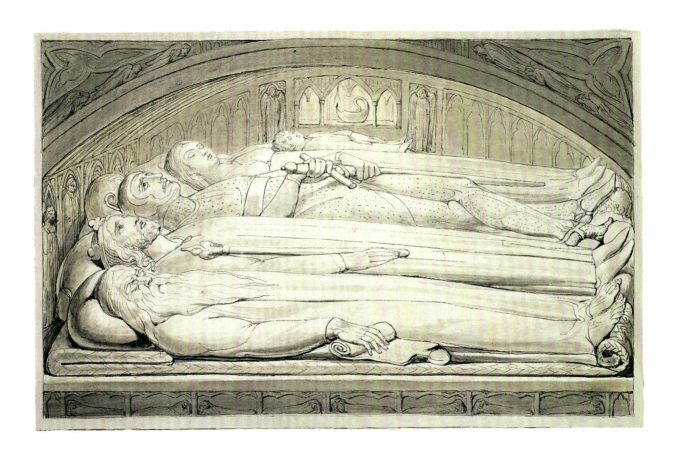

114. *The Counsellor, King, Warrior, Mother & Child, in the Tomb (The Counsellor, King, Warrior, Mother & Child)*, 1805
Ink and watercolour on paper, 15 × 23.4

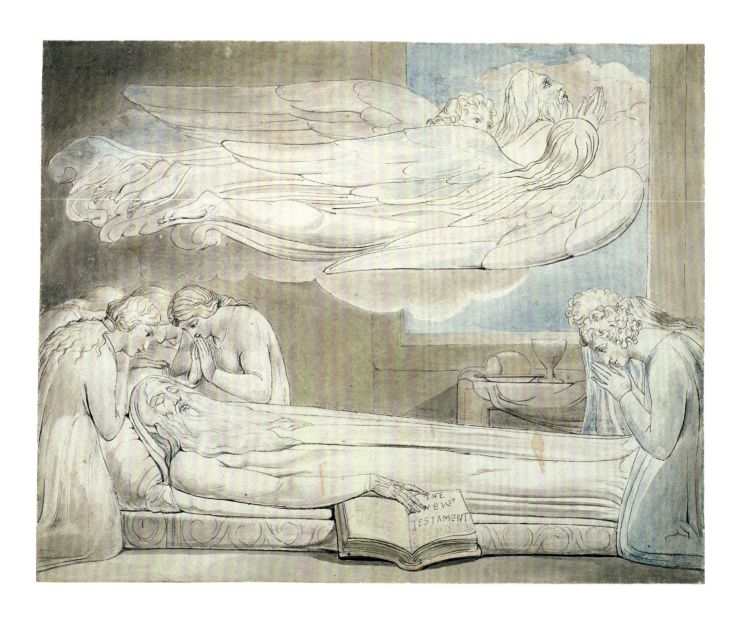

115. *The Death of the Good Old Man (The Good Old Man Dying)*, 1805
Ink and watercolour on paper, 20.2 × 25.8

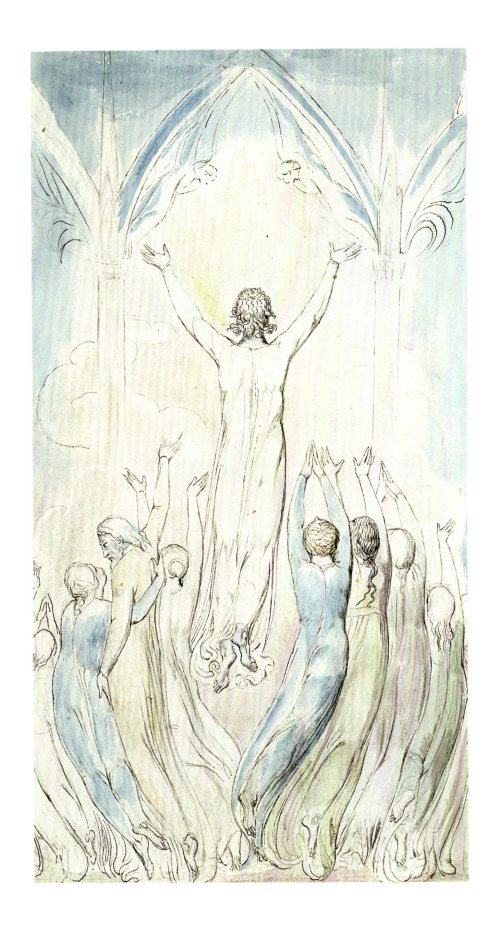

116. *Heaven's Portals Wide Expand to Let Him In*, 1805
Ink and watercolour on paper, 23.7 × 12.8

Perhaps keen to make a good impression on this new patron, Blake took little time to produce twenty drawings for *The Grave* (nos. 111–116), working, as he had done for Thomas Butts, to a rate of one guinea per watercolour, an improvement on his rate for *Night Thoughts*. Blake may have also been invigorated by the chance Blair's poem offered to meditate on the theme of transformation and of the grave as a nexus of life, death and resurrection – a motif he had explored in numerous of his other works, such as the prophetic books *Thel, Visions of the Daughters of Albion*, and *America*.[8] In Blake's designs for *The Grave*, the journey of the soul from life into death and from there to heaven, hell or judgement is evoked through the recurrence of thresholds and the suggestion of movement, as in *Death of the Strong Wicked Man* (no. 119), in which the man's soul departs his body through the window.[9]

Flaxman considered this one of 'the most Striking' of Blake's designs. Henry Fuseli, in an enthused account solicited by Cromek, cast the set as a model by which all artists 'from the Student to the finished Master' would find 'Materials of Art and Hints of Improvement!'[10] Significantly, Blake's designs for *The Grave* attracted endorsements from a far wider pool of people than his immediate associates. In November 1805, the enterprising Cromek took Blake's drawings to the Royal Academy. An illustrious list of subscribers was formed, from Academicians – including President Benjamin West, Professor of Painting John Opie, Sir William Beechey, Thomas Lawrence, Joseph Nollekens and Henry Tresham – to influential patrons Thomas Hope and William Locke. Amongst later subscribers were architect Sir John Soane and the engravers Thomas Bewick and John Landseer. This was the greatest show of support from the art world that Blake was ever to receive in his lifetime.

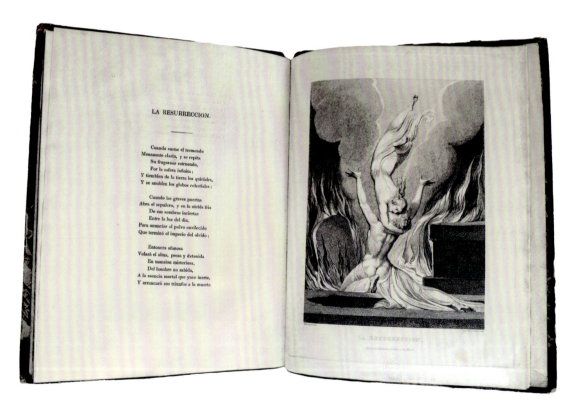

117. José Joaquín de Mora, *Meditaciones poeticas*, 1826
Open to 'La Ressureccion', featuring Luigi Schiavonetti after William Blake,
The Reunion of the Soul & the Body, etching 26.7 × 17.5

Cromek promoted *The Grave* tirelessly, taking Blake's work to new places and new publics. As well as displaying them for the benefit of potential subscribers at his London house, he toured the designs to Birmingham in July 1806 and Manchester in November 1807.[11] Blake's name appeared in advertisements for the book that Cromek placed in newspapers up and down the country, and subscriptions came in accordingly. With 684 copies ordered, *The Grave* was a relative success, reflecting the uptake in the market for luxury publications that was fuelled by Britain's emergent, ambitious and knowledge-hungry middle classes.[12] Blake's *The Grave* designs even reached as far as South America in his own lifetime, thanks to leading publisher Rudolph Ackermann, who, in 1826, published them with a Portuguese text they had inspired, *Meditaciones poéticas* by José Joaquín de Mora, for the developing print market in South America (no.117). It is no surprise, therefore, that *The Grave* became the most well-known of Blake's productions and the work which defined his posthumous reputation.

One of the unused watercolour designs which came to light only in 2001 is inscribed 'Friendship' (no.113).[13] It depicts two men, one of them perhaps intended to signify Jesus, on the pathway to heaven, which is depicted as a radiant mass of spires and a Gothic archway. This is a hopeful image, projecting the eternal benefits of kinship. In *The Grave*, Blair writes:

> Friendship! Mysterious cement of the soul!
> Sweet'ner of life! And solder of society![14]

Although Blake had made reference to 'my Friend Cromek'[15] in a letter, and Cromek had declared his 'private Friendship'[16] with the artist in the prospectus for *The Grave*, this was not a relationship that would prove a 'sweet'ner' to Blake's life. Things soured when, within the same month as announcing Blake as the project's engraver, Cromek issued another prospectus ascribing that role to Luigi (or Louis, as he was referred to in the book's title) Schiavonetti. Blake had engraved one image, *Death's Door* (no.118), but, perhaps alarmed by its overwhelming dark tonality, Cromek turned to Schiavonetti, whose engraved style was, by contrast, more delicate, refined and appealing to fashionable taste.

118. *Death's Door*, 1805
White-line etching with touches of hand tinting, 18.6 × 11.7

119. Luigi Schiavonetti after William Blake,
'Death of the Strong, Wicked Man', plate from
Robert Blair *The Grave*, 1808, 2nd edn 1813
Etching, 23.6 × 33.1

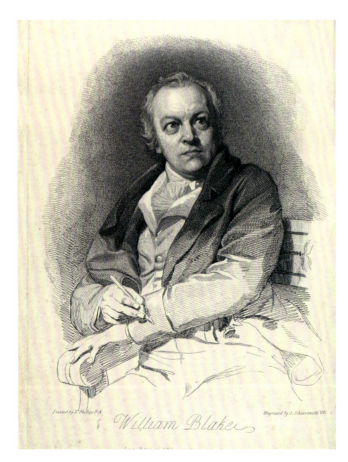

120a. Luigi Schiavonetti after Thomas Phillips, *William Blake*,
frontispiece to Robert Blair *The Grave*, 1808, 2nd edn 1813
Etching, 33.1 × 23.6

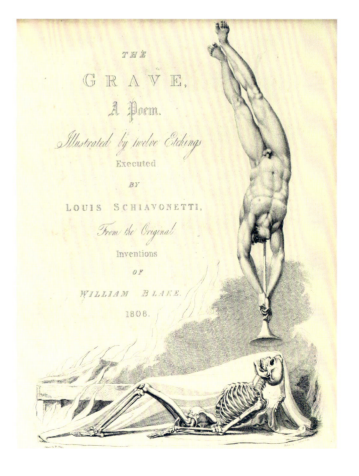

120b. Luigi Schiavonetti after William Blake,
Titlepage to Robert Blair *The Grave*, 1808, 2nd edn 1813
Etching, 34.9 × 25.7

This was a blow to Blake, not least financially. At the outset of the project he had written to William Hayley that *The Grave* 'bids fair to set me above the difficulties I have hitherto encountered' and it was surely galling for him to read in the eventual publication that 'no artist could have executed so ably' his own drawings.[17] He channelled his ire in verse, renaming Schiavonetti 'Assassinetti' (echoing his comment of 1804 that London was a 'City of Assassinations'), and writing of Cromek that he 'loves artists as he loves his Meat / He loves the Art but 'tis the Art to cheat'.[18] Blake continued to invest energy in *The Grave*, perhaps all too aware of the boost to his reputation and the chance for independence that this well-publicised project offered. With help from miniature painter Ozias Humphry he secured permission to dedicate his designs for *The Grave* to Queen Charlotte, a major coup. It was a coup for Cromek, too, although his response to it veered into a cruel diatribe in which he claimed that he had found Blake 'without reputation' and made 'Herculean' efforts to promote him, given that he had 'not only the public to contend with but … to battle with a man who had predetermined not to be served'.[19]

From this point on, Blake determined to serve himself and assert his presence on the London art scene through two major ventures: the production of a painting illustrating the characters from Geoffrey Chaucer's fourteenth-century poem, *Canterbury Tales*, which became the basis for the largest print he would ever make (no. 121), and a solo exhibition staged in 1809. These interlinked endeavours demonstrate Blake's desire to play the game of commerce, to gain greater financial independence and, ultimately, to find a public that understood and could recognise the contribution his art made to society.

Canterbury Pilgrims was conceived as a flagship project through which Blake could independently stake out his intellectual territory and revive his reputation as both painter and engraver. Capitalising on his own knowledge of medieval art and aimed at the growing popular interest in gothic culture, it had lucrative potential. At least it would have had, if, as Blake saw it, Cromek had not stolen his idea. While this accusation is impossible to verify, Cromek commissioned Stothard to paint this subject around the same time that Blake was working on it. The resultant composition was almost identical to Blake's but it was Stothard's picture, engraved by Schiavonetti and promoted by Cromek, that became the runaway success. Though embittered, Blake was undeterred from peddling his version, and although it found few subscribers when first published in 1810 he re-advertised it in 1812, and continued to re-work and take new impressions from the plate until around 1823. In 1881, as interest in Blake's work was reviving, art dealers Colnaghi acquired the *Canterbury Pilgrims* plate and made another impression; a further one was taken in 1941.[20] While it may not have achieved what he had hoped in his own lifetime, posthumously *Canterbury Pilgrims* eventually became one of Blake's most widely circulated and best-known images.

Its importance for Blake is indicated by the various texts he wrote about it.[21] Whereas Cromek and Stothard's error-ridden *Canterbury Pilgrims* was an image 'thrown together in the random manner', in Blake's, every detail, 'every particular of Dress or Costume', was 'minutely labour'd'.[22] This emphasis on specificity echoes his repeated statements on the value of drawing and strength of outline, and the furious comments he was making around this time upon his copy of Sir Joshua Reynolds's *Discourses*, whose promotion of painterly generalisation he despised.[23] Thus the print displayed 'a Precision not to be seen but in the work of an Original Artist' and a 'depth of work peculiar to Mr B's Prints'.[24] Indeed, by comparison to other engravings on the market, *Canterbury Pilgrims* was a peculiarity, its mesh of subtle tonal contrasts and exaggerated outlines lending the scene a two-dimensional quality that is decidedly antiquated. This was the desired effect: Blake proclaimed himself a successor of the Renaissance printmaker Albrecht Dürer and *Canterbury Pilgrims* a riposte to modern engraving,

which could 'never produce Character & Expression'.[25] He used the print as the vehicle for an extended diatribe on the ills of contemporary engraving in his so-called *Public Address* of c.1810 which, despite its title, was never published.[26] In this he railed against the commercial print market, a hive of 'Mediocrity to which I have hitherto been the victim' and contemptuously asserted his originality:

> I know my Execution is not like Any Body Else I do not intend it should be so ‹None but Blockheads Copy one another›.[27]

The painting of *Canterbury Pilgrims* was a centrepiece in Blake's 1809 exhibition, the most significant intervention Blake was to make in the London art world and a pivotal moment in his career. This 'Exhibition of Paintings in Fresco, Poetical and Historical Inventions', which comprised sixteen paintings and an associated catalogue, was an attempt to throw off his reputation as simply 'Mr Blake, the engraver' and to emerge as a serious painter of historical subjects.[28] Held at 28 Broad Street, Golden Square, Soho, in rooms above the haberdashery shop that his brother James had taken over from their father, he pitched this as an exhibition of 'real Art' and 'the greatest of Duties to my Country'.[29] But Blake's duty would go unrecognised and his ambitious undertaking ultimately proved to be in vain.

Blake stated in his catalogue that the regular rejection of his watercolours by the British Institution, which was run by amateurs and patrons predisposed to Old Master-inspired oil paintings, and by the Royal Academy, had driven him to stage his own exhibition, despite the fact that only a year before the Academy had shown two of his watercolours (these, including no.125), were re-exhibited at Broad Street in 1809).[30] In a move surely designed to maximise its impact, Blake held his show concurrently with the Academy's summer exhibition, and, somewhat disproportionately, set the same fee of 1 shilling to see his sixteen paintings as was charged for entrance to the biggest art event of the calendar.[31] His *Descriptive Catalogue* was available for a further two and a half shillings. Channelling Cromek's promotional techniques, he issued flyers amongst his supporters, and circulated a prospectus for *Canterbury Pilgrims*. Although several of the works on display at 28 Broad Street had been borrowed back from their owners for the exhibition, the catalogue made clear that this was a selling exhibition. Blake was clearly determined to find his audience and distribute his art.

Be it in the pursuit of greater publicity, profit, or an act of defiance, it was not unusual for artists to become their own curator and promoter. In 1775, the Irish-born Academician Nathaniel Hone staged what is thought to be the first such venture in St Martin's Lane, close to where Blake was training as James Basire's apprentice. Like Blake, Hone produced a catalogue protesting his treatment by the Royal Academy. Later, in the 1790s, Blake witnessed Fuseli establish his Milton Gallery, an ill-timed attempt to promote literary subjects just as the market for them was collapsing. More recently, from 1804, J.M.W. Turner had begun to mount exhibitions of his work at his Harley Street house. His decision to double his prices to compensate for the risk he was taking paid off: his 1808 show was particularly successful in terms of sales to high-profile buyers.[32] In 1809, Blake's exhibition coincided with Turner's.[33] Despite the contrast between the domestic space at 28 Broad Street in which Blake held his show and Turner's gallery, a space fitted out for purpose complete with a ceiling lantern to light works from above, a key similarity lay in the familial support their ventures received. Just as Turner's father acted as the custodian of his son's gallery, so, too, were James Blake and his wife on hand to welcome visitors into their home and make sales of works and catalogues on Blake's behalf.[34]

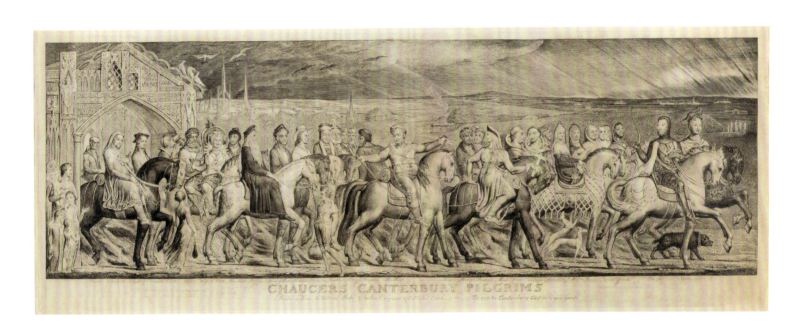

121. *Chaucer's Canterbury Pilgrims*, 1810
Engraving on paper, 45.7 × 135.8

Yet while Turner trammelled the convention of commercial exhibition-making in his catalogue, a basic list of titles, Blake's loquacious text was, like Hone's, highly polemical and crammed with overt criticism of the art market, 'knaves' like Cromek and subservient artists 'more obedient to an employer's opinions'.[35] While he clearly hoped to make money and sales, Blake intended his exhibition as a corrective – to 'give the lie' to claims that his work was the product of 'eccentricity and madness ... unfinished and neglected by the artist's violent temper' and to reform and refine public taste so that they may appreciate 'real Art'.[36] 'The times require that every one should speak out boldly', he wrote. Though his views often ran counter to mainstream patriotism, he appropriated Nelson's famous appeal, to proclaim that 'England expects that every man should do his duty, in Arts, as well as in Arms, or the Senate'.[37]

Blake believed he could best fulfil his duty to the country by painting on a grand scale in a public space. He envisaged this fate for the first two works in his exhibition, *The Spiritual Form of Nelson Guiding Leviathan* and *The Spiritual Form of Pitt Guiding Behemoth* (nos.123 and 124). Claiming to have seen Asia's great monuments in a vision, he conceived of these as 'similar to those Apotheoses of Persian, Hindoo, and Egyptian Antiquity'.[38] Blake was confident that he would receive

> a national commission to execute these two Pictures on a scale that is suitable to the grandeur of the nation, who is the parent of his heroes, in high finished fresco, where the colours would be as pure and as permante [sic] as precious stones though all the figures were one hundred feet in height.[39]

This statement is surprising in two ways. First, it provides a stark counterpoint to the concept of Blake created by his illuminated books, which, though large in ambition, possessed an intimacy of scale and interaction that dominates our understanding of the physicality of his works.

Second, if history painting was a mode of instruction, intended to clearly communicate values the public should aspire to, Blake's eschewal of standard allegorical iconography rendered his works unequivocally ambiguous. Despite their halos, the hero of the Battle of Trafalgar, Admiral Lord Nelson, and ex-Prime Minister William Pitt are presented as anarchic warmongers, bent on destruction and commanding biblical beasts that Blake saw as symbols of Apocalypse-inducing war.[40] Having expressed his disdain for the on-going wars with France elsewhere and been trialled for sedition in Felpham, it was perhaps as well to refrain from making explicitly subversive statements on the moral worth of Britain's heroes. Yet Blake's declaration that these were works in which 'more is meant than meets the eye' hints at the very quality that would have precluded them from being executed on a grand scale in a public space.

Blake's patriotism was coloured by his belief in the moral, social and cultural supremacy of medieval Britain, a time before 'the Sun of Britain s[e]t'.[41] This was the subject of the largest painting Blake would ever make, *The Ancient Britons*. Now lost, it measured an estimated 3 × 4.25 metres and contained 'Figures full as large as Life'; it was a commission from the Welsh antiquarian William Owen Pughe. This was an extraordinary achievement. Commissions for large-format, serious historical subjects were rare enough, even for Academicians, and Blake had no track record of working on this scale, which showed remarkable faith in his ability on Pughe's part. This colossal canvas was already lost by 1865, when one of Blake's contemporaries, Seymour Kirkup, recalled it as a 'master-piece' that had impressed itself upon his mind.[42] Though lost, the work proves the seriousness of Blake's intent, and his success, to project his visions on a far larger scale than can now be appreciated from his surviving works alone.

Together with *Nelson* and *Pitt*, *The Ancient Britons* was an example of what Blake termed 'the lost art of fresco'. The principal similarity between his method

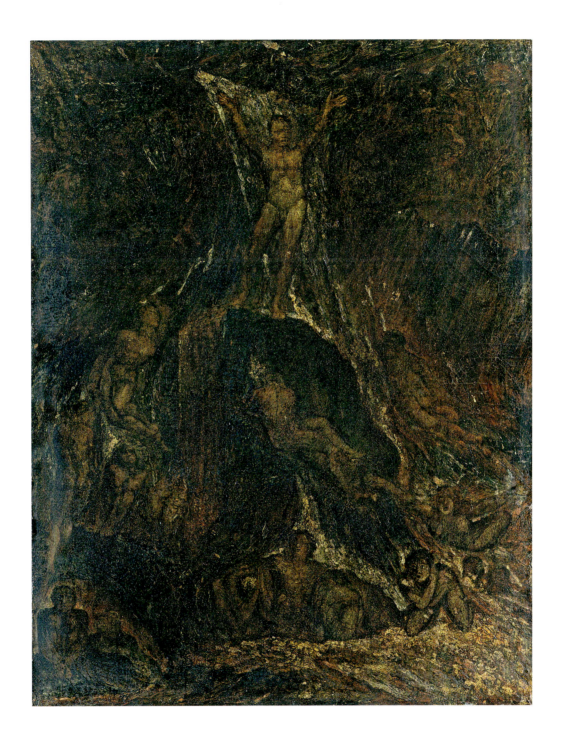

122. *Satan Calling up his Legions*, c.1809
Tempera on canvas, 21.5 × 16.5

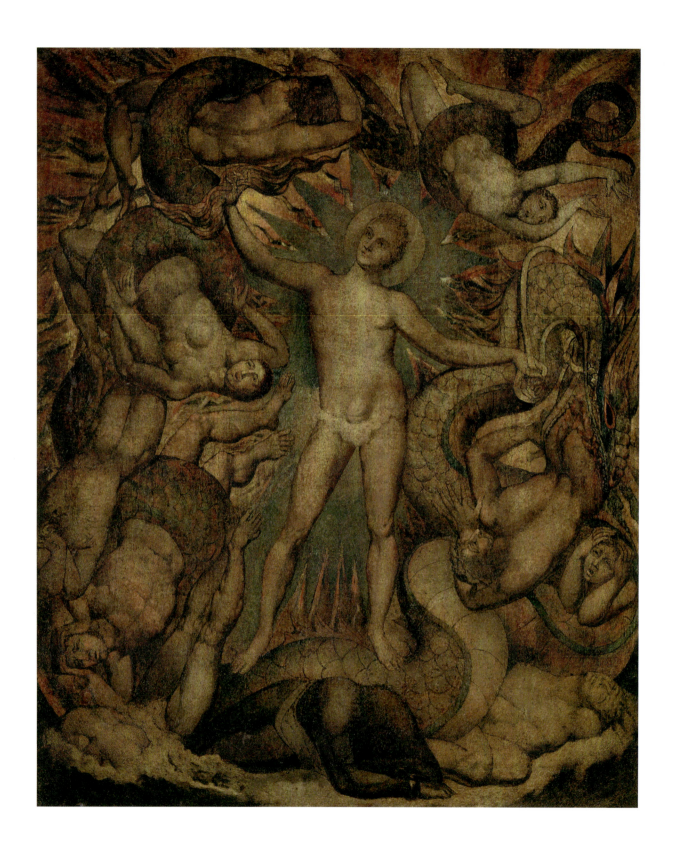

123. *Spiritual Form of Nelson Guiding Leviathan*, c.1805–9
Tempera on canvas, 76.2 × 62.5

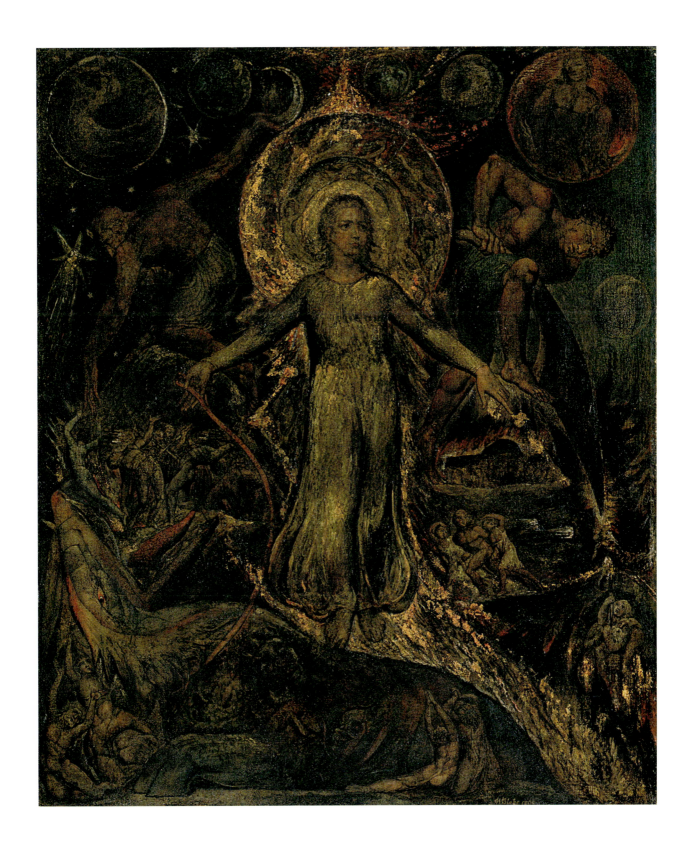

124. *Spiritual Form of Pitt Guiding Behemoth*, 1805
Tempera on canvas, 74 × 62.7

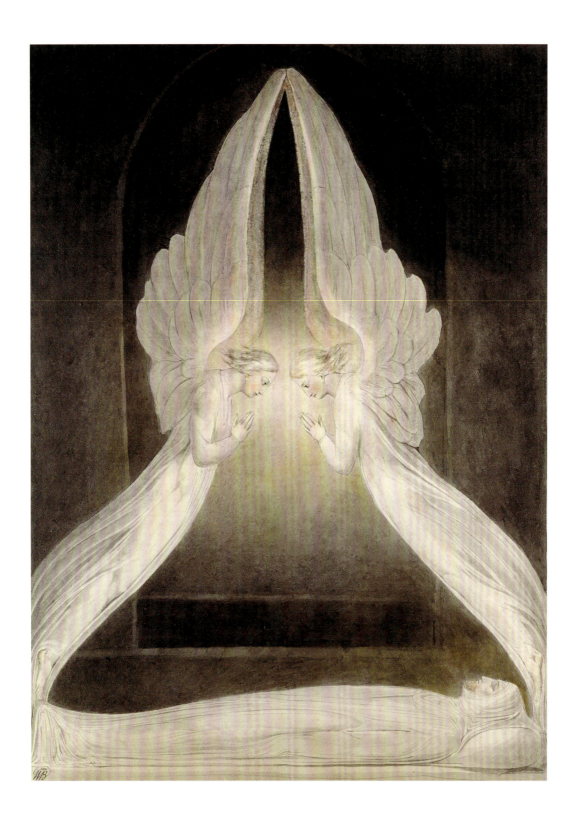

125. *The Angels Hovering over the Body of Christ in the Sepulchre*, c.1805
Ink watercolour on paper, 42.2 × 31.4

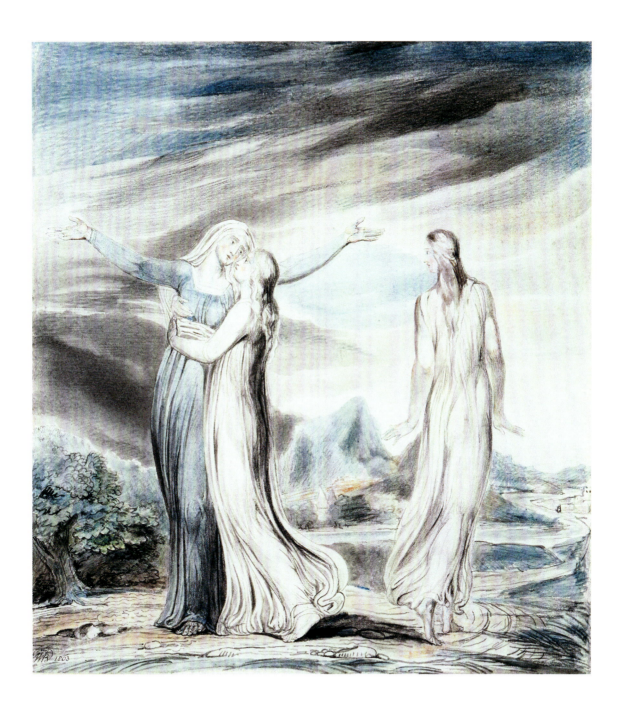

126. *Ruth, the Dutiful Daughter-in-Law Naomi entreating Ruth and Orpah to return to the land of Moab*, 1803
Wash, graphite and chalk on paper, 34.2 × 31.4

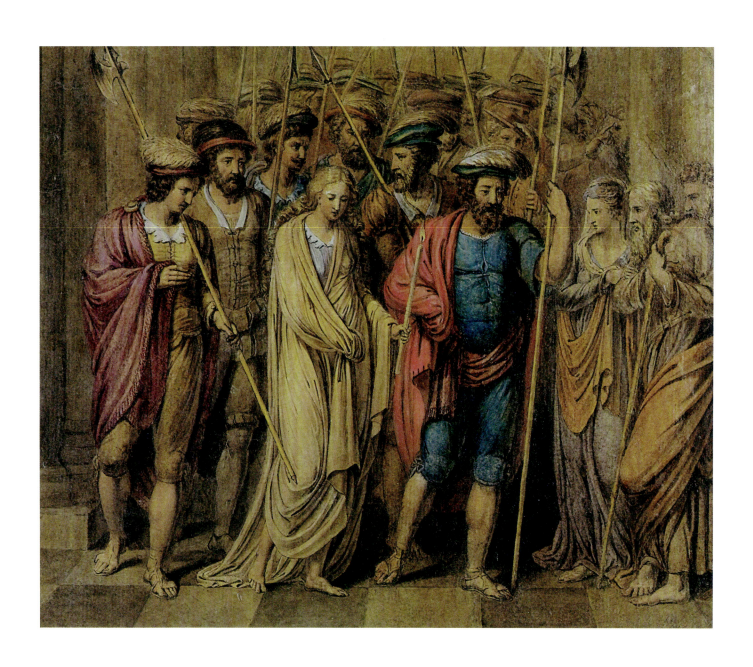

127. *The Penance of Jane Shore in St Paul's Church*, c.1793
Ink, watercolour and bodycolour on paper, 24.5 × 29.5

and the traditional art of mural painting was the election of a non-oily binding medium ('common carpenter's glue', according to John Linnell) to 'temper' his pigments, hence the contemporary description of these works as temperas.[43] The disavowal of oil paint was central to Blake's desired aesthetic, his artistic identity, and his envisaged legacy. In his entry for *Ruth* (no.126), he declared that

> The great and golden rule of art, as well as of life, is this: That the more distinct, sharp, and wiry the bounding line, the more perfect the work of art; and the less keen and sharp, the greater is the evidence of weak imitation, plagiarism, and bungling. Great inventors, in all ages, knew this: Protogenes and Apelles knew each other by this line. Rafael and Michael Angelo, and Albert Durer, are known by this and this alone.

Watercolour allowed for prominence of outline and was an inherently transparent medium by which Blake proclaimed his inheritance of classical and medieval tradition, thus marking himself out as a truth-teller of contemporary history painting. Oil paint, on the other hand, was 'a fetter to genius, and a dungeon to art', without the ability to 'absorb colour enough to stand the test of very little time'.[44] Unfortunately, Blake's temperas have not stood the test of time. Though now much diminished in their effect, *Nelson* and *Pitt* would have been particularly sumptuous. Technical research has revealed Blake's application of gold leaf between paint layers, which would have served to reflect light through the picture's surface and increased the brilliance and intensity of its colour. Blake's use of this expensive material indicates the importance of these works to him and the investment he made in techniques that aligned his practice with medieval painting.[45]

Blake's 1809 show was also distinct for its presentation of works such as *Satan Calling up his Legions* (no.122), which he professed to be failed experiments. These, the reader of his catalogue

is told, 'were the result of temptations and perturbations' that had 'been bruized [sic] and knocked about, without mercy, to try all experiments'.[46] Whatever his original intent, Blake claimed they resulted from 'temptations' to do as many of his contemporaries had done and emulate the methods of continental Old Masters (or 'Venetian and Flemish demons', as he termed Titian and Rubens) in order to appeal to prevailing taste. This, however, had resulted in pictures that were 'blocked up with brown shadows'. Behind a thin veil of open and honest self-criticism there lay a lesson in the perils of 'walking in another man's style', the display of these failed pictures serving to reinforce the integrity and authenticity of his own practice.

Blake's hopes that his 1809 exhibition would gain him recognition as a genius of his time were dashed by its pitiful reception. Despite an extended run of over twelve months, only a handful of visitors are recorded, no sales were made, and its only review was savage. Writing in the left-wing journal, *The Examiner*, Robert Hunt pronounced Blake 'an unfortunate lunatic', decried his 'badly drawn', 'wretched pictures', and called his catalogue a 'farrago of nonsense, unintelligibleness, egregious vanity'. If Blake believed his exhibition was 'the greatest of Duties to my Country', Hunt felt it a 'duty to endeavour to arrest' 'the ebullitions of a distempered brain'.[47] Significantly, Hunt drew attention to Blake's standing as one who had been 'held up to public admiration by many esteemed amateurs and professors as a genius in some respect original and legitimate', but even Blake's friends had been confused by his rambling catalogue: Cumberland thought it 'part vanity part madness – part very good sense'.[48]

A major factor in the exhibition's failure was most likely the location in which it took place. Broad Street was a bit too distant and tucked away from the main luxury shopping and leisure areas, so this was not a neighbourhood likely to attract passing trade for art exhibitions. They were on the Strand,

in Bond Street and Pall Mall. Indeed, the Broad Street of 1809 was not the one Blake had known in 1779, when he had moved back to live with his parents as a twenty-two-year-old. While Kirkman the harpsichord maker remained at numbers 18–19 and a perfumier and dance master lived further down at numbers 15 and 11, the terrace opposite the Blakes was now home to a milkman, a victualler, a plumber, a carpenter and an ironmonger. Some of Broad Street's high-end tradesmen and retailers were no doubt among the many casualties of the financially straitened wartime context, but the rise of industrialisation altered the atmosphere there, too – literally, in the form of the steam engine installed in 1800 by Stretton's brewery. Less genteel, and now more susceptible to crime, the Broad Street at which Blake held his major solo exhibition had become a microcosm of London at large; it would become notorious in 1854 as the place from which the cholera outbreak originated (see also p.30). Lines from *Jerusalem* appear to recognise the decline of the area Blake had been born and worked in, reflecting the sad fate of the exhibition he staged there.

> The corner of Broad St weeps; Poland Street languishes
>
> To Great Queen Street & Lincolns Inn all is distress & woe.[49]

If, on the whole, Blake's *Descriptive Catalogue* read as the manifesto of an embittered eccentric, his impassioned views on watercolour – particularly that the 'distinction that is made in modern times between a Painting and a Drawing proceeds from ignorance of art' and his indignance that his watercolours were regularly refused by institutional exhibitions on account of their medium – resounded with arguments being made elsewhere in the artistic community.[50] Since the 1790s Britain's watercolourists had been campaigning to have their medium recognised as a form of painting capable of the same brilliance, import and academic ambition as oils and to overturn watercolour's

pejorative association with amateur practice and mechanical applications like map-making. Indeed, it was only in 1810 that artists working primarily in watercolour could become full members of the Royal Academy. Blake's refusal to paint in oils therefore excluded him from professional recognition, but, as with engraving, his application of watercolour set him apart from practitioners in this medium, too, especially as it underwent a technical revolution and an up-scaling of ambition in his time. Amongst innovators in the 1790s were Richard Westall, who applied full-bodied, high colouring to his watercolours of historical subjects, and landscapists Turner and Thomas Girtin, who conjured realistic textures and atmospheric effects in a naturalistic palette, relying less on outline than their forebears. Blake's work, on the other hand, for example, *The Angels Hovering over the Body of Jesus in the Sepulchre* (no.125), with its insistent outlines and monochromatic scheme, would have appeared deliberately regressive when exhibited at the Royal Academy in 1808, despite its high-minded subject matter.[51]

And yet, in 1812, we find Blake exhibiting work, for what would be the last time in his life, at the Associated Artists in Water Colours exhibition held at 16 Old Bond Street. It was here, at this showcase of contemporary watercolour practice in the commercial heart of London, that he debuted 'Detached Specimens' from *Jerusalem* and re-exhibited *Pitt*, *Nelson* and *Canterbury Pilgrims*.[52] This latter hung next to a work by a Miss Bourlier, who – like the exhibition's second most prolific exhibitor, enamellist and painter of Portuguese scenes, J. Léveque – lived in Soho, close to Broad Street.[53] While it is not known how Blake came to join the Associated Artists, his involvement links him, perhaps surprisingly, to a network of commercially minded practitioners whose work did not necessarily subscribe to the same ideological ambition as his own. Formed in the same spirit of defiance against the Royal Academy that had driven Blake to stage his own exhibition in 1809, it was one of two societies founded to create better conditions

for the display, sale and promotion of watercolours.[54] Its stipulation that each member must subject 'works of Imagination' suggests that Blake had found a somewhat sympathetic milieu in which to show his 'Historical Inventions', although the dominance of landscape in the watercolour market is reflected in the list of exhibits, bolstered by twenty watercolours by the up-and-coming David Cox, who would later be recognised as a pioneer in the field.[55] The Associated Artists was also distinguished for its inclusivity. It allowed women to become full members, invited non-members to exhibit, and accepted the broadest gamut of watercolour practice from portraiture and miniature painting to flower painting and architectural subjects. There may have been a note of desperation in this inclusiveness, which reflected the society's struggles to assert itself in a crowded exhibitions culture. This extended in 1812 even to admitting oil painting for display. Still, Blake's temperas stood out from the crowd. A reviewer for the *Lady's Monthly Museum* found the 'Fuselian' *Nelson* and *Pitt* 'too sublime for our comprehension' and *Canterbury Pilgrims* 'a picture of mongrel excellence' with 'a repulsive appearance', which, despite being a 'work of genius' presented a backwards step, imitating 'the arts in their degraded state'.[56]

Along with *Canterbury Pilgrims*, and Blake's 1809 solo show, the 1812 Associated Artists exhibition was another attempt at self-promotion that went sour. When the society fell behind on rent for the exhibition space, the landlord seized some of the works on display and the society folded. Yet while Blake's involvement in this endeavour was clearly a last attempt to find a broader public, he is the only exhibitor whose address is not given in the catalogue. How, then, would potential buyers seek him out? In 1800 he had shown at the Royal Academy as an Honorary exhibitor, suggesting commercial disinterest. Now he exhibited with a more overtly commercial organisation but made himself unavailable. This points to the unresolvable tension that undercut all Blake's attempts to promote his work, a tension which drove him towards the market but also pulled him back from realising its potential, which made him dependent on his friends but which could also alienate him from them.

After 1812 he made no more attempts to publicise his work through exhibition. The period from 1808 to 1812 represented a distinct episode in Blake's life, the moment of his greatest public recognition followed by elevated ambitions, and crushing defeat. In a moment of despondency, Blake wrote of himself around this time: 'I am hid.'[57] Anecdotes such as those of Cumberland and his son – who found Blake 'still poor still Dirty' in 1814, and he and his wife Catherine 'durtyer than ever' a year later – fuel the impression we have of Blake becoming a struggling recluse.[58] But the dirt may well have been ink, for although no lucrative commissions came his way, the Blakes were kept afloat in the years after 1812 by the continued patronage of Butts, and a trickle of engraving commissions. Furthermore, while his efforts to gain visibility as a painter had been thwarted, he remained a figure of great interest. He was the subject of an essay by Henry Crabb Robinson, published in Germany, and his own publications inspired lively discussion amongst the literati: Wordsworth took interest in *Songs of Innocence* and his illustrations to *Night Thoughts*; Robert Southey met Blake in 1811 and was shown *Jerusalem*, which he deemed 'a perfectly mad poem';[59] and Coleridge would proclaim Blake an 'apo- or rather – ana-calyptic Poet, and Painter!'[60] Even had Blake known the full extent of his reputation, he would still not have been satisfied: for these anecdotes point towards Blake as an eccentric wordsmith, a visionary poet, but not as a painter to rival Michelangelo. Blake the artist, as seen in Phillips's portrait poised to make his mark, remained, therefore, hid. AC

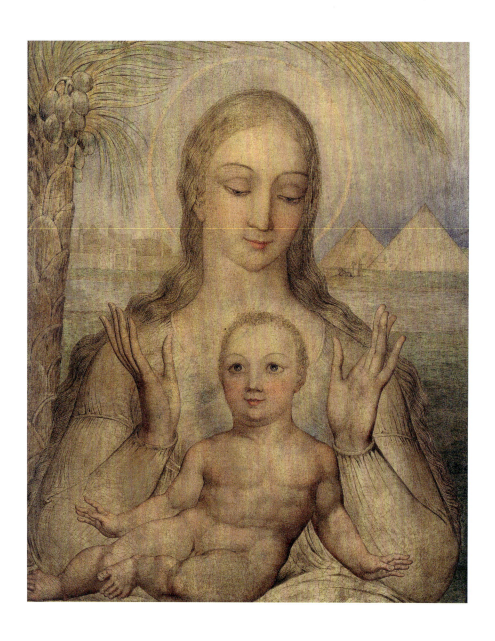

128. *Virgin and Child in Egypt*, 1810
Tempera on canvas, 76.5 × 63.5

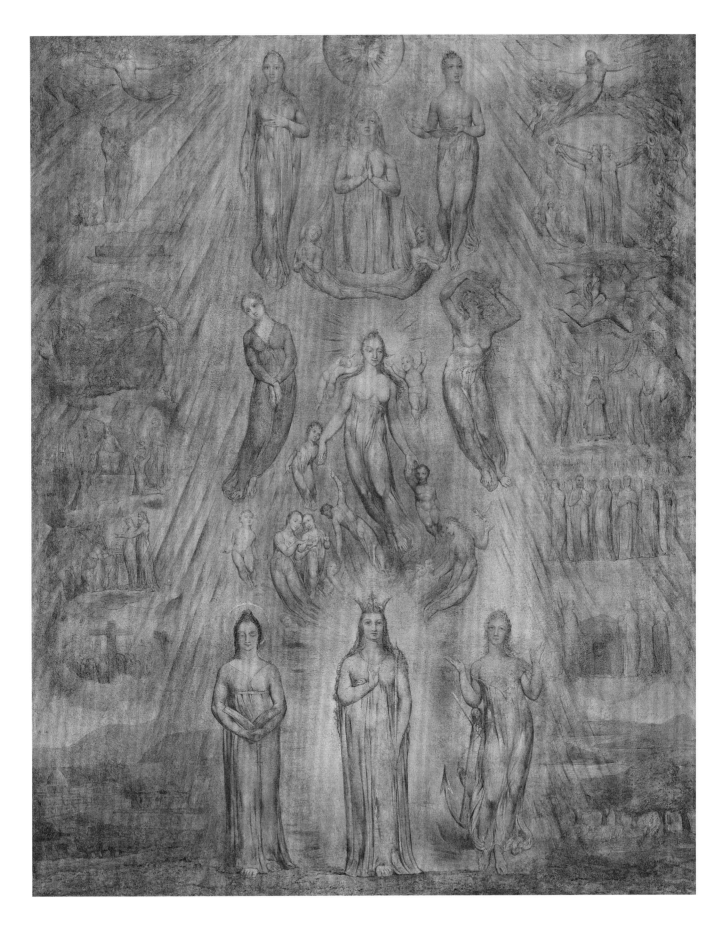

129. *Allegory of the Spiritual Condition of Man*, c.1811
Tempera on canvas, 151.8 × 120.9

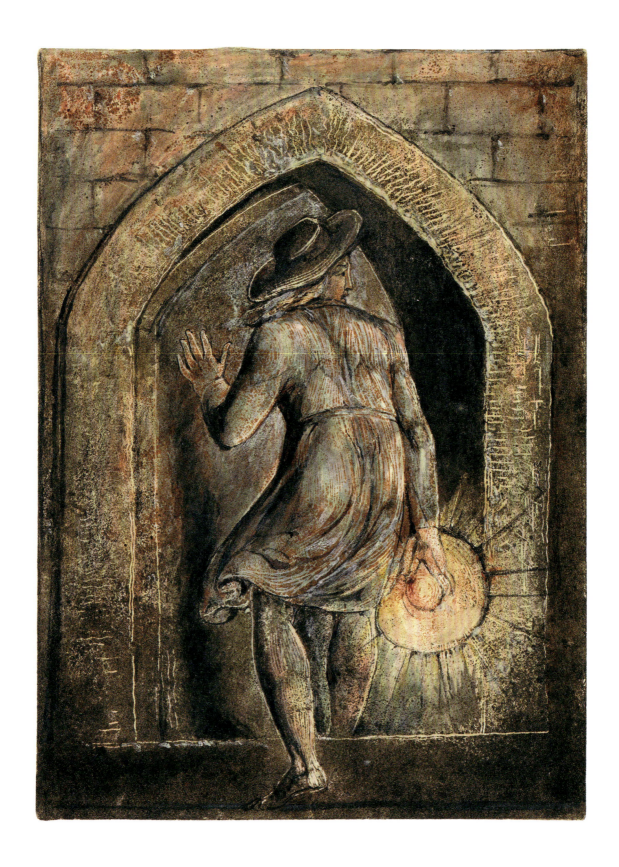

130. Jerusalem, *The Emanation of the Giant Albion, Plate 1 (frontispiece)*, c.1820
Relief and white-line etching with hand colouring on paper, 37.3 × 26.9

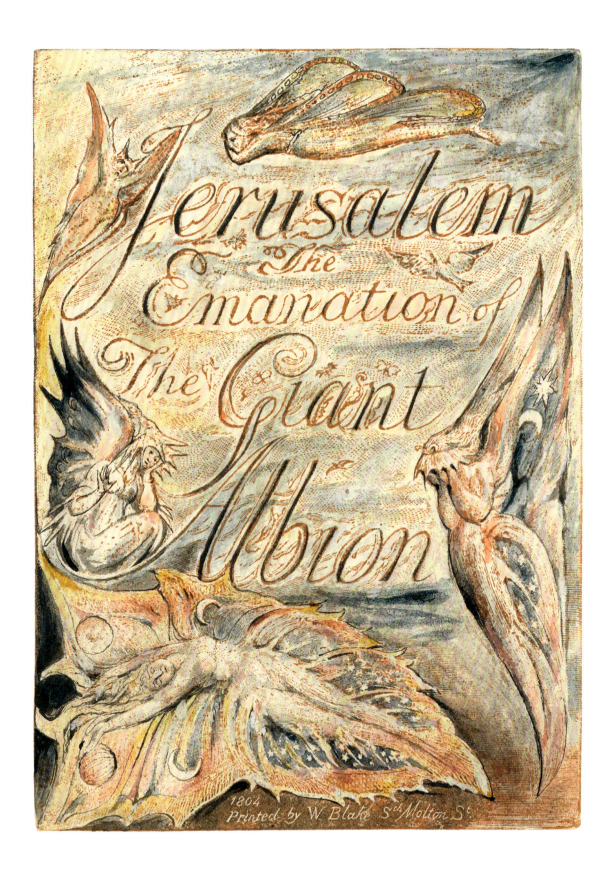

131. Jerusalem, *The Emanation of the Giant Albion, Plate 2 (title-page)*, c.1820
Relief and white-line etching with hand colouring on paper, 37.3 × 26.9

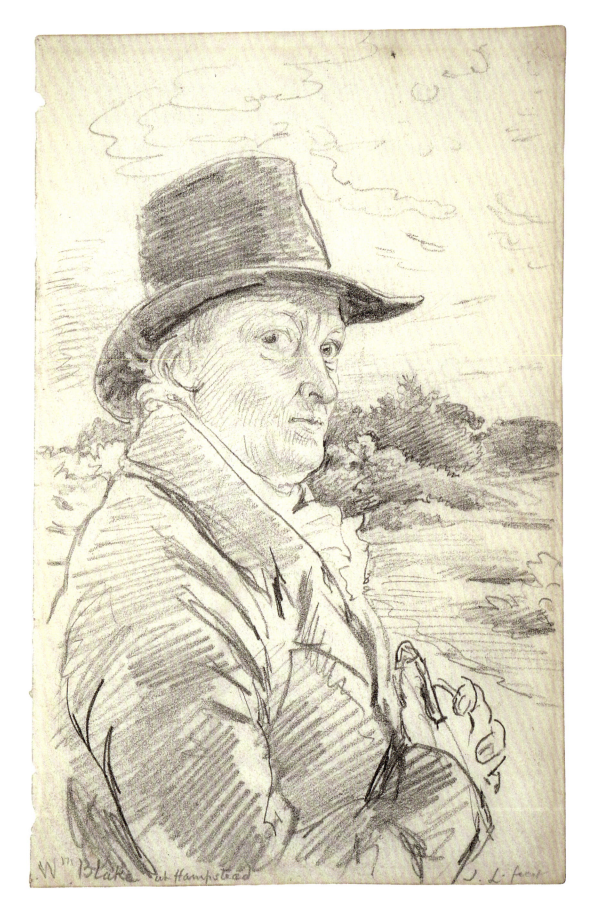

132. John Linnell, *William Blake, wearing hat, three-quarter view, half-length with hands*, c.1825
Graphite on paper, 17.9 × 11.5

'A NEW KIND OF MAN'

In his 1993 study on Blake, E.P. Thompson wrote of how the deep history of research and interpretation of Blake's life, work and relationships had revealed 'a great many William Blakes'.[1] Among these there may be, as another Blake scholar, Morris Eaves, noted in an article of around the same time, 'Blakes we want and Blakes we don't'.[2] This is not just a question of interpretation. As a writer, a painter and a printmaker, his work was inherently diverse. The present account has exposed a multiplicity of Blakes, even when considering him primarily as a maker of images: the aspiring history painter, the jobbing engraver, the cultivator of intellectually stimulating and intense relationships with patrons, and sometimes, perhaps most unexpectedly, the doggedly independent, ambitious self-promoter. As with so many other artists, the challenges of living by his profession forced Blake to wear different caps. In the 1820s, however, still another Blake emerged. This was born of new relationships and new projects that would come to define his legacy.

Key to this period was his relationship with the landscape painter John Linnell, who became a trusted friend, mentor in engraving, patron and informal agent. Through Linnell, Blake was introduced to a group of young artists who took to calling themselves 'The Ancients'. Venerating and amplifying his apparent other-worldliness, their memories of the artist in his old age have crystallised into the dominant idea of Blake: the artist as the quintessential Romantic visionary, living humbly in exile from the world, financially impoverished but intellectually and spiritually rich, and accepting of his lot as a misunderstood genius. To them he was '*a new kind of man, wholly original*'.[3]

The landscape artist Samuel Palmer, who has become the most well-known of the Ancients, left a particularly fulsome testimony of his interactions with and impressions of the older artist. Just nineteen when he first met Blake, he found the sixty-seven-year-old, 'not inactive' but 'hard-working on a bed covered with books sat he up [sic] like one of the Antique patriarchs, or a dying Michael Angelo'.[4] Evangelical in his reverence for Blake, Palmer wrote of a visit the pair made to the Royal Academy summer exhibition, describing

> Blake in his plain black suit and *rather* broad-brimmed but not Quakerish hat, standing so quietly among all the dressed-up, rustling, swelling people, and myself thinking 'How little you know *who* is among you'.[5]

Blake wears this hat in a portrait Linnell made of him around the same time, during one of their regular walks on Hampstead Heath, north of London (no.132). If Thomas Phillips's exhibited oil portrait (no.110) befitted Blake's ambition to build his public reputation in the years after the Sussex sojourn, the informality and intimacy of Linnell's pencil portrait – a private and seemingly spontaneous record of their friendship – entirely befits the last chapter in Blake's life, which was enriched by a new circle of friends who accepted, cherished and supported him, socially and financially. If Blake had felt 'hid' before, he was

now the recipient of new attention that would propel his fame in new ways, in life to a degree, and after his death, more certainly.

Blake's friendship with Linnell provided the foundation for the sociability and stability Blake enjoyed in his last decade. The son of a Bloomsbury-based woodcarver, frame maker and picture dealer, Linnell shared many of Blake's convictions: he, too, held unconventional spiritual beliefs and was fascinated by early Renaissance art. By the time he met Blake at the age of twenty-six, Linnell had established a strong position for himself in the art market: a regular exhibitor and shrewd networker, he had made good money from landscape and genre paintings that appealed to popular taste, supplementing his income by undertaking portraiture and providing tuition. It was through one of his pupils, George Cumberland Jr (the son of Blake's friend from the Royal Academy days), that Linnell first met Blake in June 1818. Britain was then in the grip of a post-Waterloo economic slump, and, accordingly, Linnell remembered it as a time when 'everything in Art was at a low ebb'. Seeking to help Blake, who had 'scarcely enough employment to live by', Linnell invited him to collaborate on a portrait engraving.[6] From then until his death, Blake was almost entirely dependent on monies obtained directly from or facilitated by Linnell.

Linnell's journal and correspondence provide insights into their shared social life over these years: the growing closeness of their families, visits to the theatre, trips to exhibitions and dinner with collectors like the German merchant Charles Aders, whose collection of Northern Renaissance paintings included a copy of Van Eyck's Ghent Altarpiece. Blake's circle of artistic acquaintances opened up, too. Through Linnell, Blake met landscapists John Constable, of whose sketch of trees on Hampstead Heath he declared, 'why, this is not drawing, but *inspiration*!', and John Varley, who, having been resident at 15 Broad Street in 1809, may well have seen Blake's exhibition that year.[7]

133. *Old Parr when Young*, 1820
Graphite on paper, 28.4 × 16.5

134. *Drawing for a Ghost of a Flea from the smaller Blake/Varley sketchbook*, c.1819
Graphite on paper, 20 × 15.3

162

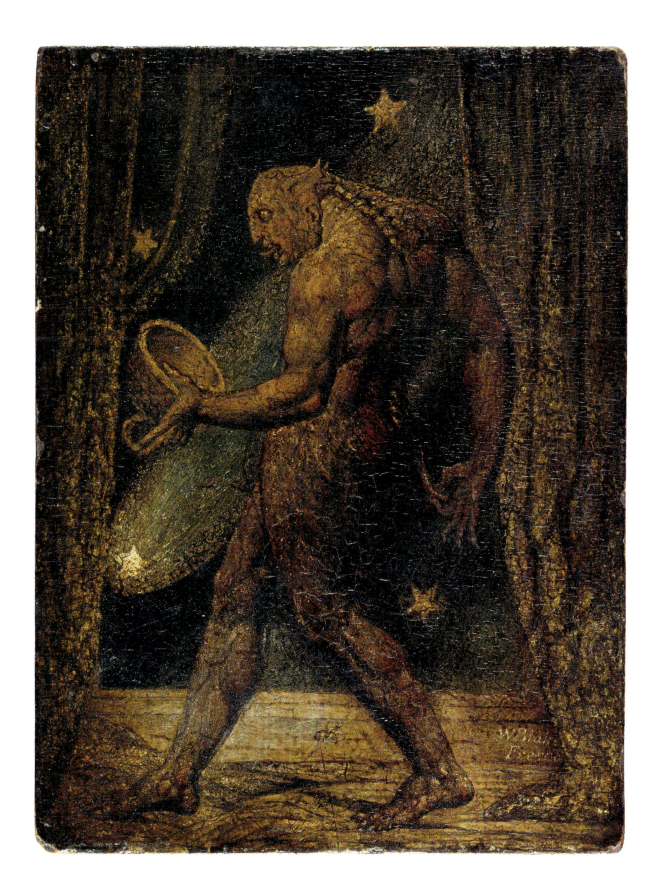

135. *The Ghost of a Flea*, c.1819–20
Tempera and gold on mahogany, 21.4 × 16.2

Soon after being introduced, Blake and Varley, who was also an astrologer, struck up a creative relationship of their own, centred around the production of the so-called 'Visionary Heads'. This was a series of over 100 portraits of characters Blake claimed he had seen and even interacted with in his visions. Over a period of six years from October 1819, Blake filled reams of sheets with figures imagined, historical, literary and legendary, from Merlin, Wat Tyler, Voltaire, Muhammad, William Wallace and Edward I to devils and other beasts. One of the series' few full-length sketches depicts Thomas Parr, who had supposedly died aged 152 in 1635, as a heroic youth (no.133). Varley was sometimes present as Blake communed with the spirits, telling of how he 'sat beside him from ten at night till three in the morning sometimes slumbering and sometimes waking, but Blake never slept'.[8] In an account published in 1830, Varley recalled Blake's excitement as he saw one particular spirit appear:

> here he is – reach me my things – I shall keep my eye on him. There he comes! his eager tongue whisking out of his mouth, a cup in his hand to hold blood, and covered with a scaly skin of gold and green.[9]

This was the character in one of Blake's most bizarre and now famous images, *The Ghost of A Flea* (nos.134 and 135). Varley watched Blake make the full-length sketch of the flea and came to own the gold-embellished tempera, in which the anthropomorphic creature is seen on a stage, flanked by curtains and before a shooting star.

According to Linnell, Varley 'believed in the reality of Blake's visions more than even Blake himself'.[10] The comment invites us to read between the lines, and we may suspect that Blake was thus enticed to perform with verve his role as the visionary artist. Linnell engraved several of the Visionary Heads, including the flea, for Varley's *Treatise on Zodiacal Physiognomy*, published in 1828, the year after Blake died. Already by 1820, however, Blake's nocturnal visions were debated as either proof of his madness or a charming quirk.[11]

136. From *Illustrations to Thornton's Pastorals of Virgil*, c.1821 printed 1830, Wood engraving on paper, 6.2 × 8.4

It was through another introduction contrived by Linnell that Blake produced similarly enduring and influential work. Linnell introduced Blake to his family physician, Dr Robert John Thornton, who commissioned a set of seventeen illustrations intended as interpretative aids for young readers of Thornton's Latin textbook, *The Pastorals of Virgil, with a Course of English Reading, Adapted for Schools* (1821). Blake's illustrations accompanied a poem by Ambrose Philips, written to emulate Virgil, telling the story of two shepherds: old, wise Thenot, who counsels young, melancholic Colinet to appreciate his lot in life. Drawing on his experience of the scenery around Felpham, the pastoral landscape Blake creates for the shepherds is a recognisably British one, featuring gently rolling hills, ancient oak trees, a signpost for London and a soaring cathedral spire.[12] Despite their minute size, Blake's designs for Thornton's *Virgil* were hugely impactful. In a reflection of their subject, of youth learning from age, they became a focus for the zeal of the fraternity of the Ancients, who adopted Blake – some forty years their senior – as their father figure. Palmer saw in the *Virgil* woodcuts

> a mystic and dreamy glimmer as penetrates and kindles the inmost soul, and gives complete and unreserved delight, unlike the gaudy daylight of this world. They are like all that wonderful artist's works the drawing aside of the fleshy curtain, and the glimpse which all the most holy, studious saints and sages have enjoyed.[13]

To face page 15.

ILLUSTRATIONS OF IMITATION OF ECLOGUE I.

THENOT.

THENOT.

COLINET.

COLINET.

no more, beneath thy
with jocund tale, or pi
Ill-fated tree! and mo
from thee, from me, a

Sure thou in hapless he
when blightning mildev
or blasting winds o'er
to kill the promis'd frui
or when the moon, by
blood-stain'd in foul ec
Untimely born, ill luck

And can there, THENO

Nor fox, nor wolf, nor
from these good sheph
against ill luck, alas!
nor toil by day, nor w

Ah me, the while! ah
Ah luckless lad! befit
Unhappy hour! when
I left, Sabrina fair, thy
Ah silly I! more silly
which on thy flow'ry b
Sweet are thy banks;
with ravish'd eyes revi
When, in the crystal o
each feature faded, an
When shall I see my
myself did raise and co
Small though it be, a
yet is there room for p

And what énticement
from thy lov'd home, a

A fond desire strange
Ah me! that ever I sh
With wand'ring feet un
I sought I know not w

137. Robert John Thornton, *The pastorals of Virgil, with a course of English reading adapted for schools*, 3rd edn 1821
Open at vol.1, pp.14–15, showing four wood engravings by William Blake (each c.7.6 × 3.2)

To these young idealists, Blake represented pure inspiration led by the spirit and unsullied by commerce, his marginal position in the art world not a sign of failure but of genius misunderstood and an indictment of the modern, urbanised and industrial world.

The humble lodgings in which the Ancients encountered Blake only reinforced their perceptions of him as a heroic artist, one who put the pursuit of his vision above material comforts. In 1821 Blake downgraded his accommodation, moving from South Molton Street to what would be his final home, two small rooms at 3 Fountain Court, a dark and narrow passage just off the Strand. This placed the mature artist close to geographical markers of his youth: Henry Pars' drawing school and the Royal Academy were a few moments' walk away, and he was separated from Lambeth by the Thames, which appeared like a 'bar of gold' from his window.[14] Fronted by an agglomerate of smoke-belching industrial premises, Lambeth appeared to be fulfilling the pessimistic prophecy set out by Blake if his words about 'dark Satanic Mills' are interpreted literally. Aside from the front room, hung with Blake's unsold temperas and watercolours, the Blakes had a back room that served as

> sleeping and living room, kitchen and studio. In one corner was the bed; in another, the fire at which Mrs. Blake cooked. On one side stood the table for serving meals, and, by the window, the table at which Blake always sat (facing the light), designing or engraving.[15]

Blake had certainly fallen on harder times. He was forced to sell his print collection, and in 1822 he received, at Linnell's arrangement, a donation of £25 from the Royal Academy Council, who referred to him as 'an able Designer & Engraver labouring under great distress'.[16]

To Henry Crabb Robinson, the Blakes' rooms in Fountain Court were 'squalid and indicating poverty'.[17] Blake himself acknowledged, 'I live

in a hole here', but anticipated that 'God has a beautiful mansion for me elsewhere'.[18] But if Blake's financial struggles were clearly a reality for him and Catherine, they may need to be put into perspective. The way Robinson and some other visitors to Blake late in life recoiled from his appearance and environment may reflect a certain middle-class squeamishness. Indeed, Palmer insisted that Blake, Catherine and their home were 'clean and orderly'.[19] And Blake's receipt of charity from the Academy was the only occasion on which he is known to have received institutional support (even if there were, at other times, personal gifts, such as the £100 in cash from Thomas Lawrence, which 'relieved his distresses, and made him and his wife's heart leap for joy').[20] Many other artists turned to charity, often more extensively, and this included the former Professor of Painting at the Academy, James Barry, who received monies from the Royal Literary Fund, and Blake's nemesis, the critic and miniature painter Robert Hunt, who applied to the Artists' General Benevolent Institution.[21] In 1821, the diarist Joseph Farington reported of the Academy's charitable activities that '[t]he number of applications was now so great that it had become necessary to check the expenditure in this respect'.[22]

In his last decade Blake became, with his potent combination of poverty, marginality and inspired genius, an object of fascination in some new literary and artistic circles. In 1818 he had attended a dinner party given by Lady Caroline Lamb, Byron's sometime mistress – not a setting in which we might expect to find the self-professed hidden, non-conforming artist. Here he sat by diarist Lady Charlotte Bury, who 'could not help contrasting this humble artist with the great and powerful Thomas Lawrence', determining that Blake 'was fully if not more worthy of the distinction and the fame ... from which *he* is far removed'.[23] Yet whereas his friends of the 1820s – middle-class intellectuals – saw this as a by-product of desirable characteristics, Lady Bury saw room for improvement in Blake's social conduct and, therefore, his standing and his wealth, diagnosing his situation thus:

though he may have as much right, from talent and merit, to the advantages of which Sir Thomas is possessed, [Blake] evidently lacks that worldly wisdom and that grace of manner which make a man gain an eminence in his profession, and succeed in society.[24]

These incisive comments echo the ambivalence about Blake's expressed lack of money by his old friends William Hayley and John Flaxman. According to Flaxman, Blake stood to 'do well' if only he paid more 'attention to his worldly concerns', like 'every one does that prefers living to Starving'.[25] The inference here is that Blake's poverty was somewhat self-determined, deriving from rejection of the demands of a commercial career. His was an ambiguous identity, in which the boundaries between amateur and professional, impoverished artisan and gentleman artist, were blurred in the passionate pursuit of his vocation. Indeed, Blake appeared to Lady Bury as one who could afford to exercise the choice to be an 'eccentric little artist … not a regular professional painter, but one of those persons who follow the art for its own sweet sake, and derive their happiness from its pursuit'.[26]

It was Linnell's comparative social grace and entrepreneurial ease that allowed Blake to stand aloof from 'worldly concerns'. By facilitating sales and providing Blake with projects sympathetic to his interests, Linnell largely freed him from the onerous pursuit of commercial work. After a ten-year hiatus Blake began to reprint his illuminated books, now recasting them as a central aspect of his practice, if only as a kind of 'loss leader':

> [t]he few [books] I have Printed & Sold are sufficient to have gained me great reputation as an Artist which was the chief thing Intended.[27]

Precipitated by the upsurge in antiquarian and literary culture, the market for fine publications – valued as aspirational displays of affluence and gentlemanly status – was growing. Blake's increased prices placed them firmly at the luxury end.

In response to an unsolicited enquiry from Yarmouth banker and antiquarian Dawson Turner, Blake referred to his books as 'unprofitable enough to me tho [sic] Expensive to the Buyer'.[28] In 1827 George Cumberland wrote that his friends in Bristol were 'very anxious to have [Blake's] works', but feared his 'prices above their reach'.[29] Blake had written to Cumberland correlating his prices with his lamentable surroundings at Fountain Court: if once he had 'had a whole house to range in', he was now 'shut up in a Corner'. This inconvenience forced him 'to ask a Price for them that I scarce expect to get from a Stranger'.[30] Blake's higher prices might also be explained by his evolved approach to the production of illuminated books: although the text was never altered, a greater emphasis was placed on the images and the rich colouring, even gilding, of the sheets.[31] This new-found visual sumptuousness was also a practical means to engage buyers who would not necessarily connect with the by-now outmoded political ideologies enshrined in their text.[32]

That Blake's new customers engaged with his books differently, acquiring them as curiosities and focal points for salon-style parties, is evident in an 1824 account of Isaac D'Israeli, who

> loves his classical friends to disport with [Blake's works], beneath the lighted Argand lamp of his drawing room, while soft music is heard upon the several corridores [sic] … Meanwhile the visitor turns over the contents of the Blakëan portefeuille. Angels, Devils, Giants, Dwarfs, Saints, Sinners, Senators, and Chimney Sweeps, cut equally conspicuous figures.[33]

It was as a fantastical antiquarian discovery that Blake's most ambitious and lengthy illuminated book, *Jerusalem*, had been puffed in 1820 by Thomas Griffiths Wainewright, another of Linnell's associates.[34] Begun in 1804, at its completion the text of *Jerusalem* had been brought up to date with allusions to the executions of Mexican insurgent leaders by Spanish colonial authorities and the end

ספר איוב

ILLUSTRATIONS of

The BOOK of JOB

Invented & Engraved
by William Blake
1825

London Published as the Act directs March 8:1825. by William Blake N°3 Fountain Court Strand

of the Napoleonic wars.[35] Wainewright, who determined to own all of Blake's works, came to own a copy of *Jerusalem* (see nos.130–1), comprising the first twenty-five plates but fully coloured by the artist.[36] Blake produced only one complete, coloured copy of all 100 plates, which, on account of its price, he doubted would sell and indeed remained unsold at his death.[37]

Deemed as 'epic in its range of graphic techniques as it is in its poetry', *Jerusalem* may have benefited from Linnell's encouragement.[38] But if the younger artist had a part in spurring the production of this final and most epic book, he was decisive in Blake's return to ostensibly more conventional engraving projects at the very end of his life. He commissioned and carefully managed the production of the series *Illustrations to the Book of Job*, which was published in 1826. Marrying modern effects Blake had once scorned, such as dramatic chiaroscuro, with Dürer-like crisp lines derived from exclusive use of the burin (the tool for incising lines on the plate), *Job* represents a complete technical evolution.[39] This was lost on Blake's detractors, though, one of whom complained that *Job* was 'very apt to be repulsive to print-collectors', and indeed the work sold slowly.[40] According to early biographer Alexander Gilchrist, however, *Job* proved Blake was no longer a 'mere engraver' but now 'an artist, making every line tell'.[41] Linnell recalled Blake's virtuosity in the production of the plates' distinctive borders, which were, apparently, 'an afterthought, and designed as well as engraved upon the copper without a previous drawing'.[42] The Old Testament story of Job, who prevailed through a series of painful trials and tests of his faith, was a familiar subject for Blake: he had made drawings and watercolours on the theme back in the 1780s, and in 1805–6 had produced nineteen illustrative watercolours for Thomas Butts. With his permission, these became the basis for the new *Job* engraving project. A collaborative effort by Linnell and Blake to trace outlines from Butts's watercolours got it off to an efficient start in September 1821, but it was not until March 1823 that Blake signed Linnell's Memorandum of Agreement for the engraving of this

new set of Job images; this, too, was a collaborative process, with Catherine helping to print proofs.[43]

Blake extended his revisiting of Job in the production of two tempera paintings (nos.139 and 140). Whilst their subject matter looks back to compositions from the series he had made for Butts twenty years earlier, Blake's use of a wooden support was a new departure. This new feature, along with his tendency to make heavier use of gold in illuminated books and works like *Epitome of James Hervey's 'Meditations among the Tombs'* (no.141), was perhaps inspired by visits he made with Linnell to Old Master collections in London, notably his encounters from 1825 with the Northern Renaissance works owned by Linnell's friends, the Aders.[44] As Angus Whitehead has noted, the presence of a gilder, John George Lohr, as a neighbour in Fountain Court, was a convenient circumstance that may also have influenced Blake's use of gold.[45]

Linnell was also the force behind Blake's final, extensive watercolour series, illustrating medieval Italian poet Dante's *Divine Comedy* (nos.142–158). This was the project that Palmer famously found Blake at work upon in 1824:

> Lame in bed, of a scaled foot (or leg) … Thus and there was he making in the leaves of a great book (folio) the sublimest design from his (not superior) Dante.[46]

Linnell had provided this 'great book' – a large, bound album – with a view to publishing Blake's designs, although the suite of 102 drawings was left unfinished and Blake engraved only seven of them before his death.[47] This was a gargantuan task and an opportunity ripe for Blake to unleash the power of his imagination. He threw himself into it wholeheartedly – and apparently learned Italian especially, though is known to have used the Reverend Henry Cary's translation of Dante's text (published in 1814), and owned an earlier translation of *Inferno*, by Henry Boyd.[48] Interest in Dante's text had been steadily growing since the beginning of

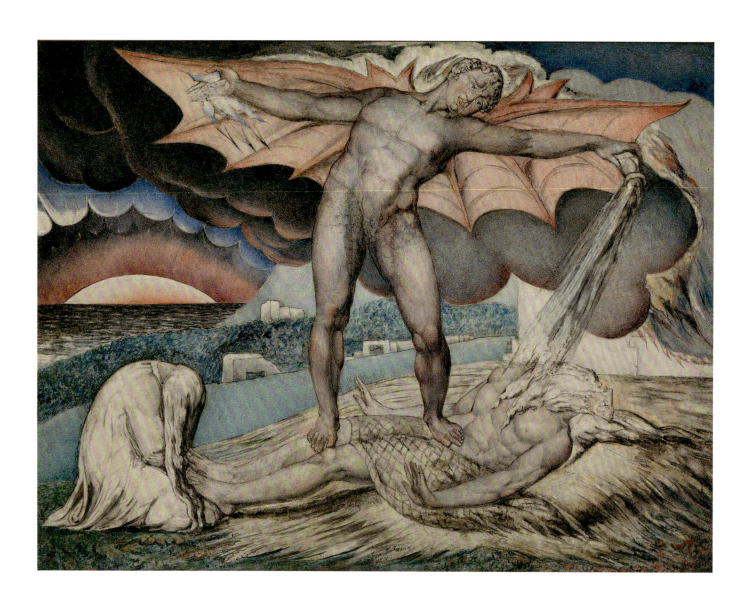

139. *Satan Smiting Job with Sore Boils*, c.1826
Ink and tempera on mahogany, 32.6 × 43.2

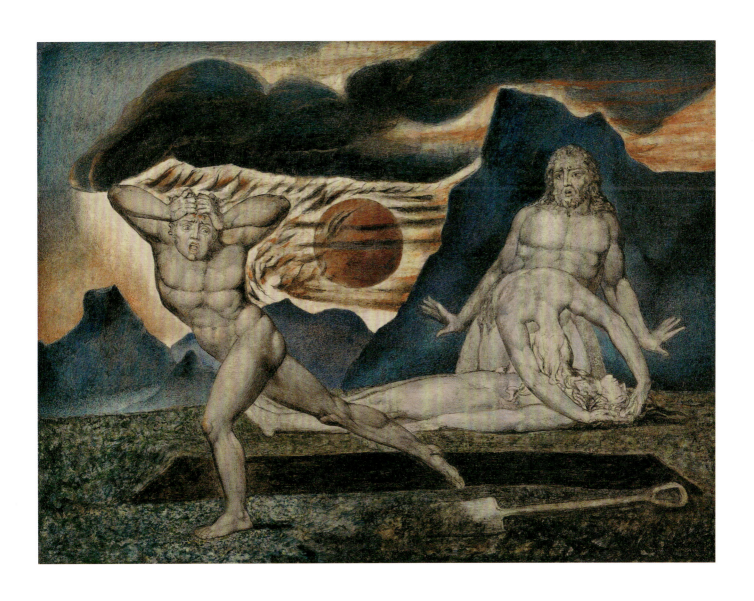

140. *The Body of Abel found by Adam and Eve*, c.1826
Ink, tempera and gold on mahogany, 32.5 × 43.3

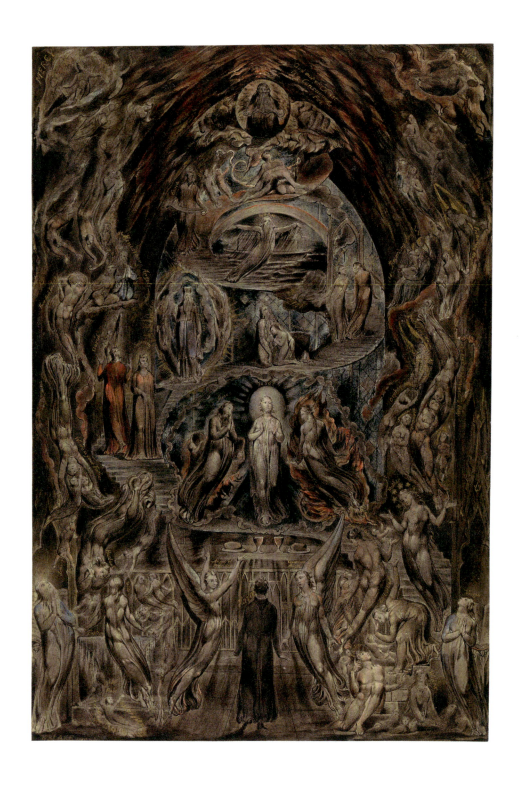

141. *Epitome of James Hervey's 'Meditations among the Tombs'*, c.1820–5
Ink, watercolour and oil paint on paper, 43.1 × 29.2

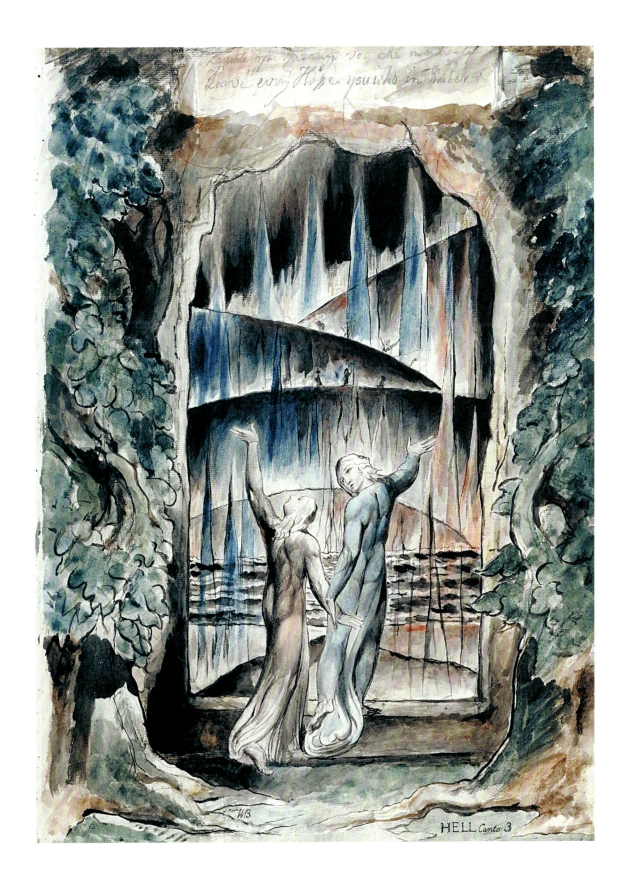

142. *The Inscription over the Gate*, 1824–7
Graphite, ink and watercolour on paper, 52.7 × 37.4

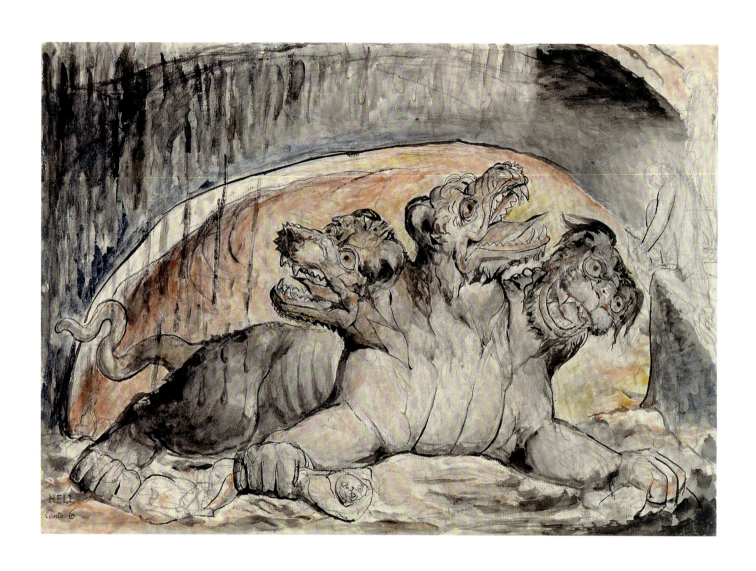

143. *Cerberus (first version)*, 1824–7
Graphite, ink and watercolour on paper, 37.2 × 52.8

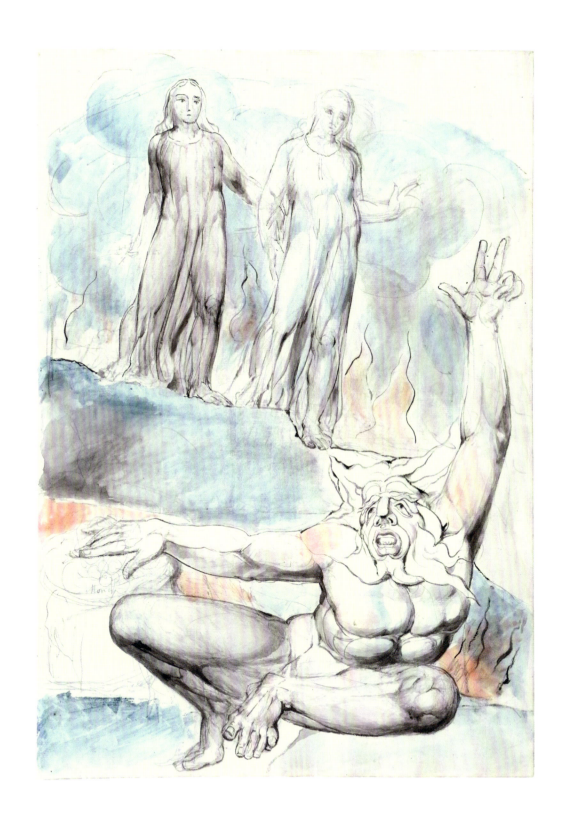

144. *Plutus*, 1824–7
Graphite, ink and watercolour on paper, 52.7 × 37.1

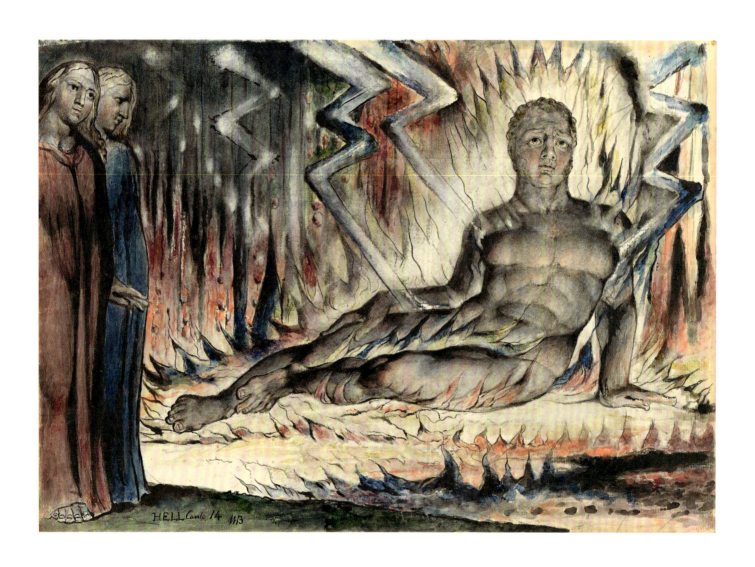

145. *Capaneus the Blasphemer*, 1824–7
Ink, watercolour, graphite and chalk on paper, 37.4 × 52.7

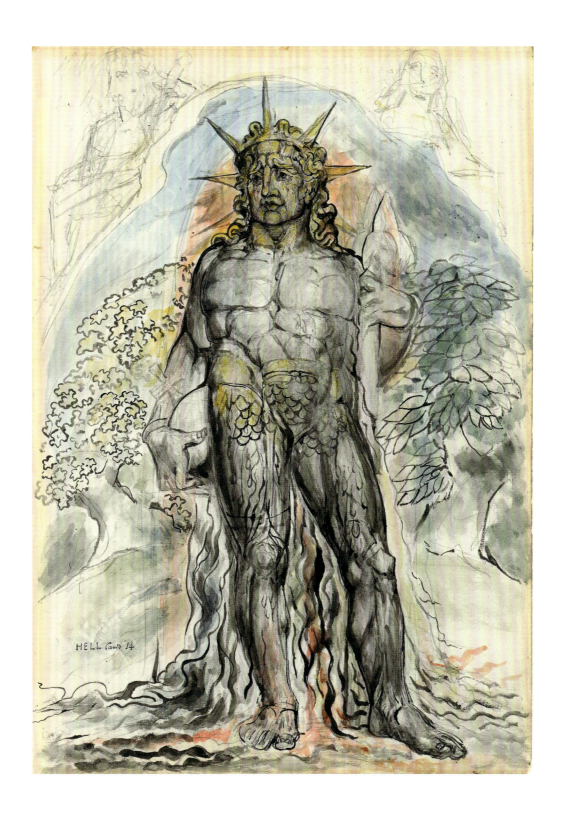

146. *The Symbolic Figure of the Course of Human History described by Virgil*, 1824–7
Ink, watercolour and graphite on paper, 52.7 × 37.3

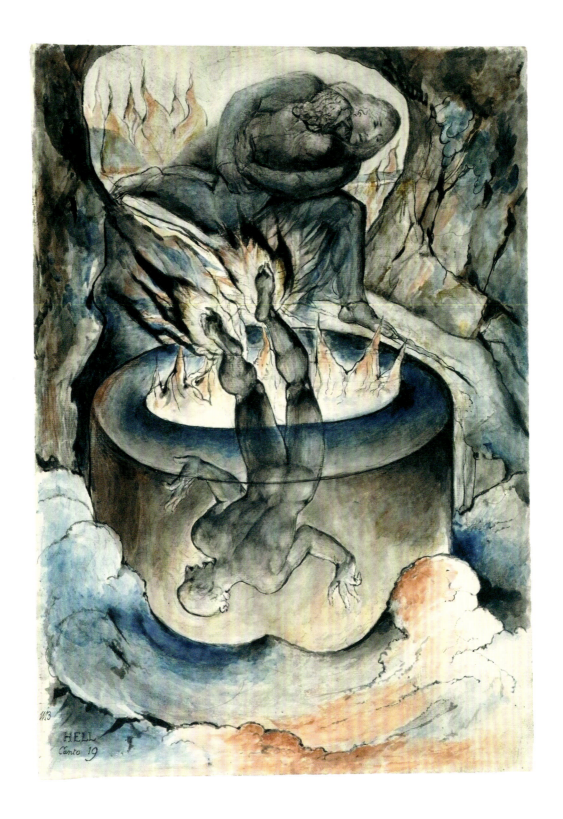

147. *The Simoniac Pope*, 1824–7
Ink and watercolour on paper, 52.7 × 36.8

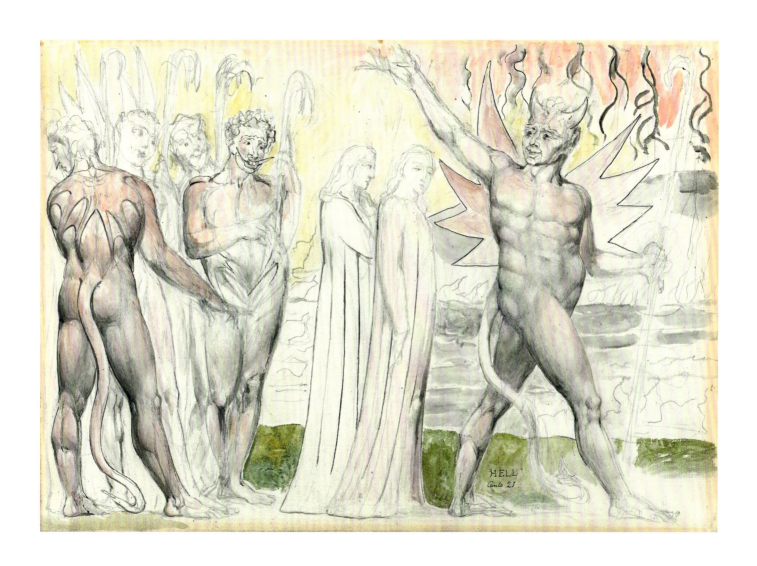

148. *The Devils setting out with Dante and Virgil*, 1824–7
Ink, watercolour, graphite and chalk on paper, 37.2 × 52.8

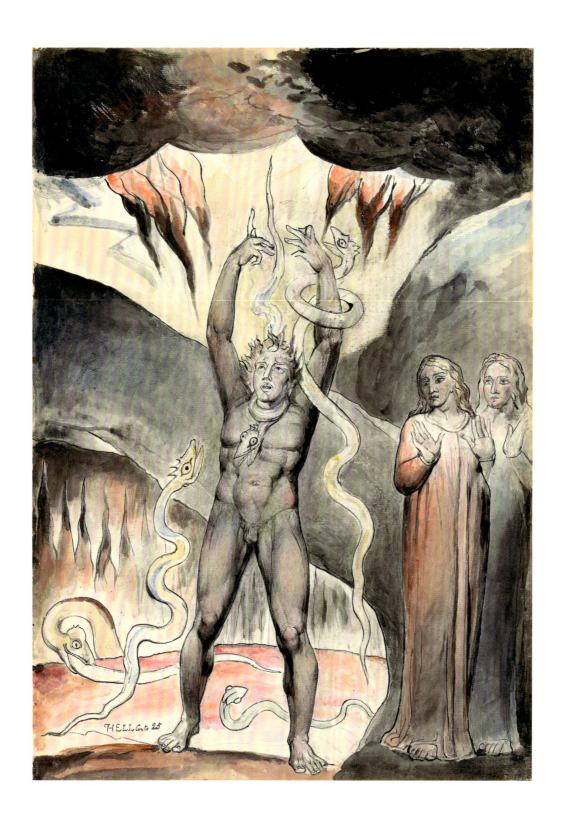

149. *Vanni Fucci 'making Figs' against God*, 1824–7
Ink, watercolour, graphite and chalk on paper, 52.7 × 37.2

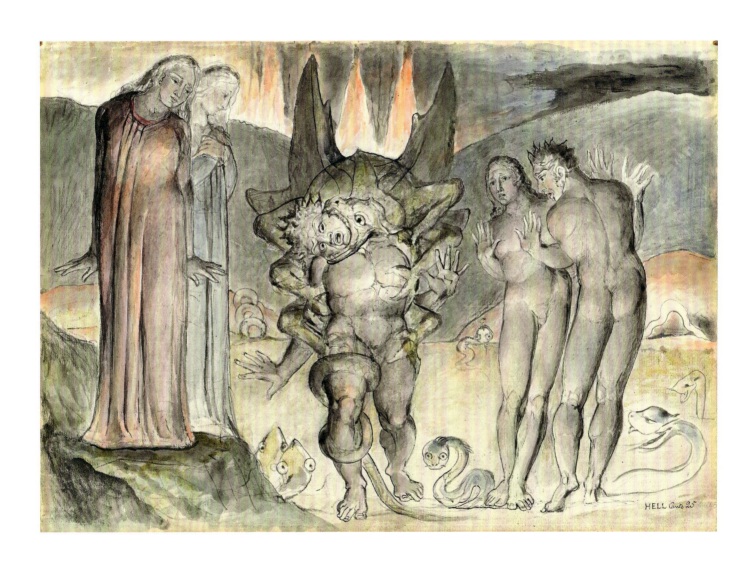

150. *The Six-Footed Serpent attacking Agnello Brunelleschi*, 1824–7
Ink, watercolour, graphite and chalk on paper, 37.3 × 52.7

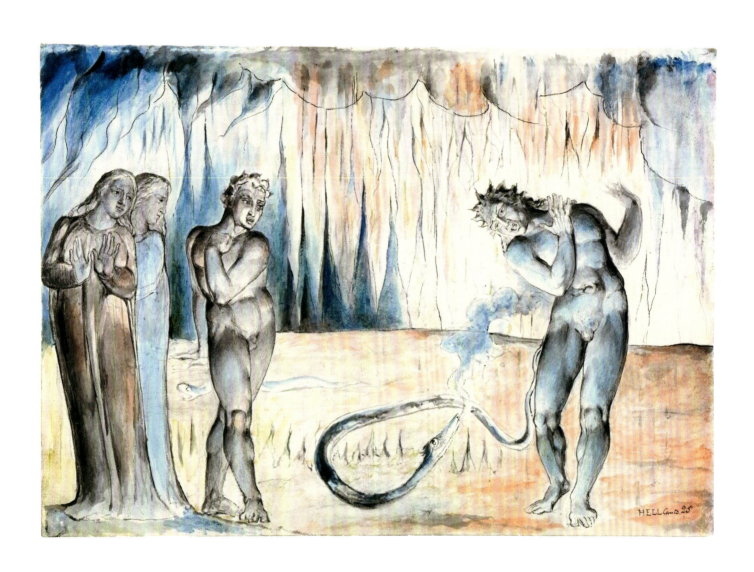

151. *The Serpent Attacking Buoso Donati*, 1824–7
Ink and watercolour on paper, 37.2 × 52.7

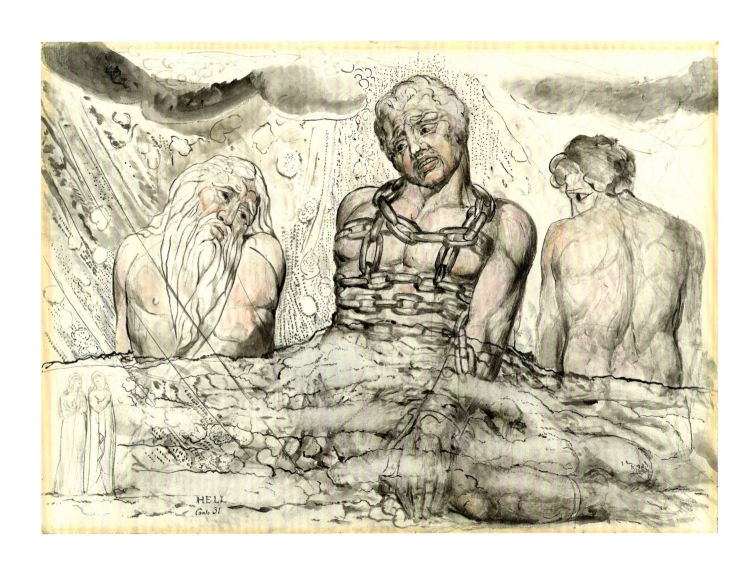

152. *Ephialtes and two other Titans*, 1824–7
Ink, watercolour, graphite and chalk on paper, 37.3 × 52.7

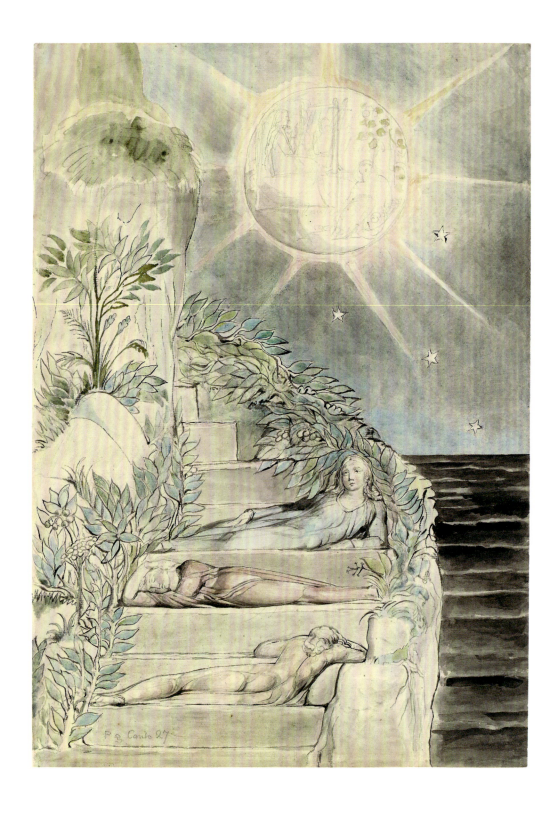

153. *Dante and Statius sleeping, Virgil watching (illustration to the 'Divine Comedy', Purgatorio XXVII)*, 1827
Ink, watercolour and graphite on paper, 52 × 36.8

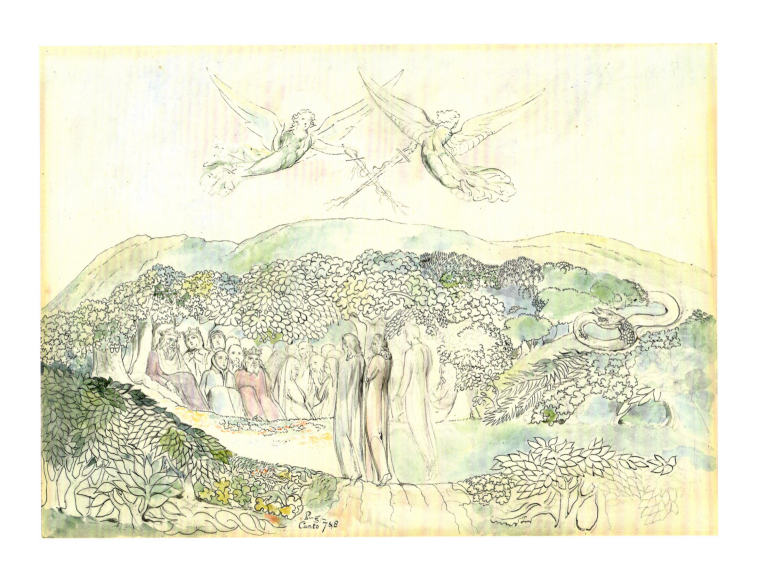

154. *The Lawn with the Kings and Angels*, 1824–7
Ink, watercolour, chalk and graphite on paper, 37.3 × 52.7

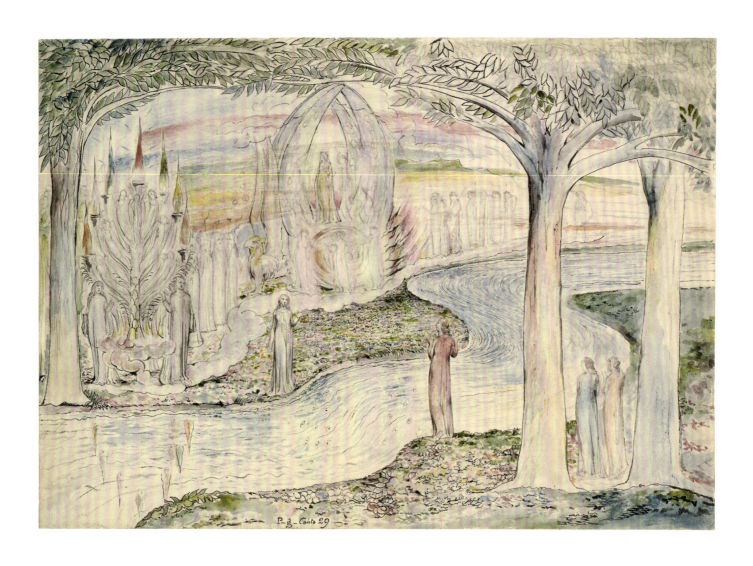

155. *Matilda and Dante on the Banks of the Lethe with Beatrice on the Triumphal Chariot*, 1824–7
Graphite, ink and watercolour on paper, 36.7 × 52

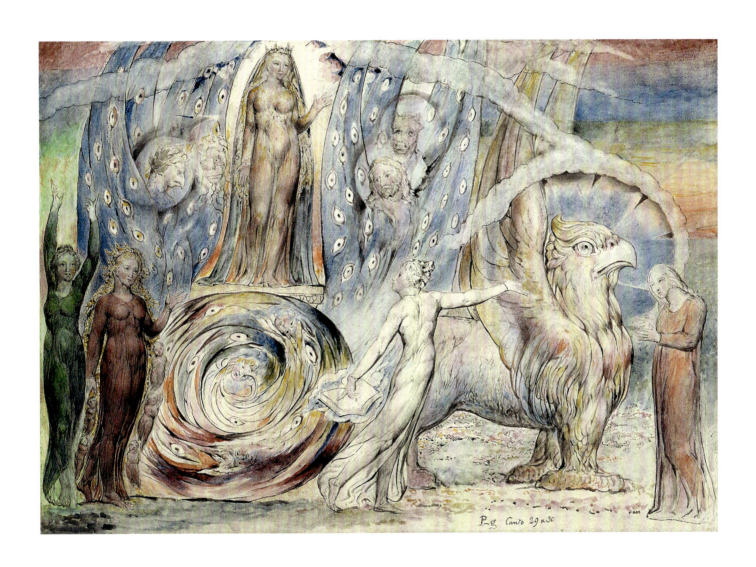

156. *Beatrice Addressing Dante from the Car*, 1824–7
Ink and watercolour on paper, 37.2 × 52.7